BELFAST TROLLEYBUSES
1938-1968

DAVID HARVEY

AMBERLEY

Cover images:

Front top: Waiting to turn right from Royal Avenue into Castle Street is trolleybus 217, (OZ 7319). Even though it was now about ten years old and the trolleybus fleet was already being phased out by the type of MH Cars Daimler 'Fleetlines' passing it on the nearside, these Harkness-bodied six-wheelers were still handsome-looking vehicles. 217 is working on the 13 route to Glen Road from Whitewell, though the bottom destination blind is incorrectly set showing 'CARLISLE CIRCUS'. (J. Bishop)

Front below: Speeding up the steep hill from the impressive Massey Gates at the turning circle in Massey Avenue is Harkness-bodied Guy BTX trolleybus 107, (GZ 7892). It is working on the 23 route towards the terminus behind the Stormont Parliament Buildings and is passing the beautifully tended formalised ceremonial gardens which surround the Government buildings. (D. R. Harvey Collection)

Rear: On 23 July 1963, AEC 664T trolleybus 89, (FZ 7874), splashes along Donegall Place passing the junction with Castle Street. It has left Donegall Square in the distance, dominated by the domed City Hall, while working on the 35 route to Carr's Glen. (A. D. Packer)

First published 2010

Amberley Publishing
Cirencester Road, Chalford,
Stroud, Gloucestershire, GL6 8PE

www.amberley-books.com

British Library Cataloguing in Publication Data.
A catalogue record for this book is available from the British Library.

ISBN 978 1 84868 466 9
Typesetting and Origination by Amberley Publishing.
Printed in Great Britain.

CONTENTS

ACKNOWLEDGEMENTS

The author is grateful to the many photographers acknowledged in the text who have contributed to this volume. I sincerely thank all of those who are still alive for allowing me to use pictures, many of which were taken more than forty-five years ago. Where the photographer is not known, the photographs are credited to my own collection. Special thanks are due to my wife Diana for her splendid proofreading and to Jason Matthews for his informative comments. Roger Smith's excellent maps are wonderfully informative and help the reader to place the photographs in their correct location. The book would not have been possible without the continued encouragement given by Sarah Flight and Jessica Andrews of Amberley Publishing. I would also wish to thank John Hughes who examined the electrical equipment on the beautifully preserved trolleybus 246 at the Black Country Living Museum. Thanks are also due to Mike Maybin for providing me with various vital pieces of information, to Tom Ferris for doing some research for me and to Alan W. Robertson of the Public Record Office of Northern Ireland, Belfast, and to the librarian of the Ulster Folk & Transport Museum Library.

David Harvey
Dudley
June 2009

PREFACE

This book examines the development, expansion and eventual decline of the Belfast trolleybus system, which was the only one to be built in Ireland. Belfast's trolleybuses had over twenty years of stability, but with a change of policy, the operation had five years of stability before the final five years in which the 37½-mile system was totally abandoned.

This volume has been set out in a less orthodox way than perhaps is normal. It is an attempt to show every one of Belfast's trolleybuses from 1 to 246 and by so doing show a wide variety of locations both in the city centre and in the suburbs of Belfast. Unfortunately, not all of Belfast's trolleybuses were photographed, and there are some that appear to have been photographed only once. In the former case, please be indulgent, and in the latter case, it could be that the trolleybus photograph has been published before, when other authors have borrowed Belfast trolleybus photographs from the author's own collection. With any luck, this repetition will not detract from the book, as the captions hopefully throw a new light on the street scene and the individual trolleybuses. By doing it this way, all of the Belfast trolleybus routes are examined in detail, as are the differences in the numerous classes of trolleybus. Each chapter looks at a selection of the trolleybuses used on the route over time and the areas through which the route travelled. Enjoy the journey around one of the best-maintained Belfast systems whose conversions from tram to trolleybus were curtailed by the Second World War, but which nonetheless thrived for thirty years in the middle years of the twentieth century.

INTRODUCTION

Let us look at the 246-strong Belfast fleet of trolleybuses that were operated between 1938 and 1968. During this thirty-year period, the trolleybus fleet expanded dramatically under the enthusiastic leadership of the general manager, Col Robert McCreary. Fourteen experimental trolleybuses, consisting of seven pairs of six-wheeled chassis, six types of electric motor and the products of five different coachbuilders were bought as a trial along Falls Road on 28 March 1938. This route was chosen because it virtually stood on its own and was long enough to accomplish a worthwhile test of this new mode of transport. Additionally, the conversion of the Falls Park tram depot to trolleybuses could be easily undertaken, as it was located at the outer end of the route. This made the depot ideal for garaging the trolleybuses, maintaining them and assessing the performance of the vehicles along Falls Road.

The trolleybuses proved to be triumphant on this one route, increasing the revenue by 7 per cent in comparison to the Falls Road tram they had replaced. It therefore came as no surprise that Col McCreary recommended to the city council on 9 January 1939 that the tram services be replaced across the entire city. The first routes to be converted to trolleybus operation would be all the East Belfast tram routes on the County Down side of the city. This would be followed by the southern routes, which were, in the event, barely reached by trolleybuses, and finally, the northern tram routes. These conversions were to have been achieved by 1944, but wartime conditions and post-war delays in the delivery of new vehicles ensured the survival of the tramcar on Belfast's streets for another ten years. 114 six-wheeled AEC 664T GEC-powered Harkness-bodied trolleybuses were ordered and the eastern expansion scheme began to operate when the Cregagh route was opened on 13 February 1941. During the Second World War, another four groups of trolleybus routes were, perhaps surprisingly, opened but the last twenty-six of the AEC chassis were never delivered.

After the war, the tram to trolleybus conversion was slowly resumed with the deliveries of the semi-utility four-wheelers in 1946. The conversion plan was altered in that the Ormeau Road service, introduced in 1948, was the only one to the south of the city to be actually converted. The three northern groups of tram services on the Antrim side of the River Lagan were converted to trolleybus operation between 1949 and 1951.

For virtually the first twenty years of its life, the system continued to expand, but after Col McCreary announced his retirement in May 1951, it was significant that

only another four trolleybus routes were introduced. Mr Mackle replaced the last tram routes by motor buses by 1954, and by 1956, the first withdrawals of trolleybuses had taken place. When the final trolleybus entered service on 1 October 1958, the fleet strength was reduced to 221 vehicles, with the elimination of the fourteen original trolleybuses and all of the eleven second-hand former Wolverhampton trolleybuses. Two routes had gone that year, but there was still one more extension to be introduced; the trolleybus route to Holywood Road became the first to be closed on 1 June 1958, but four more routes were opened between 1952 and 1959 when the Whiterock spur off Falls Road became the last conversion on 19 May 1959.

In 1958, with the AEC six-wheelers coming towards the end of their lives, consideration was given to purchasing replacement vehicles, and four experimental buses were purchased, though only one was a trolleybus. 246 was a Harkness-bodied four-wheeled Sunbeam F4A, and despite a press announcement that it was going to be the first of another one hundred new trolleybuses, this plan was quickly dropped. In 1959, it was decided that all the East Belfast trolleybus routes would be withdrawn in 1963, so although 1958 was 'the beginning of the end', there were another five years of stability before the East Belfast routes were removed in 1963. After that, the system was gradually wound down over the next five years until the final trolleybuses ran on 12 May 1968, leaving just eight trolleybus systems in the British Isles.

At its maximum, the Belfast trolleybus system could boast that it was the second largest outside London, had a total route mileage of some 37½ miles and for three years between 1954 and 1957 had a fleet size of 245 smart and well-maintained vehicles.

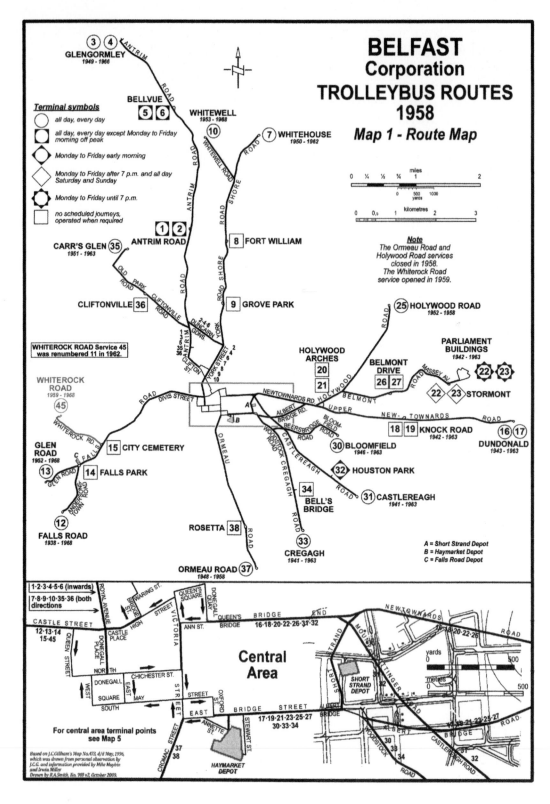

BELFAST
Corporation
TROLLEYBUS ROUTES
1958
Map 1 - Route Map

Terminal symbols

○ all day, every day

▢ all day, every day except Monday to Friday morning off peak

◇ Monday to Friday early morning

◇ Monday to Friday after 7 p.m. and all day Saturday and Sunday

✪ Monday to Friday until 7 p.m.

☐ no scheduled journeys, operated when required

③ ④ GLENGORMLEY 1949 - 1966

BELLVUE ⑤ ⑥

⑩ WHITEWELL 1953 - 1968

⑦ WHITEHOUSE 1950 - 1962

① ② ANTRIM ROAD

⑧ FORT WILLIAM

CARR'S GLEN ㉟ 1951 - 1963

CLIFTONVILLE ㊱

⑨ GROVE PARK

㉕ HOLYWOOD ROAD 1952 - 1958

PARLIAMENT BUILDINGS 1942 - 1963

Note
The Ormeau Road and Holywood Road services closed in 1958. The Whiterock Road service opened in 1959.

WHITEROCK ROAD Service 45 was renumbered 11 in 1962.

WHITEROCK ROAD 1959 - 1968

㊺

HOLYWOOD ARCHES
⑳
㉑

BELMONT DRIVE
㉖ ㉗

㉒ ㉓ STORMONT

GLEN ROAD 1952 - 1968

⑬

⑭ FALLS PARK

⑮ CITY CEMETERY

⑱ ⑲ KNOCK ROAD 1942 - 1963

⑯ ⑰ DUNDONALD 1943 - 1963

㉚ BLOOMFIELD 1946 - 1963

㉜ HOUSTON PARK

⑫

FALLS ROAD 1938 - 1968

㉞ BELL'S BRIDGE

㉛ CASTLEREAGH 1941 - 1963

ROSETTA ㊳

㉝ CREGAGH 1941 - 1963

ORMEAU ROAD ㊲ 1948 - 1958

A = Short Strand Depot
B = Haymarket Depot
C = Falls Road Depot

1·2·3·4·5·6 (inwards)
7·8·9·10·35·36 (both directions)

12·13·14 15·45

16·18·20·22·26·31·32

17·19·21·23·25·27 30·33·34

16·18·20·22·26

17·18·21·23·25·27

Central Area

SHORT STRAND DEPOT

For central area terminal points see Map 5

HAYMARKET DEPOT

Based on J.C.Gilham's Map No.473, 4/d May, 1996, which was drawn from personal observation by J.C.G. and information provided by Mike Maybin and Irwin Miller.
Drawn by R.A.Smith, No. 910 v2, October 2009.

BELFAST TROLLEYBUS FLEET

Fleet No.	Reg. No.	Chassis	Chassis No.	Motors	Body	Body No.	Seating capacity	In service	Out of service
1-2	EZ 7889-7890	AEC 664T	664T551-552	EE 95 hp	Harkness		H36/32R	28/3/1938	30/9/1958
3	EZ 7891	Crossley TDD6	92316	MV 95 hp	MCCW/Crossley		H36/32R	28/3/1938	31/5/1958
4	EZ 7892	Crossley TDD6	92317	MV 95 hp	Harkness		H36/32R	28/3/1938	31/5/1958
5	7893	Daimler CTM6	21002 1937 CMS exhibit	MV 95 hp	Harkness		H36/32R	28/3/1938	31/5/1958
6	EZ 7894	Daimler CTM6	21003	MV 95 hp	Harkness		H36/32R	28/3/1938	21/2/1956
7	EZ 7895	Guy BTX	BTX 24609	EE 95 hp	Park Royal	B4908	H36/32R	28/3/1938	31/5/1958
8	EZ 7896	Guy BTX	BTX 24610	ECC 95 hp	Harkness		H36/32R	28/3/1938	31/5/1958
9 -10	EZ 7897-7898	Karrier E6A	31106/31127	Cromp West 95 hp	Harkness		H36/32R	28/3/1938	31/5/1958
11 -12	EZ 7899-7900	Leyland TTB4	16303-4	GEC 95 hp	Leyland		H36/32R	28/3/1938	31/5/1958
13 -14	EZ 7901-7902	Sunbeam MS2	12148-9	BTH 95 hp	Cowieson		H36/32R	28/3/1938	31/5/1958
15	FZ 7800	AEC 664T	664T 716	GEC 95 hp	Harkness		H36/32R	13/2/1941	15/3/1963

Fleet No.	Reg. No.	Chassis	Chassis No.	Motors	Body	Body No.	Seating capacity	In service	Out of service
16	FZ 7801	AEC 664T	664T 717	GEC 95 hp	Harkness		H36/32R	26/9/1940	1/4/1963
17	FZ 7802	AEC 664T	664T 718	GEC 95 hp	Harkness		H36/32R	9/10/1940	10/6/1963
18	FZ 7803	AEC 664T	664T 719	GEC 95 hp	Harkness		H36/32R	13/2/1941	1/4/1963
19	FZ 7804	AEC 664T	664T 720	GEC 95 hp	Harkness		H36/32R	5/6/1941	22/10/1963
20	FZ 7805	AEC 664T	664T 721	GEC 95 hp	Harkness		H36/32R	13/2/1941	10/6/1963
21	FZ 7806	AEC 664T	664T 722	GEC 95 hp	Harkness		H36/32R	13/2/1941	22/10/1963
22	FZ 7807	AEC 664T	664T 723	GEC 95 hp	Harkness		H36/32R	10/10/1940	10/6/1963
23	FZ 7808	AEC 664T	664T 724	GEC 95 hp	Harkness		H36/32R	14/2/1941	10/6/1963
24	FZ 7809	AEC 664T	664T 725	GEC 95 hp	Harkness		H36/32R	13/2/1941	22/10/1963
25	FZ 7810	AEC 664T	664T 726	GEC 95 hp	Harkness		H36/32R	13/2/1941	1/4/1963
26	FZ 7811	AEC 664T	664T 727	GEC 95 hp	Harkness		H36/32R	13/2/1941	1/2/1963

Fleet No.	Reg. No.	Chassis	Chassis No.	Motors	Body	Body No.	Seating capacity	In service	Out of service
27	FZ 7812	AEC 664T	664T 728	GEC 95 hp	Harkness		H36/32R	13/2/1941	1/4/1963
28	FZ 7813	AEC 664T	664T 729	GEC 95 hp	Harkness		H36/32R	13/2/1941	10/6/1963
29	FZ 7814	AEC 664T	664T 730	GEC 95 hp	Harkness		H36/32R	13/2/1941	22/10/1963
30	FZ 7815	AEC 664T	664T 731	GEC 95 hp	Harkness		H36/32R	5/6/1941	10/6/1963
31	FZ 7816	AEC 664T	664T 732	GEC 95 hp	Harkness		H36/32R	5/6/1941	1/3/1963
32	FZ 7817	AEC 664T	664T 733	GEC 95 hp	Harkness		H36/32R	13/2/1941	1/2/1963
33	FZ 7818	AEC 664T	664T 734	GEC 95 hp	Harkness		H36/32R	13/2/1941	22/10/1963
34	FZ 7819	AEC 664T	664T 735	GEC 95 hp	Harkness		H36/32R	13/2/1941	1/2/1963
35	FZ 7820	AEC 664T	664T 736	GEC 95 hp	Harkness		H36/32R	13/2/1941	22/10/1963
36	7821	AEC 664T	664T 737	GEC 95 hp	Harkness		H36/32R	13/2/1941	1/2/1963
37	FZ 7822	AEC 664T	664T 738	GEC 95 hp	Harkness		H36/32R	26/3/1941	1/3/1963
38	FZ 7823	AEC 664T	664T 739	GEC 95 hp	Harkness		H36/32R	5/6/1941	1/4/1963

Fleet No.	Reg. No.	Chassis	Chassis No.	Motors	Body	Body No.	Seating capacity	In service	Out of service
39	FZ 7824	AEC 664T	664T 740	GEC 95 hp	Harkness		H36/32R	5/6/1941	28/3/1963
40	FZ 7825	AEC 664T	664T 741	GEC 95 hp	Harkness		H36/32R	5/6/1941	22/10/1963
41	FZ 7826	AEC 664T	664T 742	GEC 95 hp	Harkness		H36/32R	13/2/1941	1/3/1963
42	FZ 7827	AEC 664T	664T 743	GEC 95 hp	Harkness		H36/32R	13/2/1941	22/10/1963
43	FZ 7828	AEC 664T	664T 744	GEC 95 hp	Harkness		H36/32R	5/6/1941	22/10/1963
44	FZ 7829	AEC 664T	664T 745	GEC 95 hp	Harkness		H36/32R	26/3/1941	10/6/1963
45	FZ 7830	AEC 664T	664T 746	GEC 95 hp	Harkness		H36/32R	5/6/1941	10/6/1963
46	FZ 7831	AEC 664T	664T 747	GEC 95 hp	Harkness		H36/32R	1/12/1941	1/4/1963
47 -50	FZ 7832-35	AEC 664T	664T 748-751	GEC 95 hp	Harkness		H36/32R	5/6/1941	22/10/1963
51	FZ 7836	AEC 664T	664T 752	GEC 95 hp	Harkness		H36/32R	26/3/1942	1/2/1962
52 -54	FZ 7837-39	AEC 664T	664T 753-5	GEC 95 hp	Harkness		H36/32R	5/6/1941	1/4/1963
55	FZ 7840	AEC 664T	664T 756	GEC 95 hp	Harkness		H36/32R	5/6/1941	10/6/1963

Fleet No.	Reg. No.	Chassis	Chassis No.	Motors	Body	Body No.	Seating capacity	In service	Out of service
56	FZ 7841	AEC 664T	664T 757	GEC 95 hp	Harkness		H36/32R	26/3/1942	1/4/1963
57	FZ 7842	AEC 664T	664T 758	GEC 95 hp	Harkness		H36/32R	1/12/1941	12/7/1962
58	FZ 7843	AEC 664T	664T 759	GEC 95 hp	Harkness		H36/32R	1/12/1941	1/4/1963
59	FZ 7844	AEC 664T	664T 760	GEC 95 hp	Harkness		H36/32R	26/3/1942	2/7/1962
60-	FZ 7845	AEC 664T	664T 761	GEC 95 hp	Harkness		H36/32R	1/12/1941	1/4/1963
61	FZ 7846	AEC 664T	664T 762	GEC 95 hp	Harkness		H36/32R	1/12/1941	22/10/1963
62	FZ 7847	AEC 664T	664T 763	GEC 95 hp	Harkness		H36/32R	26/3/1942	22/10/1963
63	FZ 7848	AEC 664T	664T 764	GEC 95 hp	Harkness	16498	H36/32R	9/7/1941	1/4/1963
64	FZ 7849	AEC 664T	664T 765	GEC 95 hp	Harkness	16501	H36/32R	6/10/1942	1/4/1963
65	FZ 7850	AEC 664T	664T 766	GEC 95 hp	Harkness		H36/32R	26/3/1942	1/4/1963
66	FZ 7851	AEC 664T	664T 767	GEC 95 hp	Harkness		H36/32R	26/3/1942	10/6/1963

Fleet No.	Reg. No.	Chassis	Chassis No.	Motors	Body	Body No.	Seating capacity	In service	Out of service
67	FZ 7852	AEC 664T	664T 768	GEC 95 hp	Harkness		H36/32R	26/3/1942	1/4/1963
68	FZ 7853	AEC 664T	664T 769	95 hp	Harkness		H36/32R	1/12/1941	22/10/1963
69 -72	FZ 7854-57	AEC 664T	664T 770-773	GEC 95 hp	Harkness		H36/32R	26/3/1942	2/7/1962
73	FZ 7858	AEC 664T	664T 774	GEC 95 hp	Harkness	16499	H36/32R	1/8/1942	2/7/1962
74	FZ 7859	AEC 664T	664T 775	GEC 95 hp	Harkness	16500	H36/32R	16/11/1942	10/6/1963
75	FZ 7860	AEC 664T	664T 776	GEC 95 hp	Harkness	16496	H36/32R	8/7/1942	2/7/1962
76	FZ 7861	AEC 664T	664T 777	GEC 95 hp	Harkness	16502	H36/32R	16/11/1942	2/7/1962
77	FZ 7862	AEC 664T	664T 778	GEC 95 hp	Harkness	16503	H36/32R	5/11/1942	2/7/1962
78	FZ 7863	AEC 664T	664T 779	GEC 95 hp	Harkness	16504	H36/32R	16/11/1942	2/7/1962
79	FZ 7864	AEC 664T	664T 780	GEC 95 hp	Harkness	16505	H36/32R	16/11/1942	1/4/1963
80	FZ 7865	AEC 664T	664T 781	GEC 95 hp	Harkness	16508	H36/32R	16/11/1942	10/4/1963
81	FZ 7866	AEC 664T	664T 782	GEC 95 hp	Harkness		H36/32R	26/3/1942	1/4/1963

Fleet No.	Reg. No.	Chassis	Chassis No.	Motors	Body	Body No.	Seating capacity	In service	Out of service
82	FZ 7867	AEC 664T	664T 783	GEC 95 hp	Harkness	16497	H36/32R	5/11/1942	22/10/1963
83	FZ 7868	AEC 664T	664T 784	GEC 95 hp	Harkness	16506	H36/32R	16/11/1942	1/4/1963
84	FZ 7869	AEC 664T	664T 785	GEC 95 hp	Harkness	16516	H36/32R	4/3/1943	1/2/1963
85	FZ 7870	AEC 664T	664T 786	GEC 95 hp	Harkness	16513	H36/32R	4/3/1943	1/3/1963
86	FZ 7871	AEC 664T	664T 787	GEC 95 hp	Harkness	16507	H36/32R	4/3/1943	1/4/1963
87	FZ 7872	AEC 664T	664T 788	GEC 95 hp	Harkness	16512	H36/32R	4/3/1943	1/4/1963
88	FZ 7873	AEC 664T	664T 789	GEC 95 hp	Harkness	16510	H36/32R	8/3/1943	10/6/1963
89	FZ 7874	AEC 664T	664T 790	GEC 95 hp	Harkness	16511	H36/32R	16/11/1942	22/10/1963
90	FZ 7875	AEC 664T	664T 791	GEC 95 hp	Harkness	16515	H36/32R	2/3/1943	1/3/1963
91	FZ 7876	AEC 664T	664T 792	GEC 95 hp	Harkness	16514	H36/32R	2/3/1943	1/4/1963
92	FZ 7877	AEC 664T	664T 793	GEC 95 hp	Harkness	16509	H36/32R	16/11/1942	22/10/1963

Fleet No.	Reg. No.	Chassis	Chassis No.	Motors	Body	Body No.	Seating capacity	In service	Out of service
93	FZ 7878	AEC 664T	664T 794	GEC 95 hp	Harkness	16520	H36/32R	18/1/1943	1/3/1963
94	FZ 7879	AEC 664T	664T 795	GEC 95 hp	Harkness	16517	H36/32R	18/1/1943	15/3/1963
95	FZ 7880	AEC 664T	664T 796	GEC 95 hp	Harkness	16518	H36/32R	8/3/1943	22/10/1963
96	FZ 7881	AEC 664T	664T 797	GEC 95 hp	Harkness	16519	H36/32R	8/3/1943	22/10/1963
97	FZ 7882	AEC 664T	664T 798	GEC 95 hp	Harkness	16521	H36/32R	8/3/1943	1/4/1963
98	FZ 7883	AEC 664T	664T 799	GEC 95 hp	Harkness	16522	H36/32R	8/3/1943	22/10/1963 Preserved
99	FZ 7884	AEC 664T	664T 800	GEC 95 hp	Harkness	16524	H36/32R	29/3/1943	15/3/1963
100	FZ 7885	AEC 664T	664T 801	GEC 95 hp	Harkness	16523	H36/32R	6/10/1943	10/6/1963
101	FZ 7886	AEC 664T	664T 802	GEC 95 hp	Harkness	16525	H36/32R	3/3/1943	10/6/1963
102	FZ 7887	AEC 664T	664T 803	GEC 95 hp	Harkness	16526	H36/32R	7/7/1943	28/3/1963
			103-128 not delivered, but registrations retained						

Fleet No.	Reg. No.	Chassis	Chassis No.	Motors	Body	Body No.	Seating capacity	In service	Out of service
103	FZ 7888	Guy BTX	BTX 36904	GEC 100 hp	Harkness		H36/32R	26/3/1948	4/7/1965
104	FZ 7889	Guy BTX	BTX 36905	GEC 100 hp	Harkness		H36/32R	1/10/1947	2/3/1964
105-	FZ 7890	Guy BTX	BTX 36906	GEC 100 hp	Harkness		H36/32R	26/3/1948	16/6/1965
106	FZ 7891	Guy BTX	BTX 36907	GEC 100 hp	Harkness		H36/32R	26/3/1948	16/6/1965
107	FZ 7892	Guy BTX	BTX 36908	GEC 100 hp	Harkness		H36/32R	26/3/1948	5/3/1964
108	FZ 7893	Guy BTX	BTX36909	GEC 100 hp	Harkness		H36/32R	31/3/1948	12/5/1968*
109	FZ 7894	Guy BTX	BTX 36910	GEC 100 hp	Harkness		H36/32R	5/4/1948	7/2/1966
110	FZ 7895	Guy BTX	BTX 36911	GEC 100 hp	Harkness		H36/32R	14/1/1949	4/7/1965
111	FZ 7896	Guy BTX	BTX 36912	GEC 100 hp	Harkness		H36/32R	5/4/1948	5/3/1964
112	FZ 7897	Guy BTX	BTX 36913	GEC 100 hp	Harkness		H36/32R	5/4/1948	12/5/1968* Preserved
113	FZ 7898	Guy BTX	BTX 36914	GEC 100 hp	Harkness		H36/32R	5/4/1948	5/3/1964
114	FZ 7899	Guy BTX	BTX 36915	GEC 100 hp	Harkness		H36/32R	5/4/1948	31/8/1964

17

Fleet No.	Reg. No.	Chassis	Chassis No.	Motors	Body	Body No.	Seating capacity	In service	Out of service
115	FZ 7900	Guy BTX	BTX 36916	GEC 100 hp	Harkness		H36/32R	9/4/1948	31/8/1964
116	FZ 7901	Guy BTX	BTX 36917	GEC 100 hp	Harkness		H36/32R	9/4/1948	7/2/1966
117	FZ 7902	Guy BTX	BTX 36918	GEC 100 hp	Harkness		H36/32R	9/4/1948	31/12/1964
118	FZ 7903	Guy BTX	BTX 36919	GEC 100 hp	Harkness		H36/32R	1/3/1949	5/3/1964
119	FZ 7904	Guy BTX	BTX 36920	GEC 100 hp	Harkness		H36/32R	14/1/1949	14/6/1965
120	FZ 7905	Guy BTX	BTX 36921	GEC 100 hp	Harkness		H36/32R	6/12/1948	7/2/1966
121	FZ 7906	Guy BTX	BTX 36922	GEC 100 hp	Harkness		H36/32R	2/12/1948	7/2/1966
122	FZ 7907	Guy BTX	BTX 36923	GEC 100 hp	Harkness		H36/32R	9/4/1948	31/8/1964
123	FZ 7908	Guy BTX	BTX 36924	GEC 100 hp	Harkness		H36/32R	2/5/1949	12/5/1968*
124	FZ 7909	Guy BTX	BTX 36925	GEC 100 hp	Harkness		H36/32R	9/4/1948	14/6/1965
125	FZ 7910	Guy BTX	BTX 36926	GEC 100 hp	Harkness		H36/32R	14/4/1948	12/5/1968*
126	FZ 7911	Guy BTX	BTX 36927	GEC 100 hp	Harkness		H36/32R	14/4/1948	7/2/1964

Fleet No.	Reg. No.	Chassis	Chassis No.	Motors	Body	Body No.	Seating capacity	In service	Out of service
127	FZ 7912	Guy BTX	BTX 36928	GEC 100 hp	Harkness		H36/32R	14/4/1948	12/5/1968*
128	FZ 7913	Guy BTX	BTX 36929	GEC 100 hp	Harkness		H36/32R	2/3/1949	31/8/1964
129 -130	GZ 1620- 21	Sunbeam W4	50038-39	BTH 85 hp	Park Royal	17529/8	H30/26R	1/12/1943	29/10/1958
131	GZ 2802- 13	Sunbeam W4	50207	BTH 85 hp	Harkness		H30/26R	2/5/1946	29/10/1958
132	GZ	Sunbeam W4	50208	BTH 85 hp	Harkness		H30/26R	2/5/1946	1/9/1960
133	GZ	Sunbeam W4	50209	BTH 85 hp	Harkness		H30/26R	2/5/1946	1/9/1960
134	GZ	Sunbeam W4	50210	BTH 85 hp	Harkness		H30/26R	2/5/1946	1/9/1960
135	GZ	Sunbeam W4	50211	BTH 85 hp	Harkness		H30/26R	2/5/1946	1/9/1960
136	GZ	Sunbeam W4	50212	BTH 85 hp	Harkness		H30/26R	2/5/1946	29/10/1958
137	GZ	Sunbeam W4	50213	BTH 85 hp	Harkness		H30/26R	6/5/1946	1/9/1960
138	GZ	Sunbeam W4	50214	BTH 85 hp	Harkness		H30/26R	3/5/1946	29/10/1958
139	GZ	Sunbeam W4	50215	BTH 85 hp	Harkness		H30/26R	6/5/1946	29/10/1958
140	GZ	Sunbeam W4	50216	BTH 85 hp	Harkness		H30/26R	4/5/1946	1/9/1960
141	GZ	Sunbeam W4	50217	BTH 85 hp	Harkness		H30/26R	2/5/1946	1/9/1960
142	GZ	Sunbeam W4	50218	BTH 85 hp	Harkness		H30/26R	6/5/1946	1/9/1960
143	GZ 8507	Guy BTX	BTX 36930	GEC 100 hp	Harkness		H36/32R	3/1/1949	4/7/1965

19

Fleet No.	Reg. No.	Chassis	Chassis No.	Motors	Body	Body No.	Seating capacity	In service	Out of service
144	GZ 8508	Guy BTX	BTX 36931	GEC 100 hp	Harkness		H36/32R	14/4/1948	12/5/1968*
145	GZ 8509	Guy BTX	BTX36932	GEC 100 hp	Harkness		H36/32R	14/4/1948	14/6/1965
146	GZ 8510	Guy BTX	BTX36933	GEC 100 hp	Harkness		H36/32R	11/1/1949	7/2/1964
147	GZ 8511	Guy BTX	BTX36934	GEC 100 hp	Harkness		H36/32R	2/12/1948	7/2/1964
148	GZ 8512	Guy BTX	BTX36935	GEC 100 hp	Harkness		H36/32R	14/1/1949	12/5/1968*
149	GZ 8513	Guy BTX	BTX36936	GEC 100 hp	Harkness		H36/32R	11/1/1949	7/2/1964
150	GZ 8514	Guy BTX	BTX36937	GEC 100 hp	Harkness		H36/32R	14/1/1949	7/2/1964
151	GZ 8515	Guy BTX	BTX36938	GEC 100 hp	Harkness		H36/32R	11/1/1949	14/6/1965
152	GZ 8516	Guy BTX	BTX36939	GEC 100 hp	Harkness		H36/32R	1/6/1949	5/3/1964
153	GZ 8517	Guy BTX	BTX36940	GEC 100 hp	Harkness		H36/32R	13/1/1949	31/8/1964
154	GZ 8518	Guy BTX	BTX36941	GEC 100 hp	Harkness		H36/32R	11/2/1949	12/5/1968*
155	GZ 8519	Guy BTX	BTX36942	GEC 100 hp	Harkness		H36/32R	3/1/1949	14/6/1965

Fleet No.	Reg. No.	Chassis	Chassis No.	Motors	Body	Body No.	Seating capacity	In service	Out of service
156	GZ 8520	Guy BTX	BTX36943	GEC 100 hp	Harkness		H36/32R	13/1/1949	7/2/1964
157	GZ 8521	Guy BTX	BTX36944	GEC 100 hp	Harkness		H36/32R	11/1/1949	7/2/1964
158	GZ 8522	Guy BTX	BTX36945	GEC 100 hp	Harkness		H36/32R	17/1/1949	14/6/1965
159	GZ 8523	Guy BTX	BTX36946	GEC 100 hp	Harkness		H36/32R	2/5/1949	31/8/1964
160	GZ 8524	Guy BTX	BTX36947	GEC 100 hp	Harkness		H36/32R	12/1/1949	14/6/1965
161	GZ 8525	Guy BTX	BTX36948	GEC 100 hp	Harkness		H36/32R	18/1/1949	6/6/1966
162	GZ 8526	Guy BTX	BTX36949	GEC 100 hp	Harkness		H36/32R	25/3/1949	5/3/1964
163	GZ 8527	Guy BTX	BTX36950	GEC 100 hp	Harkness		H36/32R	12/1/1949	5/3/1964
164	GZ 8528	Guy BTX	BTX36951	GEC 100 hp	Harkness		H36/32R	3/1/1949	2/3/1964
165	GZ 8529	Guy BTX	BTX36952	GEC 100 hp	Harkness		H36/32R	12/1/1949	31/8/1964
166	GZ 8530	Guy BTX	BTX36953	GEC 100 hp	Harkness		H36/32R	3/1/1949	16/6/1965
167	GZ 8531	Guy BTX	BTX36954	GEC 100 hp	Harkness		H36/32R	18/1/1949	20/7/1967

Fleet No.	Reg. No.	Chassis	Chassis No.	Motors	Body	Body No.	Seating capacity	In service	Out of service
168	GZ 8532	Guy BTX	BTX36955	GEC 100 hp	Harkness		H36/32R	31/3/1949	12/5/1968* Preserved
169	GZ 8533	Guy BTX	BTX36956	GEC 100 hp	Harkness		H36/32R	19/1/1949	16/6/1965
170	GZ 8534	Guy BTX	BTX36957	GEC 100 hp	Harkness		H36/32R	18/1/1949	4/7/1965
171	GZ 8535	Guy BTX	BTX36958	GEC 100 hp	Harkness		H36/32R	1/3/1949	5/3/1964
172	GZ 8536	Guy BTX	BTX36959	GEC 100 hp	Harkness		H36/32R	17/1/1949	7/2/1964
173	GZ 8537	Guy BTX	BTX36960	GEC 100 hp	Harkness		H36/32R	4/2/1949	31/8/1964
174	GZ 8538	Guy BTX	BTX36961	GEC 100 hp	Harkness		H36/32R	13/1/1949	26/11/1964 Burnt out Divis St riot 1/10/1964
175	GZ 8539	Guy BTX	BTX36962	GEC 100 hp	Harkness		H36/32R	12/1/1949	16/6/1965
176	GZ 8540	Guy BTX	BTX36963	GEC 100 hp	Harkness		H36/32R	25/3/1949	7/2/1964
177	GZ 8541	Guy BTX	BTX36964	GEC 100 hp	Harkness		H36/32R	2/5/1949	16/6/1965
178	GZ 8542	Guy BTX	BTX36965	GEC 100 hp	Harkness		H36/32R	25/3/1949	11/4/1964
179	GZ 8543	Guy BTX	BTX36966	GEC 100 hp	Harkness		H36/32R	29/3/1949	12/5/1968*

Fleet No.	Reg. No.	Chassis	Chassis No.	Motors	Body	Body No.	Seating capacity	In service	Out of service
180	GZ 8544	Guy BTX	BTX36967	GEC 100 hp	Harkness		H36/32R	3/1/1949	12/5/1968*
181	GZ 8545	Guy BTX	BTX36968	GEC 100 hp	Harkness		H36/32R	17/1/1949	2/3/1964
182	GZ 8546	Guy BTX	BTX36969	GEC 100 hp	Harkness		H36/32R	13/1/1949	16/6/1965
183	GZ 8547	Guy BTX	BTX36970	GEC 100 hp	Harkness		H36/32R	17/1/1949	12/5/1968* Preserved
184	GZ 8548	Guy BTX	BTX36971	GEC 100 hp	Harkness		H36/32R	18/1/1949	26/8/1964
185	GZ 8549	Guy BTX	BTX36972	GEC 100 hp	Harkness		H36/32R	19/1/1949	16/6/1965
186	GZ 8550	Guy BTX	BTX 36973	GEC 100 hp	Harkness		H36/32R	1/6/1949	5/3/1964
187	GZ 8551	BUT 9641T	9641T 211	GEC 100 hp	Harkness		H36/32R	2/10/1950	12/5/1968*
188	GZ 8552	BUT 9641T	9641T 212	GEC 100 hp	Harkness		H36/32R	2/10/1950	12/5/1968*
189	GZ 8553	BUT 9641T	9641T 213	GEC 100 hp	Harkness		H36/32R	2/10/1950	12/5/1968*
190	GZ 8554	BUT 9641T	9641T 214	GEC 100 hp	Harkness		H36/32R	3/8/1948	12/5/1968*
191	GZ 8555	BUT 9641T	9641T 215	GEC 100 hp	Harkness		H36/32R	2/10/1950	12/5/1968*
192	GZ 8556	BUT 9641T	9641T 216	GEC 100 hp	Harkness		H36/32R	2/10/1950	12/5/1968*

Fleet No.	Reg. No.	Chassis	Chassis No.	Motors	Body	Body No.	Seating capacity	In service	Out of service
193	GZ 8557	BUT 9641T	9641T 217	GEC 100 hp	Harkness		H36/32R	2/10/1950	12/5/1968*
194	GZ 8558	BUT 9641T	9641T 218	GEC 100 hp	Harkness		H36/32R	2/10/1950	12/5/1968*
195	GZ 8559	BUT 9641T	9641T 219	GEC 100 hp	Harkness		H36/32R	2/10/1950	12/5/1968*
196	GZ 8560	BUT 9641T	9641T 220	GEC 100 hp	Harkness		H36/32R	2/10/1950	1/3/1966
197	GZ 8561	BUT 9641T	9641T 221	GEC 100 hp	Harkness		H36/32R	2/10/1950	12/5/1968*
198	GZ 8562	BUT 9641T	9641T 222	GEC 100 hp	Harkness		H36/32R	2/10/1950	12/5/1968*
199	GZ 8563	BUT 9641T	9641T 223	GEC 100 hp	Harkness		H36/32R	2/10/1950	12/5/1968*
200	GZ 8564	BUT 9641T	9641T 224	GEC 100 hp	Harkness		H36/32R	2/10/1950	12/5/1968*
201	GZ 8565	BUT 9641T	9641T 225	GEC 100 hp	Harkness		H36/32R	2/10/1950	12/5/1968*
202	GZ 8566	BUT 9641T	9641T 226	GEC 100 hp	Harkness		H36/32R	2/10/1950	12/5/1968*
203	GZ 8567	BUT 9641T	9641T 227	GEC 100 hp	Harkness		H36/32R	2/10/1950	12/5/1968*
204	GZ 8568	BUT 9641T	9641T 228	GEC 100 hp	Harkness		H36/32R	2/10/1950	12/5/1968*
205	GZ 8569	BUT 9641T	9641T 229	GEC 100 hp	Harkness		H36/32R	2/10/1950	12/5/1968*

Fleet No.	Reg. No.	Chassis	Chassis No.	Motors	Body	Body No.	Seating capacity	In service	Out of service
206	GZ 8570	BUT 9641T	9641T 230	GEC 100 hp	Harkness		H36/32R	2/10/1950	12/5/1968*
207	GZ 8571	BUT 9641T	9641T 231	GEC 100 hp	Harkness		H36/32R	2/10/1950	12/5/1968*
208	GZ 8572	BUT 9641T	9641T 232	GEC 100 hp	Harkness		H36/32R	2/10/1950	12/5/1968*
209	GZ 8573	BUT 9641T	9641T 233	GEC 100 hp	Harkness		H36/32R	2/10/1950	12/5/1968*
210	GZ 8574	BUT 9641T	9641T 234	GEC 100 hp	Harkness		H36/32R	2/10/1950	12/5/1968*
211	OZ 7313	BUT 9641T	9641T 364	GEC 105 hp	Harkness		H36/32R	3/10/1953	31/10/1966
212	OZ 7314	BUT 9641T	9641T 365	GEC 105 hp	Harkness		H36/32R	8/1/1954	12/5/1968*
213	OZ 7315	BUT 9641T	9641T 366	GEC 105 hp	Harkness		H36/32R	8/1/1954	7/2/1966
214	OZ 7316	BUT 9641T	9641T 367	GEC 105 hp	Harkness		H36/32R	8/1/1954	12/5/1968*
215	OZ 7317	BUT 9641T	9641T 368	GEC 105 hp	Harkness		H36/32R	2/2/1954	7/2/1966
216	OZ 7318	BUT 9641T	9641T 369	GEC 105 hp	Harkness		H36/32R	1/3/1954	31/8/1965
217	OZ 7319	BUT 9641T	9641T 370	GEC 105 hp	Harkness		H36/32R	2/2/1954	31/8/1965
218	OZ 7320	BUT 9641T	9641T 371	GEC 105 hp	Harkness		H36/32R	1/3/1954	12/5/1968*

Fleet No.	Reg. No.	Chassis	Chassis No.	Motors	Body	Body No.	Seating capacity	In service	Out of service
219	OZ 7321	BUT 9641T	9641T 372	GEC 105 hp	Harkness		H36/32R	1/3/1954	12/5/1968*
220	OZ 7322	BUT 9641T	9641T 373	GEC 105 hp	Harkness		H36/32R	1/3/1954	12/5/1968*
221	OZ 7323	BUT 9641T	9641T 374	GEC 105 hp	Harkness		H36/32R	30/3/1954	12/5/1968*
222	OZ 7324	BUT 9641T	9641T 375	GEC 105 hp	Harkness		H36/32R	30/3/1954	12/5/1968*
223	OZ 7325	BUT 9641T	9641T 416	GEC 105 hp	Harkness		H36/32R	30/3/1954	12/5/1968*
224	OZ 7326	BUT 9641T	9641T 417	GEC 105 hp	Harkness		H36/32R	6/5/1954	12/5/1968*
225	OZ 7327	BUT 9641T	9641T 418	GEC 105 hp	Harkness		H36/32R	6/5/1954	12/5/1968*
226	OZ 7328	BUT 9641T	9641T 419	GEC 105 hp	Harkness		H36/32R	1/6/1954	12/5/1968*
227	OZ 7329	BUT 9641T	9641T 420	GEC 105 hp	Harkness		H36/32R	1/6/1954	12/5/1968*
228	OZ 7330	BUT 9641T	9641T 421	GEC 105 hp	Harkness		H36/32R	1/6/1954	12/5/1968*
229	OZ 7331	BUT 9641T	9641T 422	GEC 105 hp	Harkness		H36/32R	1/7/1954	12/5/1968*
230	OZ 7332	BUT 9641T	9641T 423	GEC 105 hp	Harkness		H36/32R	1/7/1954	12/5/1968*

Fleet No.	Reg. No.	Chassis	Chassis No.	Motors	Body	Body No.	Seating capacity	In service	Out of service
231	OZ 7333	BUT 9641T	9641T 424	GEC 105 hp	Harkness		H36/32R	1/7/1954	12/5/1968*
232	OZ 7334	BUT 9641T	9641T 425	GEC 105 hp	Harkness		H36/32R	1/9/1954	12/5/1968*
233	OZ 7335	BUT 9641T	9641T 587	GEC 105 hp	Harkness		H36/32R	1/11/1954	12/5/1968*
234	OZ 7336	BUT 9641T	9641T 588 Chassis at 1952 CMS	GEC 105 hp	Harkness		H36/32R	5/11/1954	12/5/1968*
235	DDA 182	Sunbeam MF2	13081	BTH 80 hp	Park Royal	5795	H28/26R	Ex-Wolv 282 20/3/1940. 4/11/1952	7/1954
236	DDA 986	Sunbeam MF2	13111	BTH 80 hp	Park Royal	8287	H28/26R	Ex-Wolv 286 4/3/1942 9/10/1952	30/8/1954
237	DDA 987	Sunbeam MF2	13112	BTH 80 hp	Park Royal	8286	H28/26R	Ex-Wolv 287 13/3/1942 1/8/1952	31/12/1954
238	DDA 988	Sunbeam MF2	13113	BTH 80 hp	Park Royal	8288	H28/26R	Ex-Wolv 288 18/2/1942 1/8/1952	31/12/1956
239	DDA 989	Sunbeam MF2	13114	BTH 80 hp	Park Royal	8289	H28/26R	Ex-Wolv 289 22/2/1942 8/8/1952	31/12/1956

* In service on last day of system's operation

Fleet No.	Reg. No.	Chassis	Chassis No.	Motors	Body	Body No.	Seating capacity	In service	Out of service
240	DDA 990	Sunbeam MF2	13115	BTH 80 hp	Park Royal	8290	H28/26R	Ex-Wolv 290 27/10/1942 2/10/1952	31/12/1956
241	DDA 991	Sunbeam MF2	13116	BTH 80 hp	Roe	GO 509	H29/25R	Ex-Wolv 291 7/2/1942 3/11/1952	7/1954
242	DDA 992	Sunbeam MF2	13117	BTH 80hp	Roe	GO 510	H29/25R	Ex-Wolv 292 6/2/1942 2/8/1952	7/1954
243	DDA 993	Sunbeam MF2	13118	BTH 80 hp	Roe	GO 512	H29/25R	Ex-Wolv 293 19/2/1942 1/8/1952	31/12/1956
244	DDA 994	Sunbeam MF2	13119	BT 80 hp	Roe	GO 511	H29/25R	Ex-Wolv 294 12/2/1942 4/11/1952	31/12/1956
245	DDA 995	Sunbeam MF2	13120	BTH 80 hp	Roe	GO 513	H29/25R	Ex-Wolv 295 4/4/1942 2/8/1952	7/1954
246	2206 OI	Sunbeam F4A	9045	BTH 210 AYG7 185716 120 hp	Harkness		H36/32R	1/10/1958	12/5/1968 *Preserved

BELFAST TROLLEYBUS ROUTES

Route No.	Destination	Opened	Closed
12 (9 until 1951)	Falls Road (Fruithill Park). Extended to Casement Park 1954	28/3/1938	12/5/1968
14	Falls Park (Falls Road depot), *shortworking of 12*	28/3/1938	12/5/1968
15	City Cemetery, Falls Road, *shortworking of 12*	28/3/1938	12/5/1968
33 (8 until 1951)	Cregagh, (via Queen's Bridge)	13/2/1941	13/10/1963
34	Bell's Bridge, (Cregagh Road), *shortworking of 33*	13/2/1941	13/10/1963
31 (22 until 1951)	Castlereagh	5/6/1941	20/1/1963
32	Houston Park, (Castlereagh Road), *shortworking of 31*	5/6/1941	20/1/1963
22 (28 until 1951)	Parliament Buildings, (via Queen's Bridge) Mon-Fri only. After 8pm Stormont, Massey Av, Stormont Gates	26/3/1942	31/3/1963
23 (26 until 1951)	Parliament Buildings, (via Albert Bridge) Mon-Fri only. After 8pm Stormont, Massey Av, Stormont Gates	26/3/1942	31/3/1963
26	Belmont Drive, (via Queen's Bridge), *shortworking of 22*	26/3/1942	31/3/1963
27	Belmont Drive, (via Albert Bridge), *shortworking of 23*	26/3/1942	31/3/1963
16 (briefly used tram no. 11)	Dundonald, (via Queen's Bridge)	16/11/1942	31/3/1963
17 (briefly used tram no. 13)	Dundonald, (via Albert Bridge)	8/3/1943	31/3/1963

Route No.	Destination	Opened	Closed
12 (9 until 1951)	Falls Road (Fruithill Park). Extended to Casement Park 1954	28/3/1938	12/5/1968
14	Falls Park (Falls Road depot), *shortworking of 12*	28/3/1938	12/5/1968
15	City Cemetery, Falls Road, *shortworking of 12*	28/3/1938	12/5/1968
33 (8 until 1951)	Cregagh, (via Queen's Bridge)	13/2/1941	13/10/1963
34	Bell's Bridge, (Cregagh Road), *shortworking of 33*	13/2/1941	13/10/1963
31 (22 until 1951)	Castlereagh	5/6/1941	20/1/1963
32	Houston Park, (Castlereagh Road), *shortworking of 31*	5/6/1941	20/1/1963
22 (28 until 1951)	Parliament Buildings, (via Queen's Bridge) Mon-Fri only. After 8pm Stormont, Massey Av, Stormont Gates	26/3/1942	31/3/1963
23 (26 until 1951)	Parliament Buildings, (via Albert Bridge) Mon-Fri only. After 8pm Stormont, Massey Av, Stormont Gates	26/3/1942	31/3/1963
26	Belmont Drive, (via Queen's Bridge), *shortworking of 22*	26/3/1942	31/3/1963
27	Belmont Drive, (via Albert Bridge), *shortworking of 23*	26/3/1942	31/3/1963
16 (briefly used tram no. 11)	Dundonald, (via Queen's Bridge)	16/11/1942	31/3/1963
17 (briefly used tram no. 13)	Dundonald, (via Albert Bridge)	8/3/1943	31/3/1963

Route No.	Destination	Opened	Closed
18	Upper Newtownards Road, Knock Road, (via Queen's Bridge), *shortworking of 16*	16/11/1942	31/3/1963
19	Upper Newtownards Road, Knock Road, (via Albert Bridge), *shortworking of 17*	8/3/1943	31/3/1963
20	Connswater, Holywood Arches, Upper Newtownards Road, Holywood Road, (via Queen's Bridge), *shortworking of 16*	16/11/1942	31/3/1963
21	Connswater, Holywood Arches, Upper Newtownards Road, Holywood Road, (via Albert Bridge), *shortworking of 17*	8/3/1943	31/3/1963
30 (20 until 1951)	Bloomfield	6/5/1946	13/10/1963
37 (16 until 1951)	Ormeau Road	19/4/1948	26/10/1958
38	Rosetta, *shortworking of 37*	19/4/1948	26/10/1958
1	Antrim Road, Strathmore Park, (via Carlisle Circus)	24/1/1949	5/2/1966
2	Antrim Road, Strathmore Park, (via Duncairn Gardens)	24/1/1949	5/2/1966
3	Glengormley, (via Carlisle Circus)	24/1/1949	5/2/1966
4	Glengormley, (via Duncairn Gardens)	24/1/1949	5/2/1966
5	Bellevue, (via Carlisle Circus)	24/1/1949	5/2/1966

Route No.	Destination	Opened	Closed
6	Bellevue, (via Duncairn Gardens)	24/1/1949	5/2/1966
7	Whitehouse, (Shore Road) via York Street *X city to Falls Road	2/10/1950	20/5/1962
8	Fort William, (Shore Road), shortworking of 10	2/10/1950	12/5/1968
9	Grove, (York Road), shortworking of 10	2/10/1950	12/5/1968
35	Carr's Glen, (via Albert Bridge & Cliftonville Road) *X city to Cregagh	30/4/1951	13/10/1963
36	Cliftonville	30/4/1951	13/10/1963
13	Glen Road via Falls Road *X city to Whitewell	16/4/1952	12/5/1968
25	Holywood Road	24/11/1952	1/6/1958
10	Whitewell, (Shore Road) *X city to Falls Road	26/4/1953	12/5/1968
45 (11, until 1962)	Whiterock	18/5/1959	12/5/1968

Total route mileage 37½ miles

TRACTION BATTERIES

With the exception of the 1946 Harkness-bodied Sunbeam W4s and the second-hand purchases from Wolverhampton Corporation, all of Belfast's 220 six-wheelers, as well as the single four-wheeled Sunbeam F4A, were equipped with traction batteries. This enabled the vehicles to manoeuvre away from the overhead at a slow speed for about half a mile, and although there are no photographs of a trolleybus actually being moved under its own battery power, it did occasionally happen. Trolleybuses do have gears, so there is a forward and a reverse gear as well as the usual position for power drawn from the overheads and an auxiliary position for power taken from the traction batteries. All new trolleybuses for Belfast had the throttle on the left foot and the brake on the right with the exception of the second-hand Wolverhampton vehicles, which were soon converted to the traditional 'wrong-way-round' pedal arrangements.

LIVERY

The Belfast trolleybus system was always well maintained, and the original blue and white semi-streamlined livery looked most attractive. This was phased out because the blue tended to weather quite badly, and so, all the post-war vehicles were delivered in the smartly presented red and broken-white livery with silver-painted wheels and a dark-green-painted rear dome that masked the copper and grease stains coming off the trolley skates and the overhead. There were also three thin black bands where red met cream, one below the upper saloon windows, one at upper-saloon floor level and one beneath the waistrail, and in addition, the mudguards were also painted black. Buses had the legend BELFAST CORPORATION in this white livery band on the lower-saloon waistrail, but this was all removed after repaints that took place after September 1953. As a result, repaints could be undertaken more economically but the effect was not so dignified. Unlike the motor bus fleet, the trolleybuses never lost their lower-saloon broken-white waistbands.

GENERAL MANAGERS

Andrew Nance 1881-1916
James Moffett 1916-1922
Samuel Carlisle 1922-1928
William Chamberlain 1928-1931
Robert McCreary 1931-1951
Joseph Mackle 1951-1962
Robin Adams 1962-1973

DEPOTS

Falls Park
Opened in 1886 as a horse-tram depot, it was converted to electric trams for the Falls Road service on 5 December 1905. Falls Park depot was partly converted to motor buses in 1926, becoming the corporation's first bus garage. Belfast's first trolleybuses for the Falls Road service were operated from this depot from the routes opening on

depot 1938 to 1947. Converted to buses only garage but wired for trolleybuses until 12 May 1968 for use as main bus and trolleybus repair and overhaul works. Falls Park was taken over by Citybus and latterly Metro and continues as a garage and Belfast's main bus works.

Haymarket
Opened for outdoor trolleybus parking on 13 February 1941, Hay Market, as it was first known, housed the trolleybuses for the initial services in East Belfast. It was closed on 12 May 1968 but was used for a further few months to store the withdrawn trolleybus fleet, some late withdrawn Daimler CVA6 motor buses and the new AEC 'Swift' and Daimler 'Roadliner' single-deckers whose entry into service in 1968 was delayed because of a trade union dispute.

Knock
Knock was used to store the withdrawn Wolverhampton four-wheelers between 1954 and 1956. It was never wired for trolleybuses.

Sandy Row
Although a tram depot, it was used to store the chassis of 211-234 from 1952. Sandy Row was latterly used to store withdrawn six-wheeled Guy BTX trolleybuses as reserve vehicles or those pending disposal. It was never wired for trolleybuses.

Eight withdrawn trolleybuses are parked inside Sandy Row depot in about 1965. They are in company with some GZ-registered rebodied Daimler CWA6, and judging by the dust on them, they had been parked in the former tram depot for sometime. (R. Symons)

Short Strand
This depot was opened in October 1950 for trolleybuses being employed on the post-war services on the north side of the city. It was a large outdoor parking site and a steam cleaning ramp but had undercover repair facilities. It was closed 12 May 1968.

CHAPTER ONE

THE TROLLEYBUSES IN BELFAST

THE DEMONSTRATORS

The first trolleybuses bought for the experiment along Falls Road consisted of pairs of trolleybus chassis from seven chassis manufacturers. They were supplied with the proviso that they would be on loan to Belfast Corporation until either the experimental Falls Road route was adopted or the experiment was deemed a failure and, in those circumstances, they would be returned. All were six-wheelers built to a length of 30 feet, which would give a seating capacity around the same number as the largest tramcars.

There were two AEC 664Ts, (1-2), two Crossley TDD6s, (3-4), a couple of Daimler CTM6, (5-6), a brace of Guy BTXs, (7-8), two Karrier E6As, (9-10), a duo of Leyland TTB4s, (11-12), and finally two Sunbeam MS2s, (13-14). One of the manufacturers to be approached was Ransomes, Simms & Jefferies, one-time pioneer in the development of trolleybus chassis but who, by 1937, had all but ceased to build trolleybuses except for its home-town corporation in Ipswich. Different combinations of chassis coupled with electric traction motors and a variety of body builders' products were used in this experiment. These vehicles were numbered T1-14, but the prefix T was not used after 1940 when the trolleybus system was expanded as 15-102 began to be delivered. The Falls Road trolleybus began on 28 March 1938 with a six-minute headway to the Fruithill Park terminus during the day, which was interspersed in the peak period by a six-minute service as far as the city cemetery opposite the Whiterock Road junction. The route required a maximum of twelve trolleybuses, ensuring that there were, theoretically, always two trolleybuses in reserve.

The trial was deemed a great success, but the subsequent large order of 1939 had a combination of trolleybus chassis, electrical equipment and bodywork not found in the fourteen prototypes.

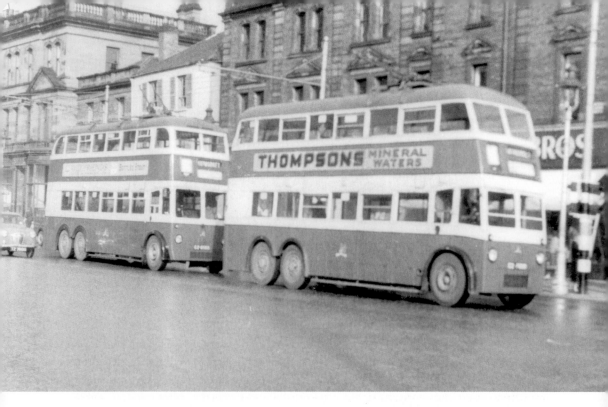

Standing in Donegall Square North on 9 September 1957 in front of the offices of the Halifax Building Society's impressive Victorian office and retail block is the much-rebuilt 1, (EZ 7889). At this time, Donegall Square North, just before the turn into Donegall Place, was still a two-way street with traffic passing in both directions in front of City Hall. Numerically the first trolleybus to operate in Belfast, this was an AEC 664T with a Harkness H36/32R body and was equipped with English Electric traction motors. The trolleybus body had been subtly rebuilt but in a style that strengthened the body and removed most of the guttering above the saloon windows. The route number box was changed from the nearside to the offside, which was easier for the driver to change. By this time the BELFAST CORPORATION legend on the lower saloon waistrail had been removed, but the red and broken-white livery, even at this late stage of its career, did look very smart. Behind no. 1 is 1950-vintage 199, (GZ 8563), a BUT 9641T with a more curvaceous Harkness body. (F. W. Ivey)

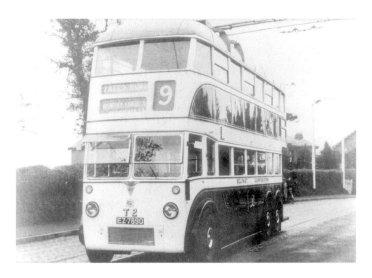

An official photograph of T2, (EZ 7890), the second of the Harkness-bodied AEC 664T trolleybuses, shows the semi-streamlined blue and white livery lined out with gold. It is standing in Falls Road displaying the 9 route number that was used until 1951. The bodywork, which had a distinctly Cowieson-styled look to it, had a pleasantly rounded front profile, but the rear dome arrangement was uncompromisingly square, which was a feature of all the Cowieson-framed Harkness bodies delivered as part of the Falls Road experimental operation. (D. R. Harvey Collection)

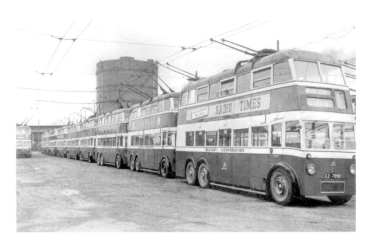

Haymarket trolleybus depot was opened on 13 February 1941, on the same day as the Cregagh route was opened. This was the first of the East Belfast trolleybus routes to open and eventually nearly all the County Down trolleybus services were operated from this large eight-laned area of open parking. The depot was located on the site of the old Hay and Straw Market whose stone walls partially served as its boundary. Behind the trolleybuses is a large gas holder in the city gasworks that dominated the skyline in the area for many years. Leading a row of eight wartime AEC 664Ts in the early 1950s is trolleybus 2, (EZ 7890). By this time, along with most of the other eight Harkness-bodied pre-production trolleybuses of 1938, this one's body had been rebuilt. It is significant that this bus body has half-drop opening windows whereas the ones behind it all had sliding saloon ventilators. The second trolleybus is 23, (FZ 7808), which is the only known photograph of this Harkness-bodied AEC 664T. (Birmingham Central Reference Library)

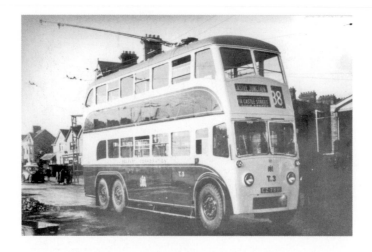

Preparations were well underway for the opening of the experimental Falls Road trolleybus service when this Metro-Vick-powered trolleybus T3, (EZ 7891), was parked outside Falls Road depot on 11 January 1938. Behind the trolleybus is a gantry used by the crews, who would still have been erecting and adjusting the overhead wires. The trolleybus is the solitary Crossley TDD6 to be fitted with Crossley's own somewhat idiosyncratic style of bodywork. This shapely waistrail style was designed to the requirements of Manchester Corporation who also adorned their bodywork with somewhat eccentric Art Deco streamlined livery swoops. Belfast's more dignified sleek blue and white livery with gold lining-out rather suited this curvaceous body. (Hogg Collection)

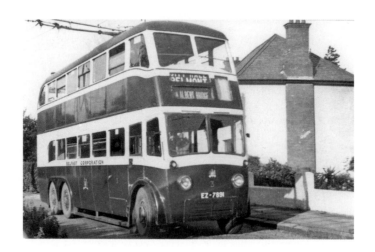

The unique style of a Crossley body can be easily recognised. Belfast's only Crossley-bodied Crossley trolleybus is standing in the turning circle in front of a row of semi-detached houses at Belmont Drive having worked on the 27 route via Albert Bridge on a shortworking of the 23 service to the Parliament Buildings at Stormont. The Stormont services were opened on 26 March 1942 and outlived this trolleybus by two months short of five years. 3, (EZ 7891), was one of only seventeen six-wheeled Crossley TDD6s built and was the only 'streamlined' Crossley body to be supplied other than to Manchester or Ashton Corporations. It is by now repainted in the post-war red and broken-white livery. (W. J. Haynes)

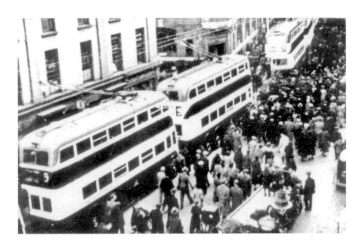

On 28 March 1938, the official opening day of the Falls Road 9 trolleybus service, the entire fleet of fourteen trolleybuses waits in Queen Street at the junction with College Street to be paraded before the assembled crowds who came to see the first trolleybuses to enter service. The Lord Mayor, Sir Crawford McCullough, drove the ceremonial last tram from Castle Street to Queen Street and then proceeded to drive the first trolleybus, the Guy BTX 7, (EZ 7895), back to Falls Park depot. Towards the rear of the line-up of these blue-and-white-painted trolleybuses is 4, (EZ 7892). This was the second of the Crossley TDD6, also powered by Metro-Vick, but this time, it was fitted with a Harkness H36/32R body. This was the only pre-war Crossley six-wheeled trolleybus to be delivered with a body other than one with a Crossley involvement. In front of T4 is the all-Leyland TTB4, 11, (EZ 7899), easily distinguished by the single-windowed upper-saloon emergency exit. (D. R. Harvey Collection)

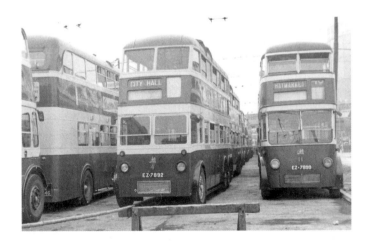

Parked at the head of a row of trolleybuses in Haymarket depot is 4, (EZ 7892). This was the solitary Crossley TDD6 with a Harkness body, which by about 1956 had not only been repainted in the post-war livery without the fleet names on the waistrail but had also been substantially rebuilt in the same style as all the other Harkness-bodied prototypes. These rebuildings somehow gave the bodywork a 'chunkier' appearance, though the shallow depth of the original windscreen, which was continued on the semi-utility Sunbeam W4s of 1946, rather spoilt the front design. All six-wheeled Crossley trolleybuses had a reputation for heavy steering and the two Belfast examples were no exception. On the right, alongside no. 4 is 11, (EZ 7899), an all-Leyland TTB4 with its somewhat subtler body styling. On the left and facing the opposite direction is a Harkness-rebodied wartime Daimler CWA6, while just in the picture is one of the 1947 Daimler CVA6s. (D. A. Jones)

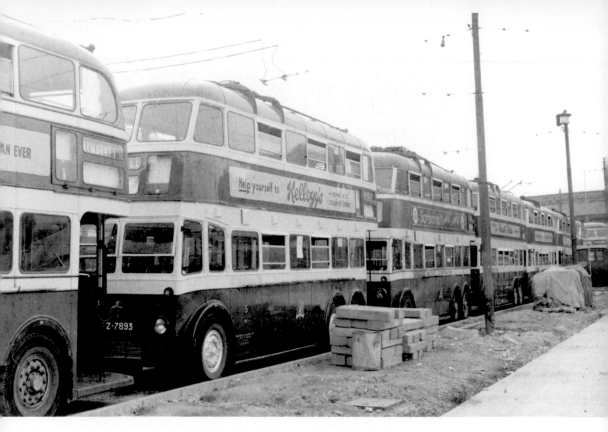

Also parked in Haymarket depot is the first of the pair of Harkness-bodied Daimler CTM6s, 5, (EZ 7893), a particularly camera-shy vehicle. If the six-wheeled Crossley was uncommon, Daimler trolleybuses were even rarer with only twenty-two pre-war four-wheeled CTM4s being produced while there were only three of the six-wheelers. The first chassis was a demonstrator registered in Coventry as DHP 112 and which eventually entered the Newcastle Corporation fleet as their 112. The only other pair of CTM6s to be built was the 'Belfast twins' mounted on chassis 21002 and 21003. 5, (EZ 7893), stands in front of 8, (EZ 7896), a Harkness-bodied Guy BTX and behind that is 13, (EZ 7901), the first of the pair of Cowieson-bodied Sunbeam MS2s. All of these three have had their bodywork rebuilt in the Falls Road workshops. Just visible at the top of the black-painted wheel arches is the neatly numbered tyre pressure of 75 psi. (D. R. Harvey Collection)

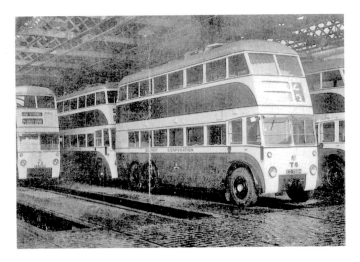

A well-known photograph of the second Daimler CTM6s, T6, (EZ 7894), shows this brand-new Harkness-bodied six-wheeler parked in the newly converted Falls Park depot in 1938, just before the opening of the Falls Road service. T6 is parked over the pits and is in company with AEC 664T 2, (EZ 7890), on the left, while on the right is Crossley TDD6, T4, (EZ7892). All three have the same style of Harkness bodywork. Behind T6 is one of the pair of Leyland-bodied TTB4s. (D. R. Harvey Collection)

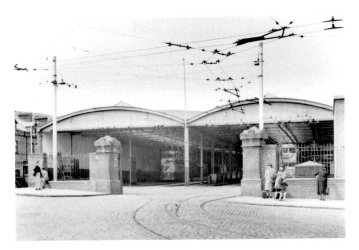

The impressive frontage of the Falls Park depot was surmounted by a lattice roof coupled with the shallow arched roof. This was a cheap and reliable method of enclosing a large ground space and was known as the 'Belfast Roof'. Falls Park was used as the running depot for the Falls Road trolleybus service from its opening until 1947 when the route was transferred to the newly opened Haymarket depot. Falls Park then became the overhaul works for the entire trolleybus fleet. Soon after the opening of the Falls Road service in 1938, parked in the depot behind the entrance pillar on the right is T6, (EZ 7894), the Harkness-bodied six-wheeled Daimler CTM6. The trolleybus on the left with the three-piece destination box is one of the pair of Cowieson-bodied Sunbeam MS2s. (W. A. Camwell)

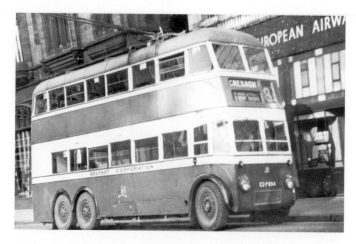

In later years, the non-streamlined livery of red and broken white looked very smart, though careful examination reveals that the swooping beading at the front of the upper- and lower-saloon side panels was simply painted over. Trolleybus 6, (EZ 7894), the second of the Daimler CTM6s, was the first of the fourteen prototypes to be withdrawn, being taken out of service on 21 February 1956, over two years before the next vehicle was retired. It is standing empty with an incorrect destination display to show that it was not actually in service. It is outside the British European Airways offices, which occupied the flamboyantly Gothic Ocean Building, dating from 1902, in Donegall Square East. (R. C. Ludgate)

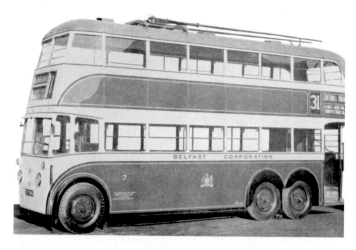

The first of the pair of Guy BTXs was 7, (EZ 7895), which had the distinction of leading the opening procession on the occasion of the opening of the Falls Road trolleybus route on 28 March 1938 when it was driven by the lord mayor of Belfast. This Guy trolleybus had English Electric equipment and a Park Royal body, which, surprisingly, was the only pre-war BTX to receive this London-based coachbuilder's bodywork. The origins of the body could be easily recognised by the radiused window bottoms, which were a typical Park Royal feature. Some of the body styling resembled the London Transport DLY-registered E3 class trolleybuses, which had been bodied on AEC 664T chassis by Park Royal in the spring of 1937. The trolleybus is displaying on the front blinds the route destination 17, which was the second service to Dundonald opening on 8 March 1943. Although there never was a 31 trolleybus route, this official photograph, taken early in 1938, does show that the transport department had already ear-marked routes and their numbers for conversion from tram to trolleybus many years before the event took place. (Park Royal)

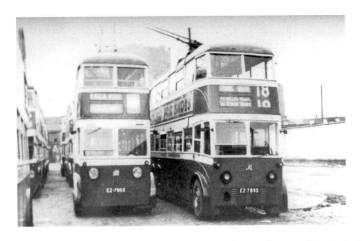

Rather neglected-looking Haymarket depot is where the Park Royal-bodied Guy BTX is parked. The depot was just off East Bridge Street between Cromac Square and Albert Bridge, and in fact, although surrounded by typically Belfast, tightly packed Victorian terraced housing, the site was actually built on the point bar of a meander on the River Lagan. The bodywork is looking in fairly original condition, save for the removal of the saloon guttering over all the fixed saloon side windows. The trolleybus is displaying the upper destination of Cromac Square, which was where East Bridge Street, the city ward continuation of Albert Bridge, met Victoria Street and, in so doing, really marked the eastern boundary of the city centre. Parked next to the Guy is 14, (EZ 7902), a Cowieson-bodied Sunbeam MS2, which was the last of the experimental fleet of 1938. (Richards)

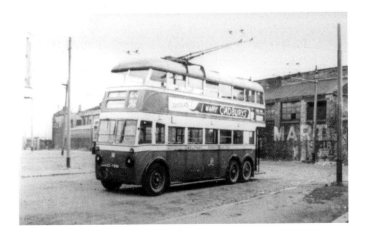

Another trolleybus seen in Haymarket depot around 1952 is the second of the Guy BTXs, 8, (EZ 7896). This had Electrical Construction Co. motors and had a rather bulbous-fronted Harkness body, which, at this time, was still in its original condition, although it does look in need of a repaint. The long front overhang is due to the ECC motors being located in the cab. The old style of Cadbury's chocolate advertisement dated from a time when the simplicity of the message was more important than the image. (Richards)

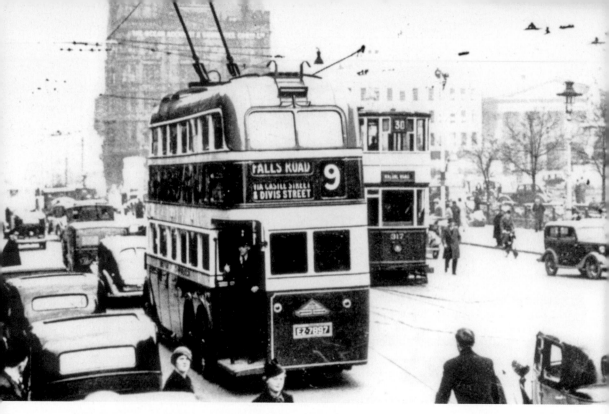

A brand-new Falls Road-bound trolleybus, 9, (EZ 7897), travels through Donegall Square North, with City Hall out of the photograph beyond the Ford Tudor Y-type 8-hp car on the right. This vehicle was the first of the pair of Karrier E6As fitted with Crompton-West 95-hp motors and a Harkness H36/32R body. This is the first day of the Falls Road no. 9 trolleybus service on 28 March 1938. At this time the trolleybuses had front, side and rear destination boxes, which were amongst the most clear in the United Kingdom. Dominating the skyline behind the trolleybus is the impressive Ocean Building. Picking up passengers at the *Titanic* memorial is 'Moffett' car 317, a 1922-vintage totally enclosed four-wheeler working on the 30 route to Malone Road. This was a route that, although proposals were made to convert it to trolleybus operation, fell foul of a change of policy introduced by Joseph Mackle, the new general manager, who discarded the trolleybus expansion plans in South Belfast. (D. R. Harvey Collection)

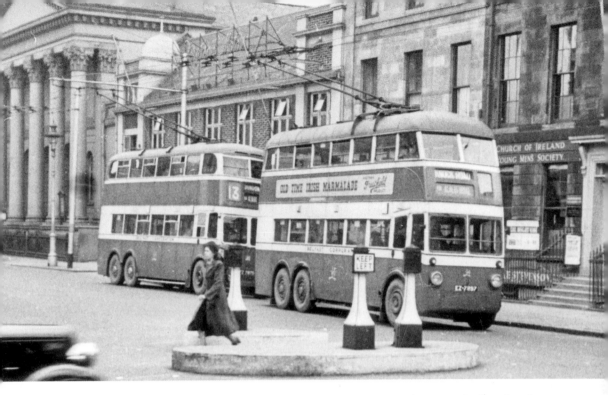

The impressive Corinthian capital pillars of the classical-style Wesleyan Methodist church dominate Donegall Square East. This was completed in 1850 to the designs of one Isaac Farrell and was reputedly the last major ecclesiastical building constructed in Belfast before the Gothic revival began to dominate the streets of the centre of the town. It survived until 1990 when the church was demolished, though the façade was incorporated into the new Ulster Bank building. Parked outside the early-nineteenth-century premises of the Church of Ireland Young Men's Society in Donegall Square East is Karrier E6A 9, (EZ 7897), with a Harkness H36/32R body. In this late 1940s view, the Karrier is working on the 19 route to Knock Road, a shortworking of 17 via Albert Bridge. Behind the Karrier is 90, (EZ 7875), one of the last AEC 664Ts with Harkness bodywork to be delivered on 2 March 1943. One major difference between the fourteen prototype trolleybuses and all subsequent ones was that the front destination number box on all the production vehicles was on the offside. (D. R. Harvey Collection)

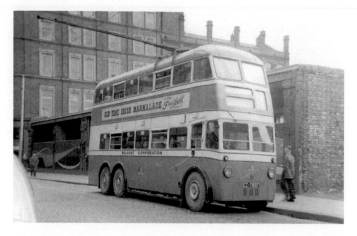

9, (EZ 7897), the Crompton-West-powered Karrier E6A, stands in Castle Street in the early 1950s when working on the 12 service to Falls Road. By now much rebuilt, this seemed to emphasise, more than on even the Guy BTXs, the long overhang between the front panel and the leading edge of the front mudguard. It is facing the junction with Queen Street where the inbound trolleybuses began their anticlockwise circuit into Donegall Square North. It is standing alongside a site made derelict in an air raid in the Second World War. In the 1960s, the site was eventually redeveloped by the Norwich Union. Behind the trolleybus is Anderson & McAuley's department store, a delightful five-storey building, which replaced an earlier building in 1890. (C. Carter)

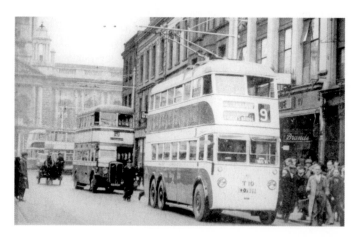

The second of the two Harkness-bodied Karrier E6As, T10, (EZ 7898), is being employed on a trial run before the opening of the Falls Road service on 28 March 1938. Careful examination shows that it has the trade plate 120 XI behind the nearside windscreen. The trolleybus has the prefix 'T' used on just the fourteen demonstration trolleybuses. Following the trolleybus is bus 72, (CZ 4600), a 1934-vintage petrol-engined AEC 'Regent' 661 with a Park Royal body, which is working on the motor bus route to Stormont. In the distant Donegall Square North in front of City Hall is a barely three-year-old streamlined McCreary tramcar and one of the 342-391 batch of 'Chamberlain' tramcars dating from 1930. (Richards)

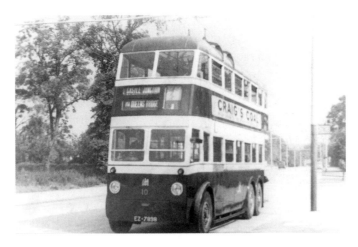

Just leaving the inbound terminus stop in Upper Newtownards Road is Karrier E6A EZ 7898. By now painted red and broken white, the bus has also lost its 'T' prefix and is now just 'plain old' 10. In the background, just visible, is the roof of the Elk Inn, which stood at the apex of Upper Newtownards Road and Comber Road and whose forecourt effectively became the anticlockwise turning circle for the Dundonald trolleybus route. On the right is Dundonald cemetery, which had opened in 1905, but was not reached from the original Knock terminus until 1924 shortly after Dundonald was absorbed into Belfast. (W. J. Haynes)

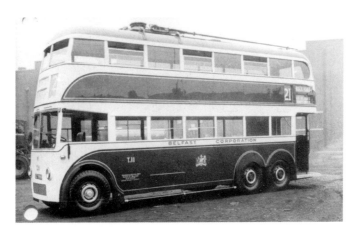

The official Leyland Motors photograph shows the newly completed T11, (EZ 7899), the first of the pair of Leyland TTB4s. This vehicle's Leyland body, although painted in the blue and white semi-streamlined livery, was virtually identical to the bodies supplied to London Transport as their K1 class registered in the series EXV 55-254. These Leyland bodies were based on the Colin Bailey design of metal-framed bodies developed for motor buses in 1936 and were well known for their strength. They were also easily recognisable by the single-paned upper-saloon emergency window. (Leyland Motors)

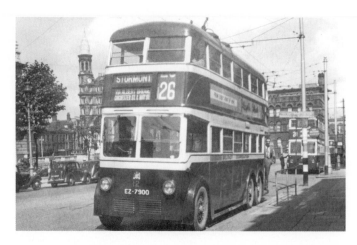

Above: Displaying the route number 26, which was used for the Parliament Buildings service to Stormont from 1942 until 1951, is trolleybus 12, (EZ 7900). This was the second of the 1938 Leyland-bodied Leyland TTB4 six-wheelers. It is parked in Donegall Square East and is repainted in the early post-war non-streamlined blue and white livery. The complicated overhead wiring allowed trolleybuses to turn into their respective bus-stops using a double figure of eight overhead layout and this was before the through running wire was put in place on the left in about 1952. This Leyland six-wheeler is sharing the stop with the Dundonald trolleybus service. The distant Italianate-style building with the tower and the clock is the Robinson & Cleaver's department store on the corner of Donegall Square North and Donegall Place, opened in 1888. (W. J. Haynes)

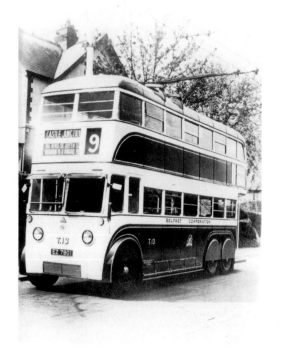

Left: Belfast did not ignore the products of the other Wolverhampton-based trolleybus-chassis manufacturer's. 13 and 14 were a pair of BTH-motored Sunbeam MS2s and were both fitted with Cowieson H36/32R bodies. Displaying the rising-sun triangular emblem beneath the centre of the windscreen, 13, (EZ 7901), looks very smart in this official photograph in its dark-blue and streamlined white livery. The trolleybus is fitted with rear-wheel bogie guards whose value was somewhat limited and it is probable that it never ran in service in this form. (Belfast CT)

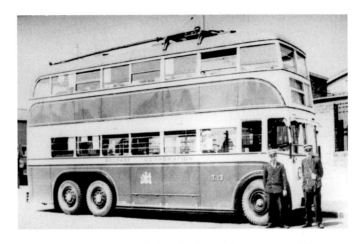

These two Sunbeams were the only trolleybus bodies to be constructed by Cowieson and were among the last bodies built by this Glasgow-based coachbuilder. The driver and conductor stand in front of T13, (EZ 7901), as it is parked in front of Falls Park depot in 1938. The unique Cowieson bodies on T13 and 14 were handsome-looking vehicles with a more upright front than on the other prototype trolleybuses, which in turn, gave a longer side front bay window. They were the only ones of the first fourteen to have a curved Weymann-styled tumblehome, while they were also fitted with rear bumpers and a simplified rear destination box layout. (Richards)

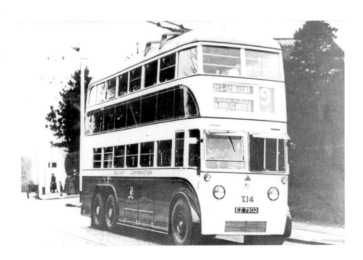

Travelling along Falls Road, when working on a driver training session, (note that it is devoid of passengers), just before the opening of the 9 route, is 14, (EZ 7902). This was the second of the two Sunbeam MS2s and, like its twin, was fitted with a Cowieson body. It must be remembered that the trolleybus route along Falls Road was initially an experiment and that, had the trolleybuses not been successful, then all fourteen vehicles would have been returned to their chassis owners. Of course, this did not happen, but as an added insurance, the tram tracks and overhead were retained until such times as the experiment was deemed a triumph. The trolleybus therefore has to travel over the cobbles and the tram tracks. (Belfast CT)

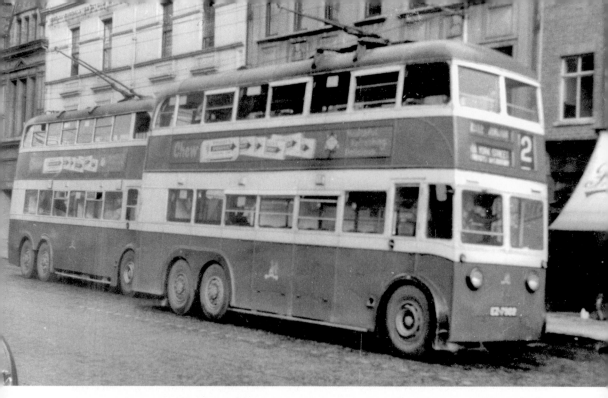

The repainting of the Cowieson bodies into the post-war red and broken-white livery had probably less of a dramatic effect than on the Harkness-bodied prototype vehicles. 14, (EZ 7902), the last of the pair of Sunbeam MS2s and the last of the Falls Road prototypes, has been working on the 12 route but appears to be displaying the destination CASTLE JUNCTION. It is standing in Chichester Street just beyond Donegall Square North and is waiting to return to Haymarket depot. (F. W. Ivey)

CHAPTER TWO

THE 'PRE-WAR' FLEET

The success of the experimental trolleybus route along Falls Road was such that at the meeting of the city council on 9 January 1939, Robert McCreary proposed that the entire tram system should be abandoned, starting with the East Belfast tram routes, which crossed the River Lagan and operated on the County Down side of the city. Surprisingly, the tram services onto Queen's Island for the Harland & Wolff shipyard workers were not included in the scheme, and in fact, these works' services survived until 12 February 1954 when the trams were replaced by buses. The intention was to replace the southern services next and, finally, the tram routes to the north along the County Antrim side of Belfast Lough, but circumstances had changed by the late 1940s and some of these proposed routes were converted to buses. The final closure of the tram system occurred on 28 February 1954.

At this 1939 meeting, the transport department, at the behest of the general manager, ordered 114 six-wheeled AEC 664Ts with GEC 95-hp motors and Harkness H36/32R bodies based on Park Royal frames. Shortly after the outbreak of the Second World War, the Ministry of War Transport cut the AEC order to just eighty-eight vehicles, although the balance of reserved registrations was used after 1947 on the 103-128 batch of Guy BTXs. The vehicles had a protracted delivery period that lasted from September 1940 until October 1943, and despite the travails of wartime production, all were finished to pre-war standards. Three of the class arrived in 1940, forty-one appropriately enough were delivered in 1941, a further twenty-seven entered service in 1942, and the final seventeen arrived in 1943. They were painted in a new version of the semi-streamlined dark-blue and white livery with gold lining-out, but with the front lower panel below the windscreen being painted dark blue. The seats in both saloons were covered in Princess Blue pleated leather while the window surrounds were capped in varnished wood. Although frequently referred to as the 'pre-war' trolleybuses, it was only the fact that they were ordered early in 1939 that made this sobriquet even remotely accurate.

These eighty-eight AEC 664Ts had long and successful lives, being used to develop the routes to Cregagh, Castlereagh, Stormont, Dundonald and Bloomfield as well as being the mainstay of the trolleybus fleet throughout the Second World War. All of the class were repainted in the late 1940s in the red and broken-white livery and continued in service until nine of them were taken out of service on 2 July 1962 as surplus to requirements after the closure of the Greencastle route some six weeks earlier. The

rest of the trolleybuses were taken out of service during the abandonments of the East Belfast services throughout 1963, with the last nineteen being taken out of service on 22 October 1963. These included the preserved 98, which is still in existence at the Cultra Folk & Transport Museum.

There are no known photographs of the following from this class: 22, 31, 34, 35, 37, 38, 46, 51, 55, 59, 70, 71, 73, 77, 88

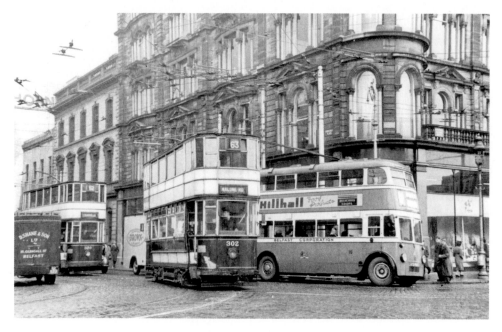

Turning from Donegall Place into Donegall Square North in the shadow of Robinson & Cleaver's department store is trolleybus 15, (FZ 7800), the first of the Harkness-bodied AEC 664Ts. This Italianate-style building with its ogee domes and towers, decorative carvings and rooftop balustrades, designed by Young & Mackenzie and built between 1886 and 1888, was opened for business in 1888. Robinson & Cleaver's Royal Irish Linen Warehouse was equipped from new with electric lighting, which, although first employed in the late 1870s, was barely out of the experimental stage. It also had an American-style elevator as well as a formidable central staircase, which looked a little like the grand staircase on the ill-fated RMS *Titanic*. Coming out of Donegall Place are two 'Moffett' totally enclosed four-wheeled trams, 302, working on the Malone Road service, closed in November 1951 and 320 going to Stranmillis, which went in the previous July. (W. J. Wyse)

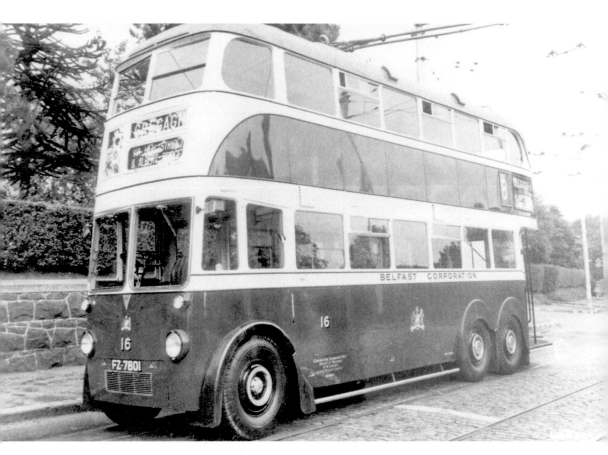

A brand new 16, (FZ 7801), which was the first of the eighty-eight AEC 664Ts to enter service on 26 September 1940, stands at the original Falls Road terminus at Fruithill Park. This was just over half a mile south-west of Falls Park trolleybus depot. The livery on these production trolleybuses was modified so that the front panel beneath the windscreen was painted blue rather than the white as found on the Falls Road prototypes. In view of the wartime requirement to have white blackout edgings to all vehicles, it did seem a little perverse to make the front of these trolleybuses less visible in the dark at night. The trolleybus blinds are set for the first of the East Belfast trolleybus conversion to Cregagh, which opened on 13 February 1941. (D. R. Harvey Collection)

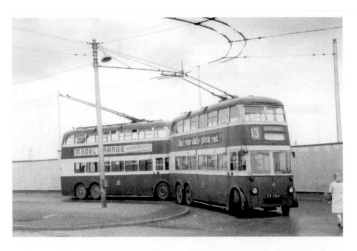

Half a mile away and fifteen or so years later, 16, (FZ 7801), stands at the second terminus of the Falls Road at Casement Park. This new terminus in Andersonstown Road was about a quarter of a mile beyond the original Fruithill Park reverser and was introduced in 1954. The trolleybus is carrying the Milk Marketing Board's advertising slogan 'Drinka Pinta Milka Day', which was introduced in 1959. The second trolleybus is 53, (FZ 7838), another of the Harkness-bodied AEC 664T six-wheelers. (J.Shearman)

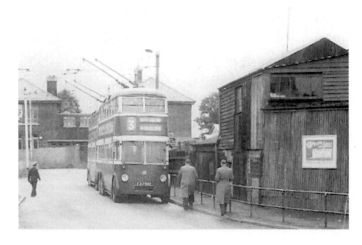

Standing at the Glengormley terminus of the 3 route off Church Road in August 1952 are two AEC 664T six-wheelers. They have both undertaken the manoeuvre into the cul-de-sac on the left, where the trolleybus driver is walking, and have pulled up to the loading stop where the gabardine-coated men are walking. The leading trolleybus is 17, (FZ 7802), which entered service on 9 October 1940, making it one of only three of the class to enter service in that year. Presumably, it was used on extra journeys on the Falls Road service before the Cregagh service was opened. 17 was also one of the longest lived of the class surviving until 10 June 1963. (R. Brook)

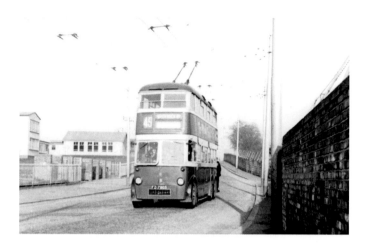

Travelling down the hill in Whiterock Road towards the Falls Road junction in April 1962 is AEC trolleybus 18, (FZ 7803). It is passing the primary school buildings near to the terminus of the 45 route. The route was the last of the trolleybus routes to be introduced in Belfast, this occurring on 18 May 1959. The trolleybus would only have barely another twelve months in service before it was taken out of service on 1 April 1963 when the Newtownards Road and Stormont trolleybus services were withdrawn. (R. F. Mack)

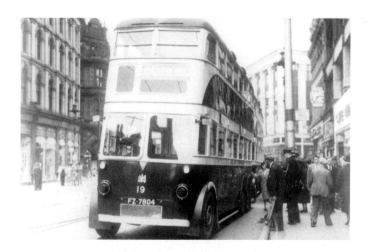

Loading up in Castle Place, with the large interwar Burton's Building behind it, is the almost new Harkness-bodied AEC 664T 19, (FZ 7804). The trolleybus is equipped with headlight masks and white-painted edges at the bottom of the front panel. Belfast, being part of the United Kingdom, was subjected to wartime blackout regulations and played a considerable part in the manufacture of war material. As a result of having such large military suppliers as Harland & Wolff and Short Brothers, Belfast was targeted four times during the war, but the raid on Easter Tuesday, 15 April 1941, by 200 German bombers was the worst. That night, 203 metric tons of high explosive bombs, 80 landmines attached to parachutes, and 800 firebomb canisters containing 96,000 incendiary bombs were dropped on the city. At least 955 citizens of Belfast were killed and over 1,500 people were injured. 3,200 houses were damaged while eleven churches, two hospitals and two schools were destroyed. Other than the raids in London, this was the greatest loss of life in a single night-time raid during the Second World War. The area behind the trolleybus in High Street was part of the city centre that was decimated in this air raid. (D. R. Harvey Collection)

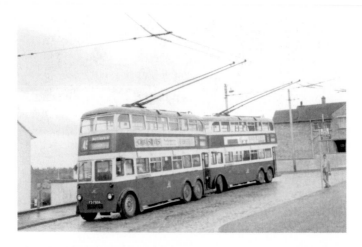

At Whiterock Road terminus in Divismore Crescent is a pair of AEC 664Ts with Harkness H36/32R bodies. 19, (FZ 7804), and 43, (FZ 7828), wait in the turning circle of the 45 route. Typical of many of Belfast's trolleybus termini, the turning circle was anticlockwise. These two trolleybuses had identical service lives, entering service on 5 June 1941 in time for the opening of the Castlereagh service. Both vehicles were withdrawn on 22 October 1963, just after the closure on the 13 October 1963 of the route to Bloomfield and the cross-city service between Carr's Glen and Cregagh. (J. Shearman)

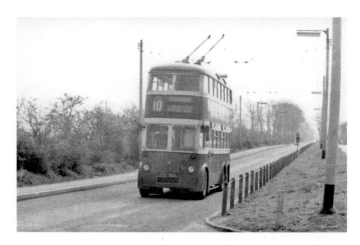

Speeding along the still-almost-rural Whitewell Road as it approaches the terminus at Throne Hospital is 20, (FZ 7805). Today, on the far side of the hedge is the M2 motorway to Antrim. This large Harkness-bodied six-wheeled AEC 664T was one of the eighteen trolleybuses that entered service in time for the opening of the Cregagh service on 13 February 1941. Even after twenty years of service, it seems to have little or no body sag and looks in remarkably good condition. Just visible is the trolleypole mounted at the bottom of the nearside lower-saloon waistrail. At the front of this panel is the bare section of aluminium that was left unpainted because the pole hook frequently damaged the bodywork. (R. F. Mack)

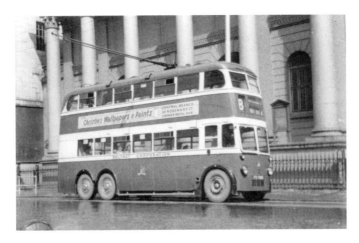

Standing in the sunshine after a recent shower with the Corinthian capital pillars of the Wesleyan Methodist church in Donegall Square East behind it is AEC 664T trolleybus 21, (FZ 7806). It is lying over, parked out of service in front of this splendid building, which dated from 1850. The trolleybus is seen in the early 1950s wearing the red and broken-white livery with black dividing strips and the fleet name tastefully painted on the lower-saloon waistrail. Just to set it all off, the wheels are painted silver. The Harkness bodywork, built on Park Royal frames, was attractively proportioned with subtle design features such as the small radii on all the fixed saloon windowpanes. (M. Rooum)

Travelling towards Belfast's Castle Junction on the 3 route from Glengormley via Carlisle Circus is 24, (FZ 7809). It is Friday 27 April 1962 as the trolleybus leaves the Newtownabbey Borough Council area, travelling along Antrim Road near to Cave Hill. The mild climate along the northern shore of Belfast Lough enabled semi-tropical trees to flourish and afforded, from its elevated position, some of the best views over the Lough. Even in the early post-war years, the Antrim Road properties, including the numerous 1930s bungalows, were highly sought after. (R. F. Mack)

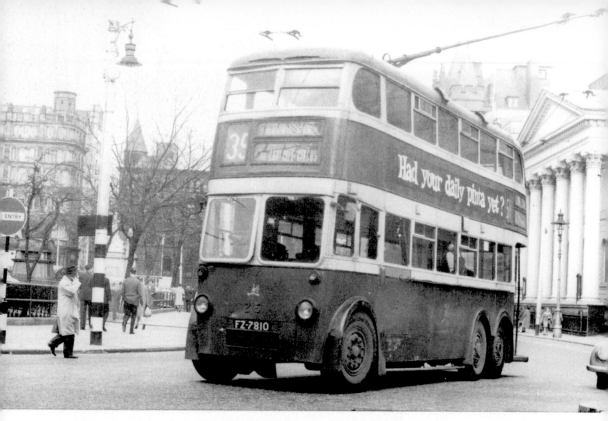

AEC 664T trolleybus 25, (FZ 7810), turns from Donegall Square East into Donegall Square South in April 1962. On the right is the Wesleyan Methodist Church while beyond the black and white-painted lamp standard is the *Titanic* Memorial. This was unveiled on 26 June 1920 in the middle of Donegall Square North in front of City Hall, but because of its location and the associated congestion, the Memorial was moved in November 1959. The trolleybus is working on the 35 route and has just come from Cregagh. It will travel all the way around City Hall before turning left into Donegall Place, just to the left of the distant Robinson & Cleaver's department store. It will then head off to the northern suburb of Carr's Glen. (R. F. Mack)

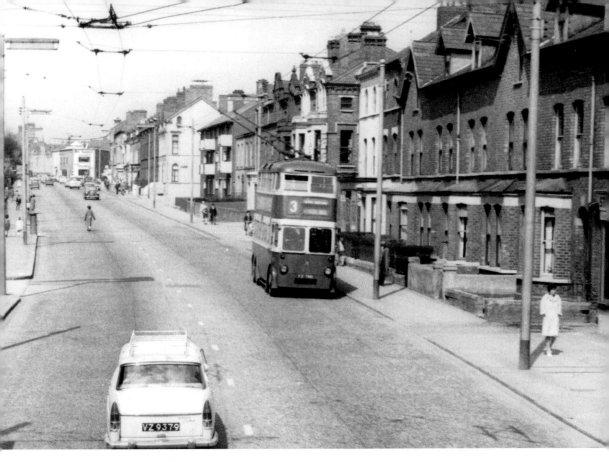

The houses lining Antrim Road generally dated from the 1880s and those between Dawson Street and New Lodge Road even had small walled gardens in front of them. They are being passed by trolleybus 26, (FZ 7811), one of the sixty-eight-seater AEC 664Ts with Harkness bodywork. This vehicle is travelling into Belfast whilst working on the 3 route and is approaching Carlisle Circus. Evidence of the wartime bombing is the block of 1950s maisonettes behind the trolleybus on the corner of Annadale Street. In the distance is the much-rebuilt McLaughlin's Bar at 151 Antrim Road, which occupied the site in the apex of Antrim Road and Halliday's Road. (R. F. Mack)

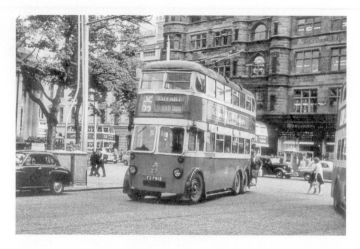

Trolleybus 27, (FZ 7812), is just turning into Donegall Square North and is passing the colonnades of the Garden of Remembrance and the Cenotaph. The trolleybus has just completed its turn of duty as the lady on the platform moves into the long-forgotten art of demounting an open-back platform vehicle. 27 was one of the AEC 664T trolleybuses with a Harkness H36/32R body that survived until the withdrawal of the Stormont and Dundonald services. (G. Lumb)

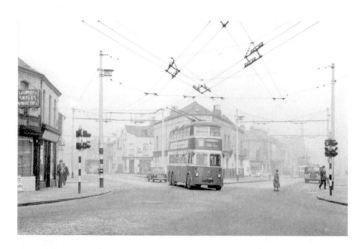

Working on an outbound 30 service to Bloomfield in about 1961 is AEC 664T trolleybus 28, (FZ 7813). The trolleybus has just coasted over the rather substantial power input cables in Beersbridge Road and is crossing the junction with Castlereagh Street. Above the junction is the notably taut wiring whose all-up weight would have been several tons. In the distance, a trolleybus is travelling on an inbound 31 route from Castlereagh and is approaching the Mountpottinger Unitarian church whose tower can just be seen against the skyline. The public house behind the trolleybus is the Castlereagh Arms. The Bloomfield service was the first new post-war trolleybus route to be introduced when operations began on Monday 6 May 1946. In order to get to the Bloomfield Road terminus, the 30 route crossed the River Lagan by way of the Albert Bridge, before turning right into Woodstock Road where it shared the overhead with the Cregagh route. It then turned left into Beersbridge Road crossing Castlereagh Road at this point before proceeding to Bloomfield. (R. F. Mack)

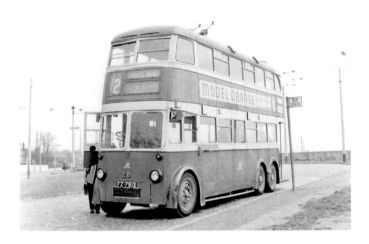

The large turning circle at the terminus at Whitehouse could easily accommodate seven or eight trolleybuses, but in November 1961, Harkness-bodied AEC 664T 28, (FZ 7813), stands in splendid isolation. This was because the terminus was beyond the city boundary and inside the jealously preserved Ulster Transport Authority's operating area. As a result, passengers were not supposed to be set down or picked up inside the turning circle! It is ready to travel across the city to the Andersonstown terminus at the end of the Falls Road route. By this date, the body of 28 had been slightly rebuilt with the upper saloon front-side windows being remounted in rubber. Just behind this is the thicker body frame that carried the power cables from the trolley collection gear, (the poles attached to the wiring), down through the body via the circuit breakers and contractor panel, which controlled the level of current reaching the underfloor-mounted traction motor. (D. F. Parker)

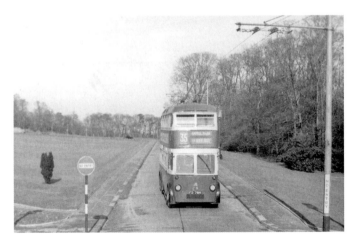

Not quite what it seems! Although displaying the 35 route number and the Carr's Glen destination, 29, (FZ 7814), travels out of the grounds of the Parliament Buildings in March 1963. This could only have been days before the routes around Stormont were abandoned. The trolleybus is probably going back empty to the depot at Haymarket and it was common practice to show an incorrect route display in order to deter waiting passengers. This AEC 664T was, despite its excellent appearance, only going to survive a few more months, being among the last twenty-two of the class to be withdrawn on 22 October 1963. (R. F. Mack)

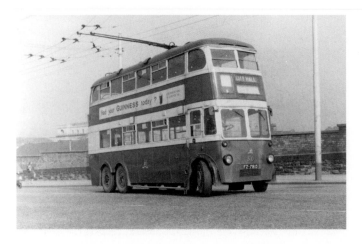

Turning right from East Bridge Street into Stewart Street, trolleybus 30, (FZ 7815), an AEC 664T with a Harkness H36/32R body, is returning to Haymarket depot. The trolleybus is using the outer set of wires, which were installed from Oxford Street and around the left-hand corner into East Bridge Street. This was in order to facilitate depot-bound trolleybuses right, or even queuing, in the middle of the road without impeding the progress of service trolleybuses bound for the eastern termini. The stone wall behind the trolleybus marks the southern edge of the May's Market. This was built on reclaimed land in Oxford Street and was opened in 1813, and within ten years, it was Belfast's main market for sale of butter, meat, eggs, potatoes and vegetables. After years of chronic decline, the East Bridge Street area has since been transformed as part of the Laganside development, begun in 1989, to regenerate the quarter both socially and economically. The focus of the site located in the Lanyon Place is the £32 million Waterfront Hall concert hall and exhibition centre. The 2,241-seater circular auditorium was completed in 1997. (A. S. Bronn)

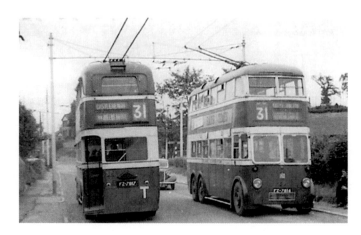

Parked at the Castlereagh terminus are Harkness-bodied AEC 664T trolleybuses 32, (FZ 7817), and with the crew sitting on the grass next to it, 29, (FZ 7814). By this time, in the early 1950s, the trolleybus route had acquired a turning circle at the Knock Road junction, but as at most of the Belfast termini, passengers were not carried when the trolleybuses turned round. The rear of trolleybus 32 shows the frosted glass, for modesty's sake, on the staircase side of the platform window, while the trolleybus is still equipped with the rather splendid rear destination box, a feature that would be omitted during the mid-1950s. (R. C. Jackson)

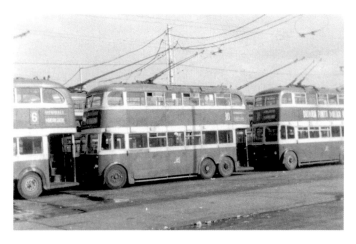

The only photograph of AEC 664T trolleybus 33, (FZ 7818), shows it parked in Haymarket yard towards the end of its long career. Behind is post-war Guy BTX 110, (FZ 7895), which serves as an interesting comparison with the eight-years-older 33. Both have Harkness H36/32R bodies, but that on 33 just looks a little more subtle with, for example, the trolleypole bracing not being exposed, whereas on the Guy there is a robust pair of gantry-like supports on the roof over the second and third window bays. (D. R. Harvey Collection)

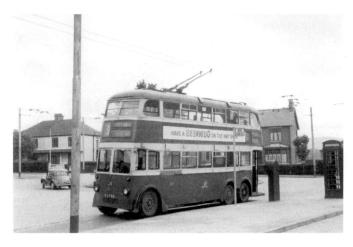

The service to Bloomfield terminated where Bloomfield Road met the junction with North Road. This was also the terminus of the 20 tram route, which was replaced by trolleybuses in 1946 and was thus quite unusual since it was one of only four trolleybus routes that only went as far as the previous tram terminus; in Belfast the replacement trolleybus route was usually beyond the original tramway. 36, (FZ 7821), waits facing back towards the city centre at the terminus in Bloomfield Road alongside the Bundy time clock. The trolleybus has done a 180-degree turn around the traffic island in front of the early-twentieth-century houses in North Road. (J. Shearman)

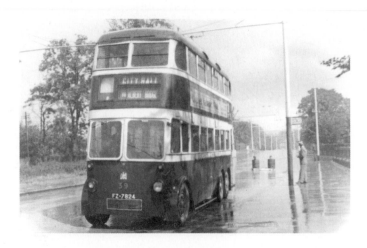

The sun has just come out after a heavy downpour as AEC 664T 39, (FZ 7824), leaves the trolleybus-stop at the Dundonald Cemetery Gates in Upper Newtownards Road. With the Elk Inn just visible in the background, the trolleybus is on its way on the long nearly six-mile journey to City Hall by way of Albert Bridge. Had the trolleybus been on a full service, rather than just going into Belfast city centre, it would have been showing the route number 17. These 7-foot-6-inch-wide trolleybuses did look a little gaunt when viewed from certain angles, but they were nicely proportioned, and despite all eighty-eight of them being delivered during the Second World War, they were all finished to full peace-time standards, which probably helps to explain why their delivery was so protracted. (D. R. Harvey Collection)

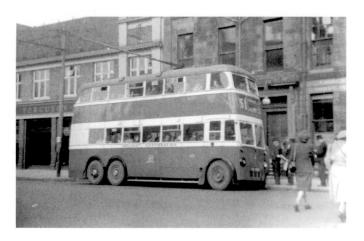

Parked outside the premises of the Church of Ireland Young Men's Society in Donegall Square East in about 1949 is AEC 664T 40, (FZ 7825). It is already full of passengers while the queue alongside it will prove too much for even its sixty-eight-seat capacity and no doubt another ten or more standing in the lower saloon. The bus is working on the 26 route to Belmont Drive by way of Queen's Bridge, which was introduced on 26 March 1942 as a shortworking of the 22 service to Stormont. The trolleybus has been repainted in the early post-war livery, but the front panel between the decks still has the beading where the original semi-streamlined livery swoop was located. (J. F. Parke)

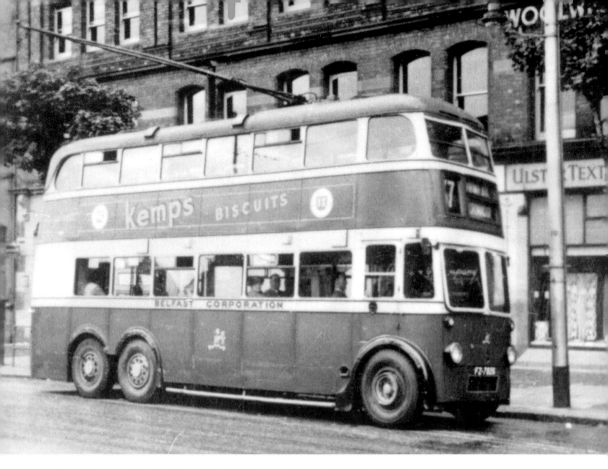

Standing outside the Ulster Textile Company's shop in Victoria Square is Harkness-bodied AEC 664T 41, (FZ 7826). This shop was in the ground floor of an 1893 building built as the premises for a seed merchant. This terminus was inconveniently located off Victoria Street some quarter of a mile away from Donegall Square. Today, after a £400 million commercial, residential and leisure development, which took six years to build, Victoria Square is now one of the most prestigious developments in Belfast, after opening 6 March 2008. The trolleybus is working on the 37 service to Ormeau Road in about 1952, which until 1951, was numbered 16. The Ormeau Road route was opened on 19 April 1948 as part of an ambitious plan to operate trolleybuses in South Belfast. These routes would have replaced tramcars on the Malone and Stranmillis Roads, along Lisburn Road and on Donegall Road to link the Falls Road to the Sandy Row area and Great Victoria Street. A change of policy and general manager in 1951 meant that only the Ormeau route was converted to trolleybuses and then, to some extent because it was geographically virtually isolated from the routes, was abandoned on 26 October 1958. (M. Corcoran)

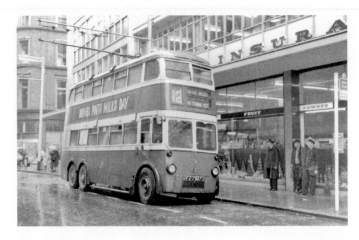

The layover point for all the Falls Road trolleybus services was in Castle Street, just beyond Fountain Street and the rear of the large Anderson & McAuley's department store. Sheltering from the rain under the canopy of the 1960s Norwich Union Insurance premises is an inspector and a trolleybus driver and a rather bored-looking conductor who is wearing his money satchel. On 23 July 1963, GEC-powered 95-hp AEC 664T 42, (FZ 7827), is waiting to travel on the 12 route along Falls Road. 42 would survive for another three months, being withdrawn on 22 October 1963. (A. D. Packer)

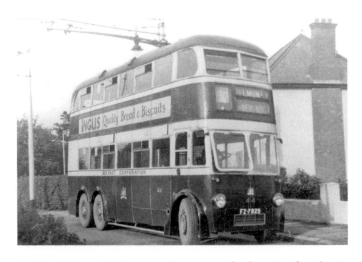

The turning circle in Belmont Drive served as a turnback point for the Stormont route. Trolleybus 44, (FZ 7829), has worked on the 26 route via Queen's Bridge and presumably will work its way back to Haymarket depot. The Harkness body carries an advertisement for James Inglis's bread and cakes. Inglis was one of Belfast's largest bakeries and was based in Eliza Street, located between the latter-day Haymarket depot and the gasworks. (W. J. Haynes)

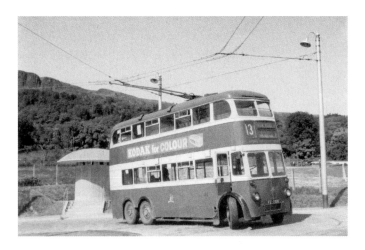

45, (FZ 7830), had the distinction of being the last trolleybus in the fleet to retain the original dark-blue and white livery. It also appeared in the 1947 film *The Odd Man Out* starring James Mason and Robert Newton and directed by Carol Reed. 45 is standing at the Whitewell terminus having travelled north as a 10 service by way of the important Shore Road through the suburbs of Fort William and Greencastle. The crew of the trolleybus are waiting in the lower saloon for their departure time before leaving to go back to Glen Road on the other side of the city as a service 13. (J. Shearman)

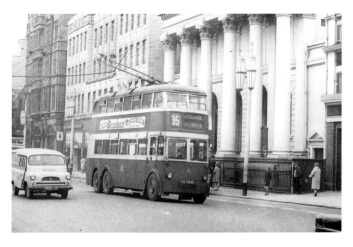

Travelling towards its pick-up point in Donegall Square East is Harkness-bodied AEC 664T trolleybus 47, (FZ 7832). This vehicle entered service on 5 June 1941 and survived until 22 October 1963. The trolleybus has travelled from the eastern suburb of Cregagh and is now working on the cross-city 35 route to Carr's Glen. It is being overtaken by a Bedford CAL van first registered in 1961. The trolleybus will travel all the way round Donegall Square and will then turn into Donegall Place. (R. F. Mack)

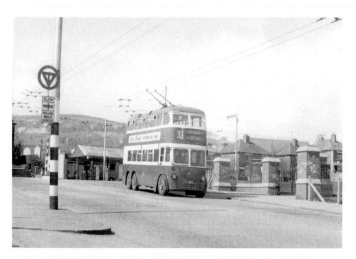

The recently overhauled trolleybus, with its shining paintwork, has just left the Carr's Glen terminus on the cross-city 33 service to Cregagh. In the early 1960s, GEC 95-hp AEC 664T 48, (FZ 7833), has just turned left into Old Park Road from Ballysillan Road in front of the Church of Ireland's 1920s-built Holy Trinity and St Silas Church. The name Ballysillan comes from an Irish Gaelic name meaning 'town land of the willow-grove'. In winter, its elevated position can make it a bleak area, but on this warm summer's day, the driver has opened the bottom of his windscreen to get a bit of cool air into the trolleybus cab, which, with all the throbbing electrical equipment, could get uncomfortably warm. (R. F. Mack)

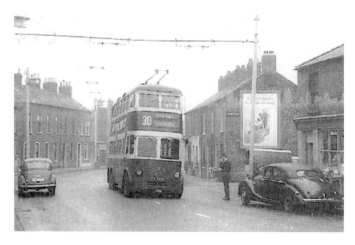

Beersbridge Road linked Woodstock Road to Newtownards Road, crossing Castlereagh Road. The only trolleybus route that used this Victorian-terrace-lined road in Ballymacarrett was the 30 route, introduced on 6 May 1946 when the newly delivered Sunbeam W4 four-wheelers opened the service. Beersbridge Road was used by the 30 route in order to take the pressure off the complicated tram and trolleybus junction at Albertbridge Road and Mountpottinger Road. On 3 November 1962, AEC 664T 49, (FZ 7834), approaches the junction with Woodstock Road as it travels towards the city centre and is passing Tamery Street just beyond the Riley RMB 2½ litre saloon on the right. At this time, the 30 route had only eleven months left to run, being withdrawn on 13 October 1963. (D. R. Harvey Collection)

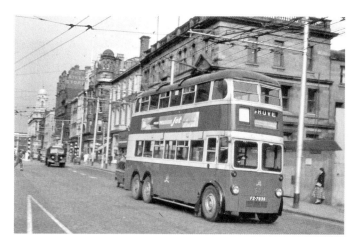

Travelling from Wellington Place and just entering Donegall Square North is AEC 664T 50, (FZ 7835). It is showing the destination 'Grove' on the blind, though it appears to be empty. Grove was the first turning loop on York Road, which was only rarely used, but this shortworking was given the route number 9. The turning circle, next to the 1960s-built international-size swimming pool, enabled trolleybuses to come back towards the city and wait for passengers coming off the trains arriving at the Northern Counties Committees York Road railway station. This L.M.S.-owned railway company operated trains from Londonderry via Antrim and Lisburn as well as the busy commuter-line trains from Carrickfergus and the important cross-Irish sea package port of Larne. (G. Lumb)

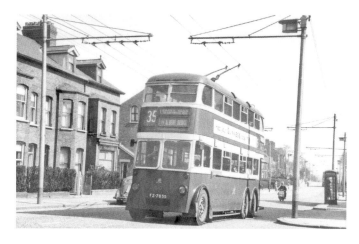

The 35 route to Carr's Glen travelled the length of Cliftonville Road, a road that was developed in the 1890s from Antrim Road to the junction with Old Park Road. The steady climb up towards the Old Park Road junction was ideal for trolleybuses, as with their 95-hp motors, they made light of such gradients, putting what the folk of Belfast called 'the petrol buses' to shame. AEC 664T 50, (FZ 7835), speeds on its way to Carr's Glen while being followed by a Vespa scooter being dwarfed by a rather large gentleman. (R. F. Mack)

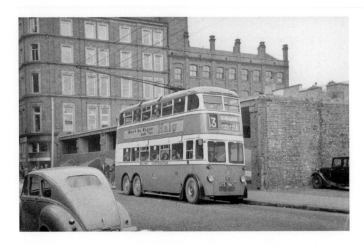

Parked in Castle Street is one of the splendid Gerald Palmer-designed flat-floor 1486-cc-engined Jowett Javelin four-door saloons. Standing opposite the car is AEC trolleybus 52, (FZ 7837), which is working on the recently introduced 13 route to Glen Road. This new route, which forked off Falls Road at the Falls Park depot, was opened on 16 April 1952. 52 is parked next to the derelict bomb-site, which over ten years later, would become the home of the new Norwich Union Insurance office block. (C. Carter)

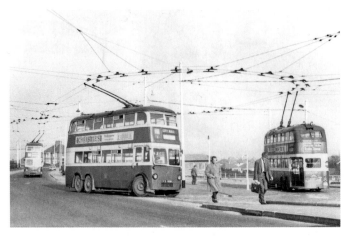

The Glen Road terminus at Bingham Drive was distinguishable by the anticlockwise route that the trolleybuses negotiated in this turning circle. Turning in front of St Teresa's Primary School in April 1962 is 7-foot-6-inch-wide AEC trolleybus 53, (FZ 7838). It has just unloaded its passengers in Glen Road, where the distant 181, (GZ 8545), is standing. Waiting in the turning circle is another one of these post-war 8-foot-wide Guy BTX trolleybuses, this time 185, (GZ 8549). (C. W. Routh)

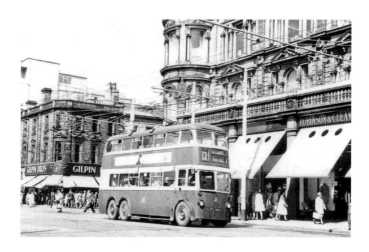

Passing the wonderful frontage of the Robinson & Cleaver's department store in Donegall Square North, opposite the front of City Hall, is AEC 664T trolleybus 54, (FZ 7839). It has come along Donegall Place, where Gilpin Brothers' 1870-built three-storey building was located. Their gentlemen's outfitters premises were eventually pulled down in the mid-1960s. This Harkness-bodied trolleybus has come from Carr's Glen and is going over the River Lagan by way of the Albert Bridge on the 33 service. (D. R. Harvey Collection)

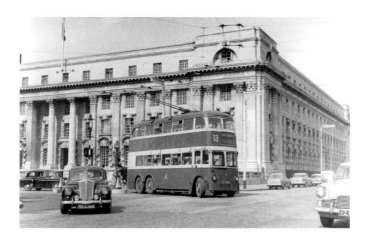

Turning right from May Street into Victoria Street is AEC 664T trolleybus 56, (FZ 7841). This Harkness-bodied six-wheeler is working on the east-bound journey on the 33 route to Cregagh in about 1959. In front of the trolleybus on the left is a 1951-registered Wolseley 6/80. These large six-cylinder 2215-cc-engined saloons were used by many British police forces as high-speed patrol cars, despite their top speed being a disappointing 78 mph. Dominating the area is the Royal Courts of Justice building in May Street whose 'twin' was the Parliament Buildings at Stormont. Built between 1928 and 1933 by James G. West, its Art Deco Imperial style had been favoured for many municipal buildings built between the wars in the UK. The forbidding Portland-stone façade is dominated by a row of Corinthian columns and thirteen bays, the central three of which are recessed to form a porch. (A. S. Bronn)

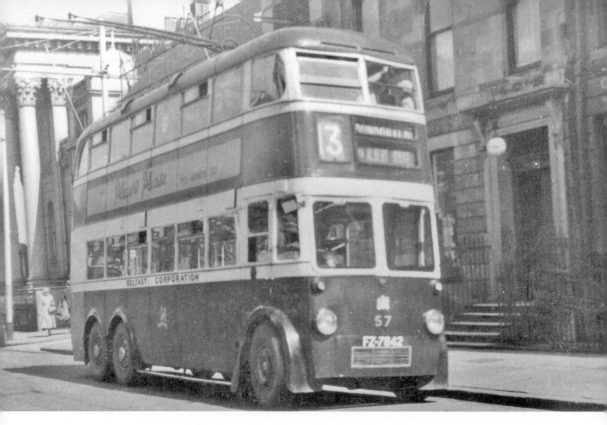

The 'Player's Please' advertisement had been used since the 1930s as John Player's cigarette advertising slogan, and by the late 1940s, it was still being enthusiastically employed on the sides of buses. Belfast trolleybus 57, (FZ 7842), stands in Donegall Square East outside the Church of Ireland Young Men's Society building. This Harkness-bodied AEC 664T is resting at its city terminus before leaving for Dundonald on the 13 route before the service was renumbered as 17 in 1951. (W. J. Haynes)

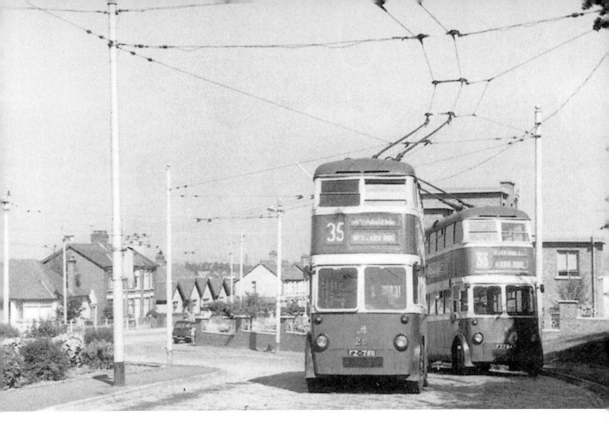

The Cregagh terminus was at the end of the long, straight Cregagh Road at Cregagh Park, just short of Knockbreda Road. Unlike the Castlereagh route, which was the next radial route to the north-east out of the city, which also terminated at Knockbreda Road, the 33 route terminus was in an area of interwar housing terminating just beyond a row of suburban shops.

The bungalow on the corner of Downview Road on the left, the block of Victorian houses and the row of bungalows still remain in Cregagh Road. AEC 664T 26, (FZ 7811), stands with its destination blind already set to return to Carr's Glen as a 35. Behind it is another of these Harkness-bodied trolleybuses, 58, (FZ 7844), which has just arrived at the Cregagh Park terminus. (D. Battams)

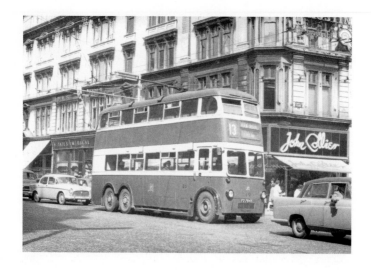

Passing the John Collier gentlemen's outfitters on the corner of Castle Place junction is Harkness-bodied trolleybus 60, (FZ 7845). This AEC vehicle is working on the cross-city 13 service from Whitewell, and as it is using the right-hand set of wires in Royal Avenue, it should be about to turn right, following the Farina-style Morris Oxford Series V, into Castle Street. There it will travel by way of Divis Street and Falls Road before turning off the main road to the Glen Road terminus. Behind the trolleybus is a Liverpool-registered 1958 Humber Hawk Mk I saloon. (R. F. Mack)

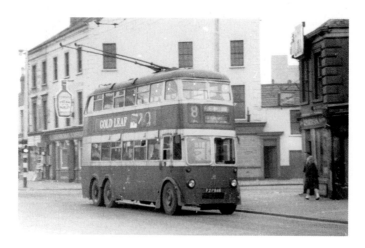

Travelling along York Road is Harkness-bodied AEC 664T 61, (FZ 7846), a trolleybus that had been in service since 1 December 1941. It is passing York Road railway station on the 3 September 1963, which was less than two months before it was withdrawn on 22 October 1963. It certainly looks as if it is nearing the end of its career. It is working on the 8 route to Fort William and has just passed the Edinburgh Castle public house on the corner of Canning Street. (F. Hornby)

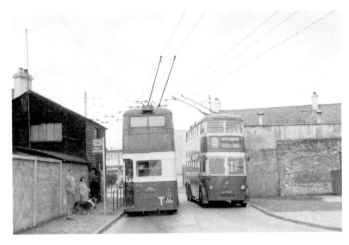

The strange terminus at Glengormley was located off Church Road in a double cul-de-sac alongside Glengormley Primary School and was the only trolleybus terminus on the system to retain a reverser rather than a turning circle. AEC 664T 62, (FZ 7847), has entered the private land on which the terminus was located from Antrim Road and has just unloaded its passengers. It will then move forward and reverse into the second cul-de-sac just visible on the extreme right. After being 'watched back' by the conductor, the trolleybus will then move forward and turn right to pick up passengers where trolleybus 196, (GZ 8560), is standing. The difference in the width between the post-war 8-foot-wide Harkness-bodied BUT 9641T and the narrower AEC, which entered service on 26 March 1942, is most noticeable. (J. Shearman)

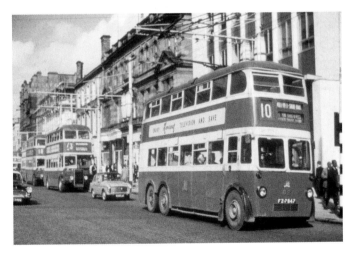

Working on the 10 route to Whitewell by way of Shore Road is AEC 664T 62, (FZ 7848). It is in Donegall Square North and is passing the 1960s-built Belfast Banking Company's city centre headquarters. Following the trolleybus is an Austin A40 Farina car, while being used on the 73 route to Ballygomartin is 345, (MZ 7443), a 1951-vintage Harkness-bodied Guy 'Arab' III, which were quite unusual for this model, as the batch of forty-five buses was equipped with Wilson pre-selector gearboxes. (Trolleyslides)

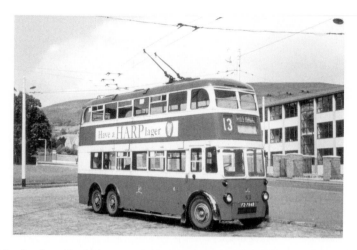

St Teresa's RC school was built in 1958 in Glen Road. The trolleybus, 63, (FZ 7848), is parked in the turning circle at the Bingnian Drive terminus of the 13 route opposite the school. When this route was introduced as a branch off the Falls Road service on 16 April 1952, this was still only a partially developed part of Belfast. Behind the trolleybus is Black Mountain, which overlooks and dominates most of west Belfast. It is a moorland-covered hill composed of a tertiary basalt cover underlain by limestone and Lias clay. It reaches a height of 1,275 feet and extends to the north as part of the Antrim plateau. (D. R. Harvey Collection)

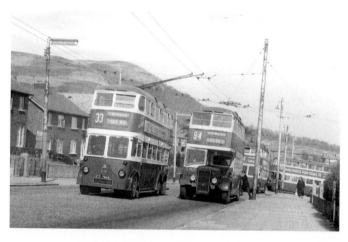

The terminus of the 35 trolleybus route was at Joanmount Gardens on Ballysillan Road but was given the more prosaic destination of Carr's Glen, named after a small valley whose stream flowed off the distant Cave Hill which dominates the skyline behind the trolleybuses and buses. As if to show that trolleybuses are manoeuvrable, 64, (FZ 7849), an AEC 664T six-wheeler with a Harkness H36/32R body has just started off on the long cross-city 33 service to Cregagh. It is overtaking a "petrol-bus" 366, (OZ 6620), a Daimler CVG6 with an attractive 8' wide 56 seat body built by Harkness in 1952 which is working on the 94 route to Ormeau via Crumlin Road and Bedford Street. Another trolleybus stands at the Ballysillan Road terminus stop between the entrance and the exit to the turning circle which was negotiated in an anticlockwise direction. Another Daimler CVG6, 356, (OZ 6610), stands at the exit to the Joanmount Gardens turning circle, which is still used by Metro in 2009. (R. F. Mack)

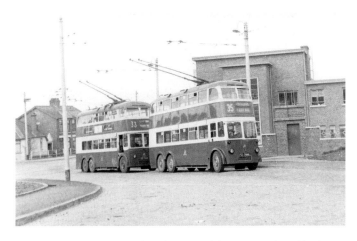

Same trolleybus, but at the other end of the line! Freshly repainted and looking very smart, 64, (FZ 7849), has arrived at the Cregagh terminus of the 33 route at the junction with Cregagh Park. It has already had its destination blind changed for the journey back across the city to Carr's Glen. Behind it is BUT 9641T Harkness-bodied trolleybus 218, (OZ 7320), which entered service on 1 March 1954. This vehicle has only just arrived here, as the destination blind has not been turned. The last half-mile of the Cregagh route was outside the Belfast boundary and was administered by the Castlereagh District Council, whose early post-war municipal offices stand behind the trolleybuses. (D. F. Parker)

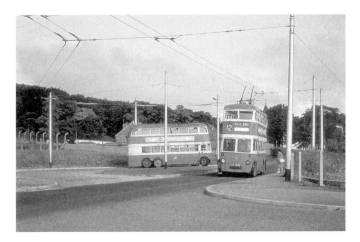

Preparing to leave the Whitewell terminus in the north of the city and just outside the city boundary is AEC 664T 65, (FZ 7850). This 1942-vintage AEC 664T trolleybus is working on the cross-city 12 service to Falls Road. Behind it is an unidentified post-war BUT 9641T from the 187-210 batch of trolleybuses. Although seemingly identical to the large batch of earlier Guy BTXs, these BUTs could be easily identified, as they had large, flat rear-wheel bogie half-shaft covers whereas the Guys had very small covers. (G. Lumb)

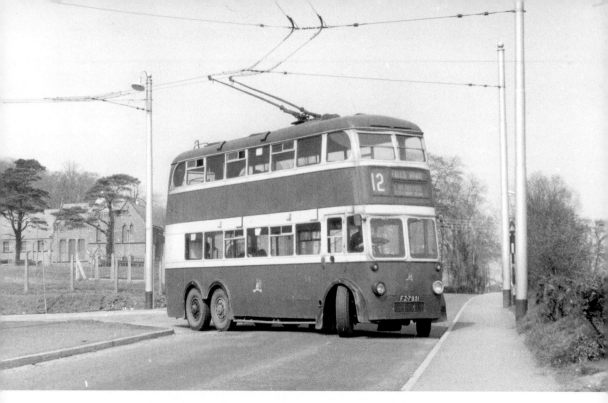

About to turn out of the terminus loop and back into Whitewell Road is AEC 664T trolleybus 66, (FZ 7851). It was quite a tight turn out of the turning circle, especially as trolleybuses had notoriously heavy steering, not helped by the lack of rake on the steering wheel, which made the driver's work even harder. The one advantage of this terminus was that the overhead wiring consisted of very short, straight sections, which made for a smoother turn for the trolleypoles, albeit noisier! Behind the trolleybus is the long-since closed Throne Hospital, which was once a private residence. The house was named after the O'Neill clan's crowning Giant's Chair stone, which was located on the top of the nearby Cave Hill, and was later converted into a hospital and convalescent home, becoming one of the pioneering centres for plastic surgery in Northern Ireland. (C. W. Routh)

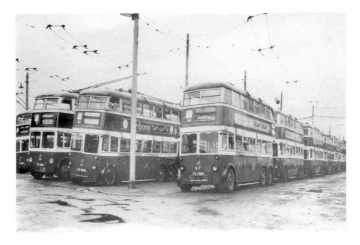

This is a bit of a cheat! In this early 1950s view of Haymarket depot yard, 97, (FZ 7882), and 61, (FZ 7846), both AEC 664Ts with Harkness H36/32R bodies are in the centre of the line-up with post-war 8-foot-wide Guy BTX 113, (FZ 7898), parked on the left. On the extreme left is 67, (FZ 7852), which entered service on 26 March 1942. This trolleybus managed twenty-one years of hard work, not being withdrawn until 1 April 1963. (Bristol Vintage Bus Group)

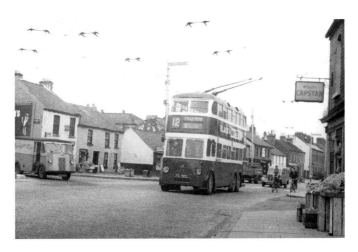

A Morris-Commercial PV 15-cwt van, owned by Harlequin Cakes, waits to come out of Whitewell Road where the Whitewell 10 trolleybus turned left up the hill to the Throne Hospital. A six-wheeled trolleybus, 68, (FZ 7853), an AEC 664T with a Harkness body, travels inbound from Whitehouse along Shore Road. It is working on the 12 route across the city to Falls Road. Just like the Bradford CC light six 'utility de-luxe' van following the trolleybus, this area has been consigned to history with much of the scene landscaped as part of the land surrounding the M2 motorway. (R. F. Mack)

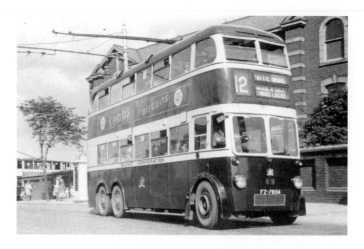

Passing the Royal Victoria Hospital, while working out of the city on the 12 route, is trolleybus 69, (FZ 7845). This Harkness-bodied AEC 664T is in the first red and broken-white livery with the legend 'BELFAST CORPORATION' on the lower-saloon waistrail. Standing in Grosvenor Road working on the 21 service to Springfield is a 'Moffett' four-wheeled, totally-enclosed tramcar. The Royal Victoria Hospital was opened in 1903 to the design of William Henman and Thomas Cooper who were Birmingham-based architects. (M. Corcoran)

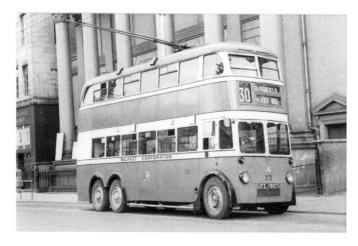

A smartly painted 72, (FZ 7857), is working on the 30 route and is waiting at the city terminus in Donegall Square East outside the classical-style Wesleyan Methodist Church. The Bloomfield service had been introduced on 6 May 1946 and was originally numbered 20. This route was renumbered 30 in 1951 and 72 is seen shortly after this date. The Harkness bodies fitted to these AEC 664Ts had Park Royal metal framing and did have a superficial similarity to the London Transport N2 class, which also had the same chassis as the Belfast examples. (D. R. Harvey Collection)

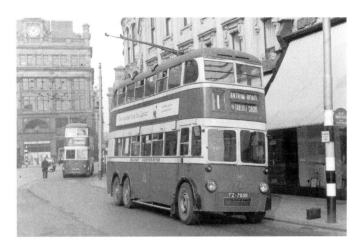

With 28, (FZ 7813), standing behind it in Castle Street, 74, (FZ 7859), another of the 1942-built AEC 664Ts with Harkness H36/32R bodywork, waits at the city centre terminus of the 1 route. Like all the Antrim Road services, the 1 route was introduced on 24 January 1949. This shortworking went as far as Strathmore Park where, in order to turn back for this shortworking, the trolleybuses, for the first year, had to reverse. 74 is parked outside Robb's department store in Castle Street. Robb's gradually expanded from no. 15 on the corner of Lombard Street in 1861 and by 1890 had expanded through to no. 1 in Castle Street in an impressive 1870s-built store. They described themselves as 'wholesale and retail silk mercers, woollen-drapers' and eventually became famous for their Irish linen hall. It finally closed in 1973, but this elegant building was not demolished until 1988 when it was finally replaced in 1990 by Donegall Arcade. Behind trolleybus 28 in Royal Avenue are the Bank Buildings, which were completed in 1900. (D. A. Jones)

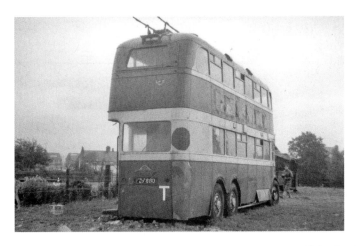

Most of the Belfast trolleybus fleet was broken up by Beatties near Hillsborough, but a few seemed to survive briefly prior to scrapping. Looking as though just a set of overhead wires needed to be put up in order for it to drive away, 75, (FZ 7860), is being used as a temporary shed sometime not too long after it became one of the first nine to be withdrawn on 2 July 1962. (R. F. Mack)

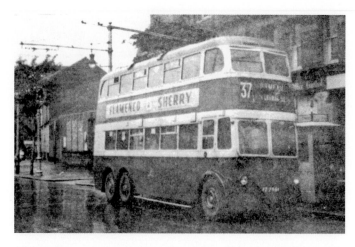

The Ormeau Road service was converted to trolleybuses on the 19 April 1948 and survived only until 26 November 1958. Harkness-bodied AEC 664T 76, (FZ 7861), is working on the short-lived 37 service and is in Ormeau Road on its way out of the city to the terminus. This trolleybus entered service on 16 November 1942 and nearly made its twentieth birthday, being withdrawn on 2 July 1962, one of the earliest of the class to be retired. (D. R. Harvey Collection)

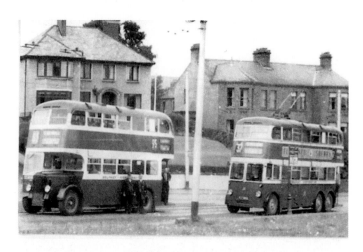

The Ormeau terminus of the 37 trolleybus route was in Saintfield Road, almost in sight of Upper Knockbreda Road. The trolleybuses shared the turning circle with the newly introduced cross-city 55 bus route to Ligoniel via the Shankhill Road opposite long-since-demolished early-twentieth-century housing. Today, this is the site of the huge out-of-town Forestside Shopping Centre. The city to Ligoniel services were the last tram routes to operate all-day services in Belfast until Saturday 30 October 1953, after which workmen's specials from Queen's Road operated a peak-hour service until Friday 12 February 1954. Both the trolleybus, 77, (FZ 7862), an AEC 664T with a Harkness H36/32R body, and 442, (OZ 6696), the 8-foot-wide Harkness-bodied Daimler CVG6, are wearing the livery with the fleet name on the lower-saloon waistrail. This was omitted on repaints after September 1953, and as 442 was new in November 1953, this dates this view to the summer of 1954 after the Ormeau Road bus service was linked to the former northern tram route. (R. C. Jackson)

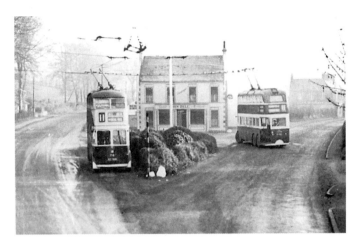

The wartime introduction of the 11 trolleybus route to Dundonald on 16 November 1942 replaced the tram route that had been latterly the home of the streamlined four-wheeled McCreary. Ten new trolleybuses were placed in service at this time, including both of these two vehicles. Moving into the turning circle in front of the Elk Inn at the apex of Comber Road on the right and Upper Newtownards Road on the left is AEC 664T 78, (FZ 7863). The trolleybus on the left is 76, (FZ 7861), another of these Harkness-bodied vehicles. Both buses are wearing the semi-streamlined blue and white livery but further adorned with white-painted blackout warning edges and masked headlights. Judging by the leafless trees, this winter scene was taken shortly after the introduction of the trolleybus service. (PRO, NI)

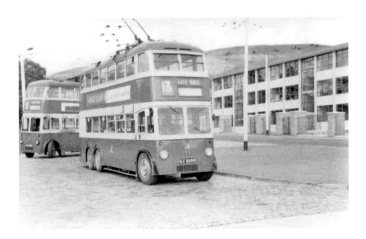

Almost hidden at the Glen Road terminus by BUT 9641T trolleybus 195, (GZ 8559), is trolleybus 79, (FZ 7864), a Harkness-bodied AEC 664T. Both trolleybuses have worked along Glen Road from the junction with Falls Road on the 13 route on 12 August 1962. Opposite the anticlockwise turning circle are the large St Teresa's Primary School and the distant moorland on Black Mountain. (D. Battams)

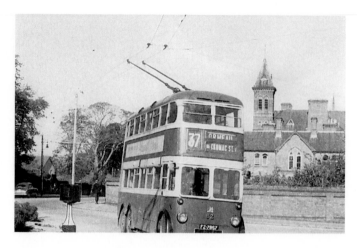

The Rosetta traffic island was the only turnback point on the Ormeau Road trolleybus service, and although only used occasionally, it was given the route number 38. Trolleybus drivers using this facility had the rare opportunity to test their power-on, power-off driving skills, as there was an automatic frog on this island. Behind the trolleybus, in the apex of Ormeau Road on the left into which the Vauxhall Velox is entering and Ravenhill Road on the right is the Victorian Roman Catholic Nazareth House Convent built in 1876 and demolished in 2001. AEC six-wheeled trolleybus 82, (FZ 7867), negotiates this junction as it plies its way towards the Ormeau Road terminus, some two thirds of a mile away. (J. H. Taylforth Collection)

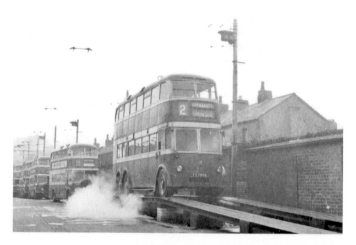

Although day-to-day maintenance of the trolleybuses took place at Haymarket depot and trolleybus overhauls were undertaken at Falls Park works, a certain amount of other work took place at Short Strand. As a trolleybus depot, it was opened on 2 October 1950 with a capacity for about eighty trolleybuses as well as around another 100 motor buses. There were some eighteen service pits and there was the facility in the covered accommodation provided by Harland & Wolff to undertake major repairs to both trolleybuses and motor buses. Steam cleaning was usually undertaken at Short Strand depot, and here, 84, (FZ 7869), is on the ramp being cleaned on Wednesday 25 April 1962. Waiting their turn for chassis cleaning are 355, (OZ 6609), and 368, (OZ 6622), a pair of exposed radiatored 8-foot-wide Daimler CVG6 with Harkness H30/26R bodies. 84 would be withdrawn on April 1963 to coincide with the closure on 31 March 1963 of trolleybuses to Stormont and the Newtownards Road routes to Dundonald. (R. F. Mack)

Travelling up the tree-lined and semi-rural Antrim Road in 1954 towards the Bellevue Zoological Gardens is Harkness-bodied AEC 664T 84, (FZ 7869). This 1943-built trolleybus is working on the 3 service to Glengormley and would serve the City Transport Department for one month short of twenty years. This trolleybus route replaced the then longest tram route on 24 January 1949 and survived to be the penultimate group of services to close on 5 February 1966. (S. E. Letts)

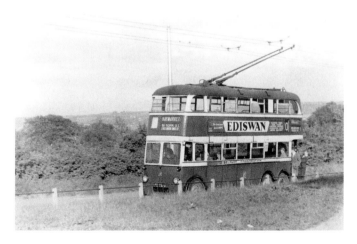

Having worked on the 10 route to Whitewell, 85, (FZ 7870), is about to leave the rural Whitewell Road terminus on a depot only working to Haymarket in about 1954. This was just about one year after the opening of this trolleybus route on 26 April 1953. It was the penultimate trolleybus route to open and was linked with either the Falls Road 12 service or the 13 route to Glen Road. The AEC 664T entered service on 4 March 1943 and managed twenty years of use bar three days, being withdrawn on 1 March 1963. The hook on the trolleybus retrieval pole mounted below the nearside lower-saloon front windowpane frequently scratched the section of panelling. On the post-war trolleybus, this 'scratch zone' was deemed unnecessary, as the pole was in a tube below the rear platform. (S. E. Letts)

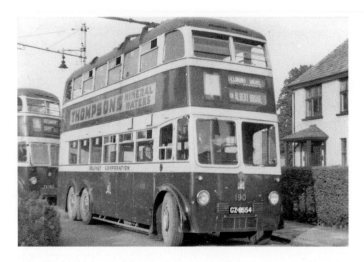

Just visible behind Harkness-bodied BUT 9641T 190, (GZ 8554), is AEC 664T 86, (FZ 7871), which entered service in March 1943. These two trolleybuses were still painted in the red and broken-white livery with fleet names on their waistrails when they were seen parked in the Belmont Drive turning circle of the 27 route in Belmont Road, suggesting that this is about 1954. Both trolleybuses have worked across the Albert Bridge on this shortworking of the 23 service to Stormont. (W. J. Haynes)

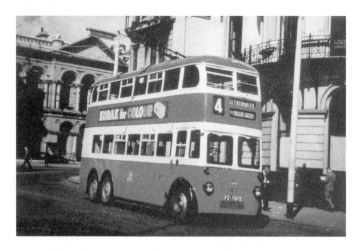

Harkness-bodied AEC 664T 87, (FZ 7872), waits outside the Belfast Bank in Castle Place. The bow-fronted building behind the traction pole is the Ulster Club, which was built in 1861 and demolished in 1991. The trolleybus has just turned into Castle Place from Royal Avenue where the classical-style Provincial Bank of Ireland stands in the background. This was designed by W. J. Barre and opened in 1870, becoming one of the last buildings to be constructed in Hercules Street before rebuilding of the road began in 1881 and it was renamed Royal Avenue. (D. R. Harvey Collection)

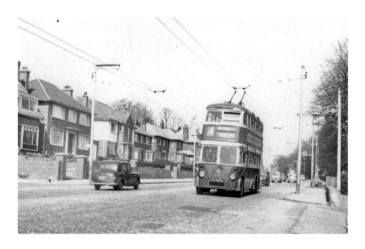

A Hillman Minx Phase VI travels towards Bellevue Zoological Gardens in Antrim Road and passes the long rows of 1930s detached houses. Working back into the Haymarket trolleybus depot on the 4 route from Glengormley is Harkness-bodied AEC 664T trolleybus 89, (FZ 7874). This vehicle is passing the Shaftesbury Inn at 739 Antrim Road, which was closed down during the first decade of the twenty-first century. (R. F. Mack)

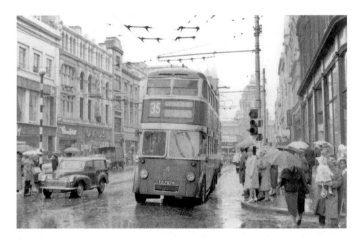

It would be too cruel to say that this is typical Belfast weather, but undoubtedly, although the rainfall at a mean of 34 inches a year is quite low, it does rain, on average, 213 days a year. So, on a miserable Tuesday, 23 July 1963, AEC 664T trolleybus 89, (FZ 7874), splashes along Donegall Place passing the junction with Castle Street. It has left Donegall Square in the distance, dominated by the domed City Hall, while working on the 35 route to Carr's Glen. This service was part of the cross-city service from Cregagh and both halves of the route were closed on 13 October 1963. Behind the trolleybus is one of the 1963 EZ-registered MH Cars-bodied Daimler 'Fleetline' CRG6LXs working on the former Greencastle trolleybus route. These buses would replace the AEC six-wheeled trolleybuses. (A. D. Packer)

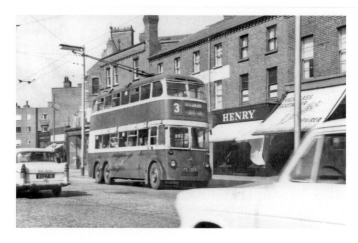

On a warm summer's day, AEC 664T travels towards Castle Junction while working on the 3 route. It is at Antrim Road's junction with Cliftonville Road, where the Carr's Glen trolleybus service turned away from Antrim Road and went in a north-westerly direction towards Old Park Road. Trolleybus 90, (FZ 7875), is still doing sterling work as it passes the row of Victorian shops in April 1962 near to the Phoenix Bar. This Harkness-bodied six-wheeler would be withdrawn exactly on its twentieth birthday on 1 March 1963. (R. F. Mack)

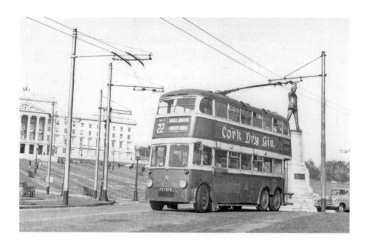

Probably the most impressive stretch of trolleybus routing in the United Kingdom was that from Massey Avenue, through the wrought iron gates and into the huge grounds of the Parliament Buildings at Stormont. This building was designed by Sir Arnold Thornley in the Greek classical style and fronted in Portland stone. It was opened by Edward, Prince of Wales, (later King Edward VIII), on 16 November 1932. The trolleybuses went up the hill to the statue of Lord Carson, located directly in front of the ceremonial drive and then turned left and followed a diamond-shaped course, taking them behind the Stormont Buildings and back to Carson's statue. Coming away from Stormont while working on the 22 route, AEC 664T trolleybus 91, (FZ 7876), has just passed Lord Carson's statue, which looks, from this angle, as though he is undertaking overhead wiring maintenance. (R. F. Mack)

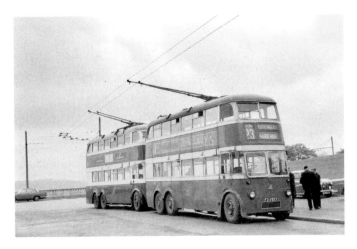

Parked at the impressive balustraded terminus behind the Parliament Buildings at Stormont is 92, (FZ 7877). This Harkness-bodied AEC 664T had the rare distinction in the Belfast fleet of having one of its front upper-saloon half-drop windows replaced by a fixed piece of glazing. It is about to return to the City Hall terminus in Donegall Square North while working via Albert Bridge on the 23 route. Parked behind the AEC is post-war Guy BTX 120, (FZ 7905), which entered service in December 1948. (J. Shearman)

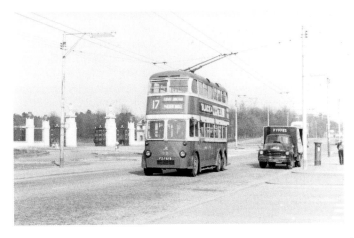

The entrance gates to the Stormont Parliament Buildings were in Newtownards Road. The ceremonial main drive was named Prince of Wales Avenue after the heir to the throne had performed the opening ceremony in 1932. Having overtaken a 1954-registered Bedford S-type lorry owned by Fyffe's bananas, trolleybus 93, (FZ 7878), speeds past the black-and-gold-painted Stormont Gates as it comes down the hill from Dundonald on the 17 route. (D. F. Parker)

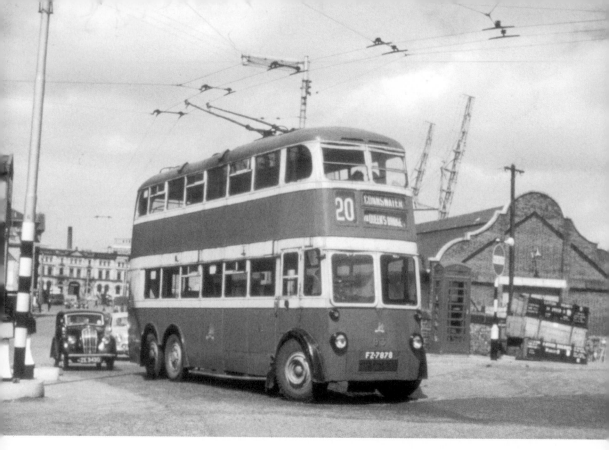

About to turn left onto Queen's Bridge is AEC 664T 93, (FZ 7878). It has left behind the distant Italian-Renaissance-style Custom's House built in 1857 and has travelled along Donegall Quay alongside 'The Sheds'. This was the gateway to Belfast where passengers disembarked from the Irish Sea ferries, where ships from Liverpool, Heysham, Barrow, Douglas, Ardrossan and Glasgow arrived at these dockside buildings. There was a wonderful smell of ships' oil, the distinctive aroma of the polish used on the wooden interiors of the ferries, muslin bags, straw and horse manure inside 'The Sheds'. It has all gone now, subsumed beneath the M3 cross-harbour motorway and the £14 million Lagan tidal weir. The trolleybus is working on the 20 route to Connswater at the Holywood Arches. This route was a shortworking of the 16 service to Dundonald, which was introduced on 16 November 1942 and was abandoned just over twenty years later on 31 March 1963. (Trolleyslides)

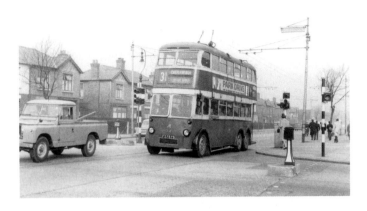

Travelling out of the city is trolleybus 94, (FZ 7879). It is in Castlereagh Road near to Houston Park and is working on the 31 route on 25 April 1962. The Harkness body is carrying an advertisement for the locally made Park Drive cigarettes. These were made by Gallaher's, who had begun cigarette manufacture in Belfast in 1840. In 1896, Gallaher's moved to a new five-storey building at 138 York Street, which, at the time, was the largest tobacco factory in the world. (D. F. Parker)

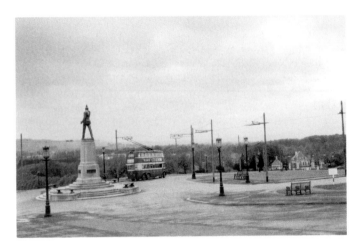

In about 1962, Harkness-bodied AEC 664T 94, (FZ 7879), is just about to start the long descent down to the side gates of Stormont at the distant Massey Avenue. This trolleybus entered service on 18 January 1943 and, by this date, had lost its impressive rear destination boxes. It was one of all but ten of the eighty-eight-strong 15-102 batch that managed over twenty years in service and was not withdrawn until 15 March 1963. The trolleybus has just passed the 1932 statue of Lord Carson standing in a dramatic pose on his plinth. Edward Carson, (9 February 1854 – 22 October 1935), was the leader of the Ulster Unionist Party, who fought against Irish Home Rule and was instrumental in the founding of Northern Ireland. (J. Shearman)

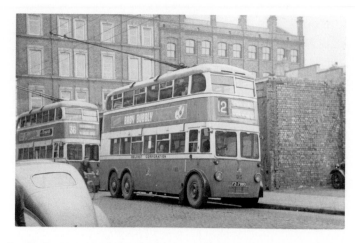

Standing in Castle Street is Harkness-bodied six-wheeled AEC trolleybus 95, (FZ 7880). It is working on the then newly opened 12 route to Glen Road, which began operating on 16 April 1952 as a branch route off the main Falls Road route. The trolleybus 95 is parked just beyond the rear of Anderson & McAuley's department store, which occupied the block between Donegall Place and Fountain Street. (C. Carter)

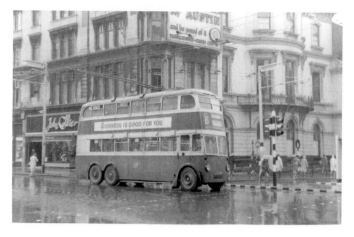

Passing Castle Place in the pouring rain on 23 July 1963 is 96, (FZ 7881). It is crossing from Royal Avenue into Donegall Place, having come into the city centre from Carr's Glen on the 35 route. 96 is only going to City Hall, as it is probably returning to Haymarket depot rather than going to Cregagh. This Harkness-bodied AEC 664T is passing the lovely Regency-style bow-fronted Ulster Club, built in 1861. When it was new, it was much further away from Hercules Place, which was widened in the late 1870s to be reborn as Royal Avenue. (A. D. Packer)

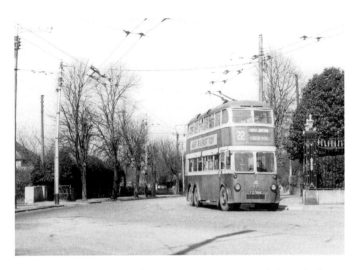

It is difficult to know if AEC 97, (FZ 7882), is going to turn round through the ornamental gates in Massey Avenue while working on the 22 route or going left through the gates and up the impressive drive to the Parliament Buildings at Stormont. It was always something of a surprise to drive along an apparently innocuous-looking tree-lined suburban road, which in reality was a cul-de-sac, only to find what was effectively 'a gap in the hedge' where the wrought-iron gates to Stormont were located. (R. F. Mack)

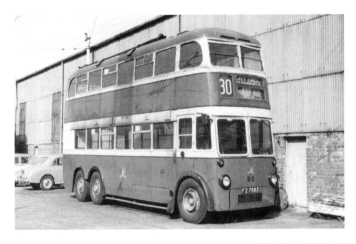

Having been taken out of service on 22 October 1963 as one of the last of the AEC 664Ts with Harkness H36/32R bodies, 98, (FZ 7883), was not scrapped. Instead, it was lovingly restored and repainted for preservation. There then followed a succession of disasters, all of which resulted in the trolleybus being stored in the open and not undercover. It is seen standing in Haymarket depot in the mid-1960s. It is already showing signs of deterioration with staining and rust badly marking the paintwork. This historically important trolleybus, one of only three pre-war AEC 664Ts to be preserved, eventually found its way to the Cultra Folk & Transport Museum, where again, it was stored outside under canvas sheeting. When last heard of, it was in grave danger of structural collapse. Poor old thing! (A. B. Cross)

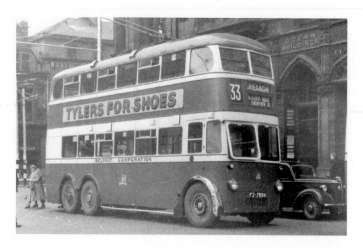

Passing the Ocean Buildings, completed during 1902, in Donegall Square East is trolleybus 99, (FZ 7884). The trolleybus is working on the 33 route to Cregagh by way of the Albert Bridge. The trolleybus still has remnants of its wartime blackout paintwork on the rather battered offside front mudguard and on the life rail, while some of the street furniture in Chichester Street behind the trolleybus still has black and white warning stripes. Alongside the trolleybus is a parked Ford Prefect E93A 10-hp saloon. (A. B. Cross)

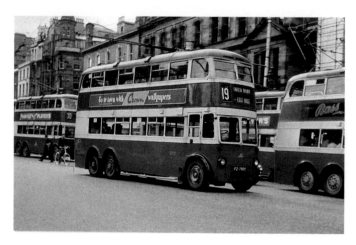

Crossing Donegall Square North and negotiating some of the six parallel sets of overhead wiring is trolleybus 100, (FZ 78885). 100's trolleybus driver was undertaking this manoeuvre in about 1960 when the Belfast Banking Company building on the right was still under construction. The trolleybus is working on the 19 route to Knock, a shortworking of the Dundonald trolleybus route introduced on 8 March 1943. Trolleybus 100 was the very last of the eighty-eight Harkness-bodied AEC 664Ts ordered in 1939 to actually enter service, in this case on 6 October 1943. Both the route and FZ 7885 would be withdrawn in the first half of 1963. (G. Lumb)

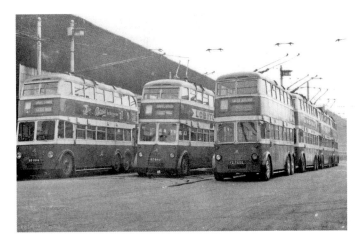

Standing in Short Strand depot yard is the penultimate AEC 664T among a fleet of post-war Guy BTXs. Short Strand was opened to trolleybuses on 2 October 1950 with a capacity for about eighty. Soon afterwards, it was able to accept an allocation of an additional 100 motor buses. Short Strand was the last of the three trolleybus depots to open in Belfast. Parked at the head of the row on the right is trolleybus 101, (FZ 7886), easily recognised by being 6 inches narrower than the Guys. On the left is the very camera-shy Harkness-bodied BTX 150, (GZ 8514), which was an early withdrawal, going on 7 February 1964, only eight months after the AEC. Sandwiched between them in the middle row is trolleybus 148, (GZ 8512), which survived until the last day of trolleybus operation on 12 May 1968. (R. F. Mack)

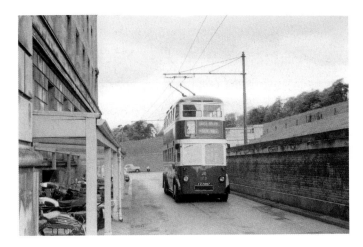

Running along the service road, passing 'the bike sheds', at the rear of the Parliament Buildings at Stormont is the last of the eighty-eight Harkness sixty-eight-seater AEC 664Ts. 102 began working on 7 July 1943, making it the penultimate member of the 15-102 class of these AEC 664Ts to enter service. A freshly overhauled 102, (FZ 7887), looking extremely smart, is on the 22 route, which is going back to Castle Junction by way of Queen's Bridge. (J. Shearman)

CHAPTER THREE

WARTIME FOUR-WHEELED TROLLEYBUSES

Of the fifty trolleybus systems to operate in the UK, there were some thirty-five still working during the Second World War, and of these, twenty-four operators received the standard four-wheeled Karrier/Sunbeam W4 Ministry of War Transport-designed trolleybuses with BTH 85-hp motors. Belfast, despite being a virtually new system with a fleet of 102 six-wheeled trolleybuses, was allocated a total of fourteen wartime trolleybuses.

The Corporation only received two Sunbeam W4s built to full wartime specification. These were numbered 129 and 139, but were allocated new registration marks despite the reserved ones for the twenty-six AEC 664Ts not at that time being used. These two Sunbeam W4 trolleybuses were the thirty-eighth and thirty-ninth of this type of chassis to be built and were fitted with Park Royal H30/26R bodies, with wooden-slatted seats and only one pair of half-drop, opening, saloon side windows. This pair of vehicles appears to have been bodied some months before they were delivered in December 1943, as their Park Royal body numbers follow on from a pair of similar vehicles delivered to Maidstone Corporation as their 54 and 55 in June 1943. These first two wartime trolleybuses were fitted with traction batteries. They were rebuilt in the early 1950s, even acquiring post-war Harkness-style windscreens, but they could always be distinguished by the angled front side cab window. They spent most of their lives at Short Strand depot moving from Falls Park after about 1950. They had long lives for a non-standard type and survived until 1958.

The second batch consisted of twelve further Sunbeam W4s, but these entered service in May 1946. They were purchased to provide extra trolleybuses to cover for the increased demand on the trolleybus fleet when the first new post-war route to Bloomfield was opened on 6 May 1946. By this time, many of the more stringent body-construction regulations had been relaxed and so these trolleybuses had semi-utility bodies built by Harkness. These attractive bodies were fitted with fully upholstered seats and a full set of sliding saloon ventilators. Unlike the Park Royal-bodied utilities, the Harkness-bodied Sunbeam W4s were never rebuilt, being withdrawn between 1958 and 1960.

There are no known photographs of the following from this class: 131, 132, 139

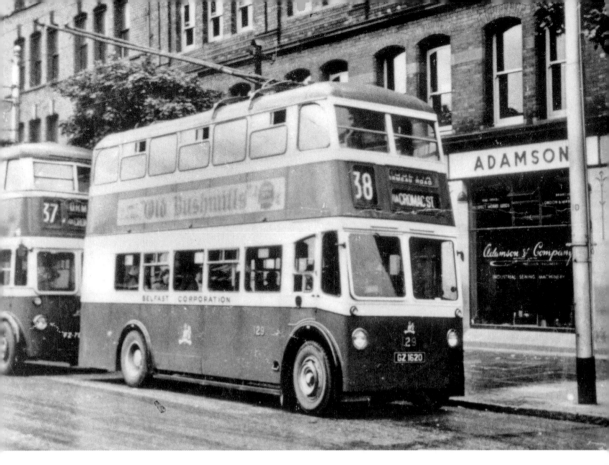

Seen after it had been built with rubber-mounted saloon glazing, although differently executed in each saloon, is the first of the pair of Park Royal-bodied Sunbeam W4s. 129, (GZ 1620), stands in Victoria Square outside Adamson's industrial-sewing-machine showroom. It is working on the 38 shortworking along Ormeau Road, which went as far as the traffic island at Rosetta. (M. Corcoran)

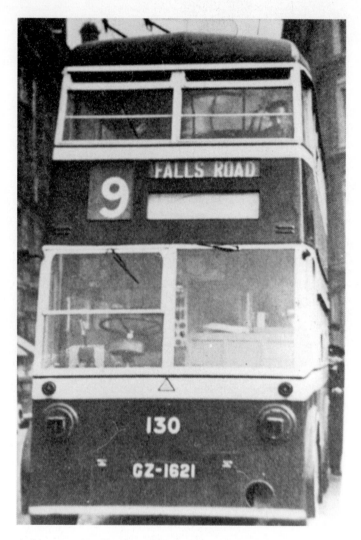

Photographs of the pair of Belfast's Park Royal-bodied Sunbeam W4s in their original, as-delivered condition are rare. Standing in Castle Street in 1944 with all the necessary blackout markings and headlight masks is 130, (GZ 1621). The original destination display for the 9 route was simply shown as Falls Road, even though the original terminus was beyond that at the reverser at Fruithill Park, just over a quarter of a mile beyond the Belfast boundary in Andersonstown Road. It was only in 1951 that the more familiar number 12 was introduced. (D. R. Harvey Collection)

Some years later, after being extensively rebuilt, 130, (GZ 1621), stands in Short Strand depot yard in front of some others of the class. The windows in the upper saloon have been totally remounted in rubber and the frugal numbers of original half-drop windows have been replaced in both decks by 'sliders'. In addition, the front windows are now fitted with half-drop, opening ventilators and the front-dome side window frames have been restyled. A further update included the fitting of a windscreen similar to the type fitted to the early post-war Harkness-bodied six-wheelers. (D. A. Jones)

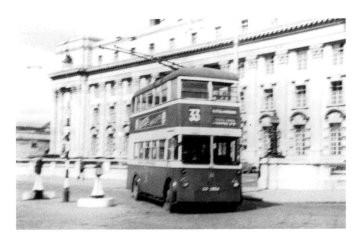

Turning right from May Street into Victoria Street is semi-utility four-wheeler 133, (GZ 2804). Towering over the trolleybus is the Royal Courts of Justice building, which dates from 1933. Similarly grandiose, imperial-style municipal buildings from the interwar period can be found in civic centre schemes in Birmingham and Cardiff and frequently looked out of place in what was essentially a late-Victorian city centre. The speeding Harkness-bodied Sunbeam W4 is working on the 33 route to Cregagh probably not long before the cross-city service to Carr's Glen was introduced on the last day of April 1951. (A. J. Douglas)

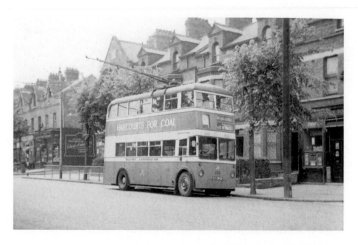

Falls Road was originally a country lane that led out towards Derriaghy, Lambeg and Lisburn. The Lower Falls area was that inner-city section between Divis Street and Grosvenor Road developed in the nineteenth century with the construction of several large linen mills. As the population grew, so did the need for housing, and around the mills grew an extensive network of small, mean, terraced, back-to-back housing in narrow streets named after recent battles in the Crimean War. As the town expanded, so the better-quality, later housing developed in the Upper Falls area, particularly around the staggered junctions at Donegall Road and Whiterock Road. Facing towards the city centre, just beyond the corner of Rockville Street where Charles Quinn's chemist shop is located, is trolleybus 134, (GZ 2805). This is one of the Harkness-bodied Sunbeam W4s of 1946 and is preparing to work back to the depot in Haymarket. This would suggest that this is well after 1947 when the Falls Park depot ceased to be a running shed for trolleybuses. (C. Carter)

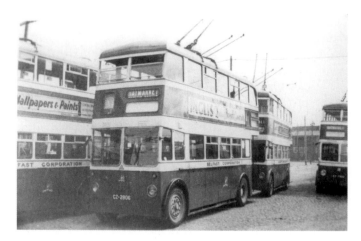

With two unidentified members of the same class in front and behind it is 135, (GZ 2806). This Harkness-bodied Sunbeam W4 is standing in Haymarket depot yard in the mid-1950s. The Harkness wartime body was built on wartime Daimler CWA6s and on rebodied pre-war AEC 'Regent' 661s and Leyland 'Titan' TD1s, so these were the only ones built on trolleybus chassis. It was an attractive-looking body, but despite entering service in May 1946, still had the 'lobster-shell' rear dome that had generally been replaced some eighteen months earlier by more-rounded versions by other UK body manufacturers. Parked on the right is Leyland TTB4 prototype six-wheeler 12, (EZ 7906). (D. R. Harvey Collection)

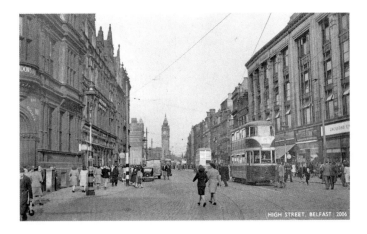

Belfast's own 'leaning tower' is the 113-foot-tall Albert Memorial Clock Tower, which stands at the River Lagan end of High Street in Queen's Square. It was completed in 1870 as a memorial to Prince Albert. It was built on reclaimed alluvial mud and gravel on the River Farset, a tributary of the Lagan, and as a result, over the years, it began to subside with a tilt of 4 feet off the perpendicular. In 2002, its restoration was completed and the angle of the tilt has been partially reduced. Travelling towards Castle Place is McCreary tramcar 423. It is passing the 1929 building occupied by Burtons and Woolworths. Just visible behind it is trolleybus 136, (GZ 2809), one of the twelve 1946-vintage Sunbeam W4s with Harkness 'semi-utility' fifty-six-seater bodies. (Commercial Postcard)

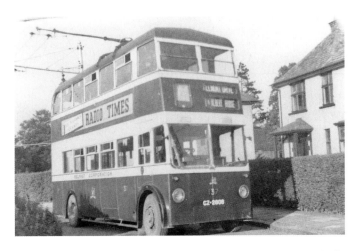

With the long afternoon shadows of the trolleybus encroaching over the hedge, the Belmont Drive turning circle is being occupied by 137, (GZ 2808). This Sunbeam W4 with a Harkness UH30/26R body had arrived in this suburban turnback after working on the 27 route via Albert Bridge. If these semi-utility bodies built by Harkness had a design fault, it was that the top of the windscreen seemed a little low, thus restricting the driver's view of the overhead. (W. J. Haynes)

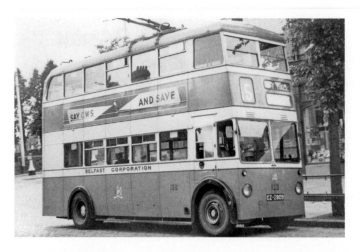

A parked semi-utility Sunbeam W4, 138, (GZ 2809), stands in Falls Road before departing for City Hall. The crew are sitting in the lower saloon of the trolleybus waiting for their time of departure to come round. It has worked on the fairly unusual 15 shortworking to the city cemetery in Falls Road, where it has just turned round in the throat of Whiterock Road. On the front of the vehicle, just below the windscreen, is the triangular Sunbeam badge with a red rising sun and radiating rays. The offside front wheel has a large nut-guard ring which was designed as a step to aid the driver's entry into the cab. (R. Marshall)

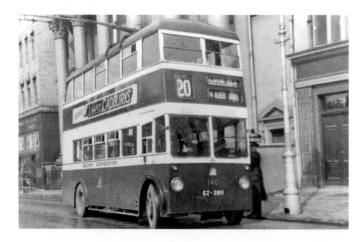

Loading up in Donegall Place East is Harkness-bodied Sunbeam W4 140, (GZ 1811). It is about to leave on the 20 route to Bloomfield, though the inspector standing at the nearside of the trolleybus might be having other ideas! These four-wheelers were purchased for the opening of the Bloomfield route in 1946. After the entry of all the Guy BTXs by 1949, these fifty-six-seat four-wheelers tended to be used on the shorter routes, peak-time services, and shortworkings. (W. J. Haynes)

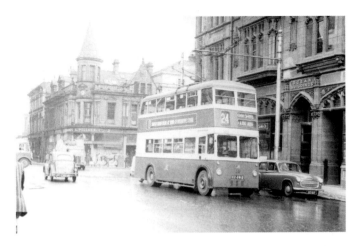

On 9 September 1957, four-wheeled trolleybus 141, (GZ 2812), travels past the Ocean Buildings in Donegall Place East. It is working on a depot-only journey back to Short Strand. The Harkness-bodied Sunbeam W4 is overtaking a parked, 1956-registered Hillman Minx Phase VIII saloon, while following the trolleybus is a Karrier Bantam articulated lorry, a type of small lorry so frequently found plying between the docks area and the city centre. (D. Battams)

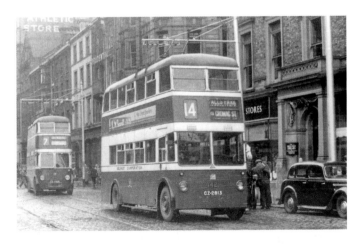

Loading up passengers outside Belfast's Linen Hall Library in Donegall Square North in 1951 is 142, (GZ 2813), the last of the twelve Harkness-bodied Sunbeam W4s, which was, by this time, some five years old. The four-wheeled trolleybus is overtaking a rather rare Singer Super Twelve 1525 cc four-door saloon dating from 1948 of which only 1,098 were ever built. 142 is working on the Falls Park 14 service, which turned back at the depot at the junction with Glen Road. Following behind the four-wheeler is AEC 664T 83, (FZ 7868), working on the newly introduced 7 route to Greencastle on a rainy day in 1951. The Linen Hall Library was built in 1864 as a linen warehouse for a company called Moore and Weinberg. When the Georgian White Linen Hall site was acquired for the construction of the proposed City Hall, which is opposite trolleybus 142 to the left, the library contained in the old building was moved into the Moore and Weinberg building; thus the Linen Hall Library name. (A. B. Cross)

CHAPTER FOUR

POST-WAR GUY BTXS

The first post-war trolleybus order to be placed was with Guy Motors in 1946 for seventy of their BTX six-wheelers. They had GEC 100-hp motors and electrical equipment and were the only post-war BTXs to be constructed at Fallings Park, Wolverhampton. In fact, Guys only manufactured another fifty post-war trolleybuses, these being the four-wheeled BT model vehicles for Wolverhampton Corporation. Guy Motors then took over the construction of Sunbeam trolleybuses after September 1948 and stopped making their own BT and BTX models soon afterwards. The Belfast BTXs were 8-foot-wide and were fitted with Harkness H36/32R bodies on Metal Section frames, which were manufactured in Oldbury. The first BTX to be delivered was trolleybus 104, which arrived in October 1947, while 186, numerically the final member of the batch, was also the last one that entered service in June 1949. The first twenty-six of these trolleybuses took both the fleet numbers and registrations of the same number of AEC 664Ts which were cancelled by the MoWT in 1940. Thus, the batch was divided into two batches with 103-128 having the FZ registrations, while the second group were numbered after the fourteen wartime four-wheelers as 143-186 with post-war GZ registrations.

The seventy Guy BTXs generally had long lives and operated successfully all over the system. Thirty-three of the batch were withdrawn during 1964 after the closure of the Stormont, Dundonald, Cregagh and Bloomfield routes, but this also included 174, which was burnt out in the Divis Street riot during the General Election campaign on 1 October 1964. Withdrawals continued apace during the next three years, leaving twelve to survive until the closure of the Belfast system on 12 May 1968. Three of the class are preserved. 112 is magnificently restored at the Ulster Folk & Transport Museum at Cultra, while 168, which was so active during the last week of operation and was the trolleybus that closed the Belfast system, is owned by the National Trolleybus Association. 183 survives under cover at Howth, near Dublin at the Transport Museum of Ireland.

There are no known photographs of the following from this class: 111, 171.

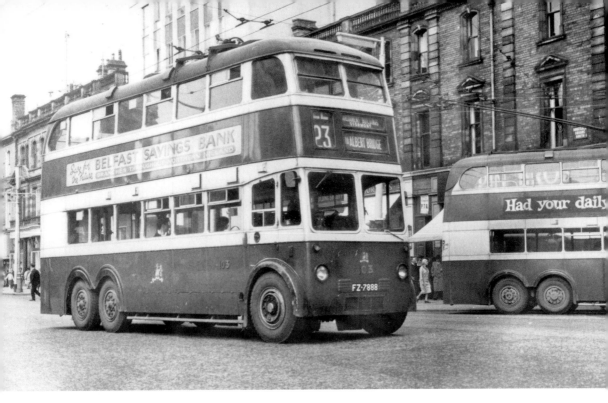

Guy BTX 103, (FZ 7888), numerically the first of the big Harkness-bodied post-war six-wheelers, travels across the maze of wiring in Donegall Square North as it moves towards Chichester Street. This sixty-eight-seater is working on the 23 route and is displaying the full route destination blind, showing 'PARLIAMENT BUILDINGS STORMONT'. On the right, an AEC 664T is turning in front of Gilpin Brothers tailors shop into Donegall Place. (D. R. Harvey Collection)

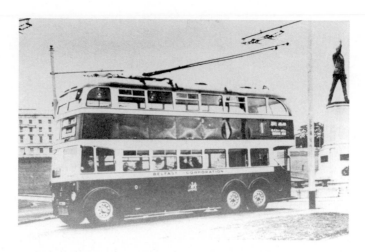

The first of the seventy Guy BTXs to enter service was 104, (FZ 7889), which arrived on 1 October 1947, which was nearly six months before the next one of the class arrived. This official Belfast Corporation publicity photograph shows 104 in the grounds of Stormont alongside the statue of Lord Carson, with a number of the transport committee on board, including a passenger in the cab. As none of Belfast trolleybuses had nearside cab doors, anyone travelling, quite illegally, in the cab would have had to clamber across from the driver's seat. What is surprising and slightly worrying on this brand-new trolleybus is the number of panels between the decks that are rippled. (D. R. Harvey Collection)

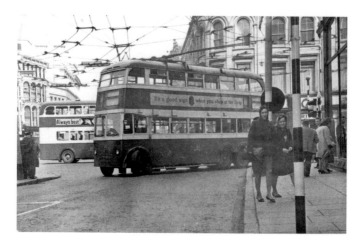

The centre of all of Belfast's municipal transport operations was Castle Place. This was at the junction of Royal Avenue, from where the Harkness-bodied Guy 'Arab' III has emerged, Donegall Place on the right and Castle Street, into which the trolleybus, 105, (FZ 7890), is turning. Tight turns such as this one only emphasised the length of these six-wheelers. This Harkness-bodied Guy BTX is not displaying any destination in the boxes suggesting that it is about to take up duties on one of the Falls Road services. (D. R. Harvey Collection)

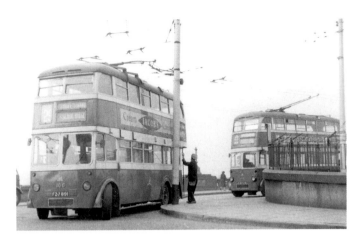

Turning left off Albert Bridge into Short Strand on 27 April 1962 is a pair of trolleybuses returning to their depot. The conductor of the leading trolleybus, Guy BTX 106, (FZ 7891), with a Harkness H36/32R body, is pulling the frog handle down in order to change the points on the overhead. In Belfast, trolleybuses going straight on or right just coasted across the frog, but left turns required either this type of activity from the conductor, or if it was an automatic frog, a solenoid was activated by the driver applying more power while applying the handbrake. About to undertake the same manoeuvre behind the Guy is AEC 664T 94, (FZ 7879). (C. W. Routh)

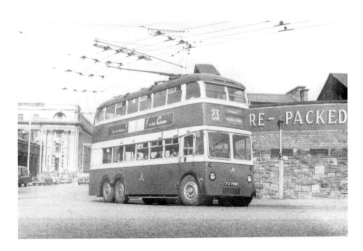

Guy BTX 107, (FZ 7892), is halfway around the turn from Oxford Street into East Bridge Street. This will take the trolleybus over Albert Bridge and on to the Parliament Buildings at Stormont. The outer set of wires was used for trolleybuses turning right into Haymarket depot. Behind the wall with the advertisement for 'Try Our Pre-Packed Meat' is the Aberdeen Meat Market, while behind the trolleybus on the corner of Oxford Street and May Street is the 1930s Royal Courts of Justice building. (R. F. Mack)

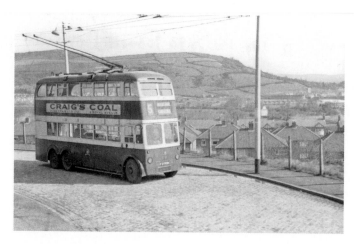

The turning circle for the Bellevue shortworking along Antrim Road was very useful, as it allowed trolleybuses to park opposite the entrance to Bellevue Zoological Park. The site was originally opened in 1911 as the Bellevue Pleasure Gardens, a public park with a Floral Hall on the slopes of Cavehill. The 12-acre gardens were opened by Belfast City Tramways as an inducement to Belfast's residents to use the company's new tramway along Antrim Road. The site was redeveloped during 1933, and the new zoo was opened on 28 March 1934 by the Lord Mayor of Belfast, Sir Crawford McCullough. When trolleybuses replaced the Antrim Road and Glengormley tram route on 24 January 1949, this new turning circle was positioned for trolleybuses returning from Glengormley or turning back to the city. It overlooks a steep drop down the hill towards the houses in Flora Road, Whitewell and the distant Shore Road at Whitehouse. Guy BTX, 108, (FZ 7893), stands on the cobbles of this picturesque spot in about 1964. (R. Symons)

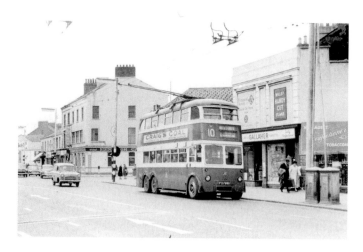

Passing Canning Street and the Edinburgh Castle public house opposite the NCC railway station in York Street is 108, (FZ 7893). This Harkness-bodied Guy BTX six-wheeler is parked outside the newsagent and tobacconist shop and is going out of the city centre on the 10 route to Whitewell in June 1964. Above it is one of the many electrical power input feeder cables under which the trolleybus driver would have to coast as otherwise the cab-mounted circuit breakers would blow in the cab and the vehicle would have to be stopped and the switches reset. (M. A. Sutcliffe)

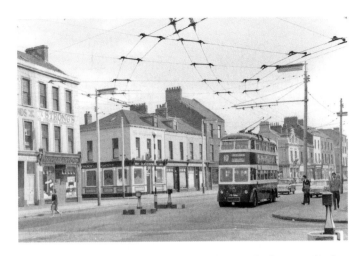

Looking from the corner of Brougham Street in a south-easterly direction back towards the city centre is Guy BTX 109, (FZ 7894), travelling along York Street on the 10 route to Whitewell and the Throne Hospital on 15 June 1964. The trolleybus wires turning in and out of Brougham Street took the 2, 4 and 6 trolleybus routes through to Duncairn Gardens where they turned right onto Antrim Road to terminate at Strathmore Park, Bellevue and Glengormley respectively. On the corner of Fleet Street is the Sportsman Arms, a hostelry originally known as the Cave Hill View Hotel, which, along with all the rest of these buildings, has long since been demolished during the Westlink A12 dual carriageway, which finally opened in March 1983. Westlink connects the M1 motorway to the south of Belfast with the M2 and M3 motorways to the north, but in doing so has removed great swathes of inner Belfast, including this section in York Street. (J. C. Gillham)

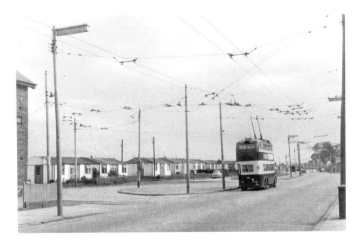

On 15 June 1964, Guy BTX trolleybus 110, (FZ 7895), passes the Fort William turning circle in Shore Road as it travels into the city. The turning circle was just beyond the former Shore Road tram depot and this turnback was given the route number 8. Behind the turning circle is the long row of prefabs, which were built in the late 1940s. On the rear of the Harkness-bodied trolleybus by this time, the destination boxes have been removed so, from the back, it is impossible to know on what route the vehicle is working. The vehicle has, in common with all the Belfast fleet, a large letter T on the rear. (J. C. Gillham)

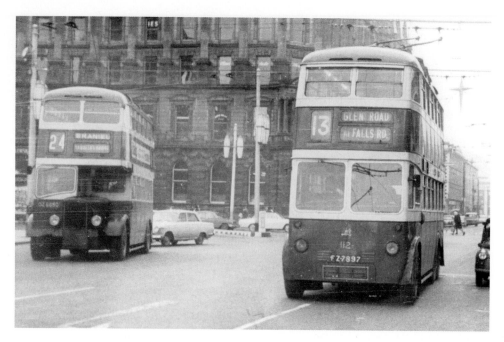

Above: The inbound 13 trolleybus route from Glen Road turned off Castle Street before turning right into Queen Street prior to going left into Wellington Place, which is behind the trolleybus, and straight on into Donegall Square North. Guy BTX 112, (FZ 7897), is about to turn left into Donegall Place and then left again at the end of this central shopping street back into Castle Street. This somewhat-battered-looking Harkness trolleybus was just another of the seventy Guys to enter service between 1947 and 1949, yet survives today as an immaculately preserved vehicle at the Cultra Folk & Transport Museum. On the left is bus 396, (OZ 6650), a Daimler CVG6 with a Harkness H30/26R body dating from 1953. It is working on the 24 service to the Braniel housing estate by way of Queen's Bridge. (A. J. Douglas)

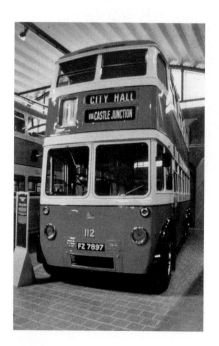

Left: It cost about £100,000 to restore 112, (FZ 7897), to this condition and it looks absolutely magnificent. Seen at the Cultra Folk & Transport Museum in May 1997, the Harkness-bodied Guy BTX looks as if it is ready to enter service, and so it is just such a pity that it hasn't got a set of overhead wires under which it could be operated! (D. R. Harvey)

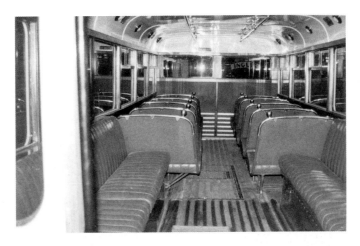

The interior of the lower saloon of Harkness-bodied Guy BTX was all red pleated leather and polished wood. With accommodation for thirty-two in the lower saloon, the long sideways-facing seats over the rear bogie wheels could manage, with a squeeze, six passengers on each side. The high bulkhead windows did restrict the view forward and certainly prevented enthusiastic little boys from watching the driver perform in his cab. (M. Maybin)

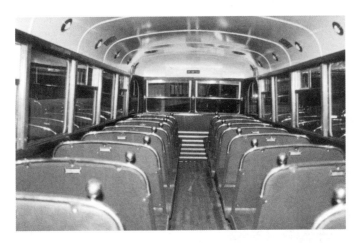

The upper saloon was much to the same quality as the downstairs. Typical of Belfast's trolleybuses was the lack of grab poles, but each seat did have a grab knob. The front body pillars in the first bay were thicker than those elsewhere, and just visible at the rear of the single-skinned front dome is an extension into the ceiling of the wooden pillar covers that hid the electrical cabling taking the power from the trolleypoles down through the cab eventually to the electric motors. Notice the match strikers on the back of every upper-saloon seat, redolent of a different age. (M. Maybin)

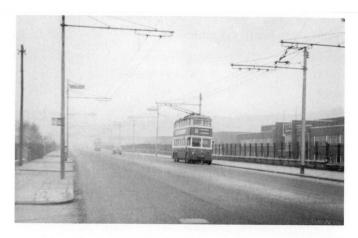

Travelling along Castlereagh Road on the 31 service is Harkness-bodied Guy BTX 113, (FZ 7898). It is standing in the long siding outside the Triang toy factory, which was one the early post-war factories built by the Northern Ireland Government in an attempt to diversify and increase employment in the province. The anticipated 'boom' was hardly heard and this section of double wiring was rarely used to park trolleybuses waiting for the factory whistle to sound. Today, the premises are part of the Castlereagh Industrial Estate and are occupied by Sangers (NI) Ltd, who supply pharmaceutical and health products to pharmacies across Northern Ireland. Originally, the company was founded as Thomas McMullan and Co. as a retail pharmacy operating from Victoria Street in Belfast in 1881. (D. R. Harvey Collection)

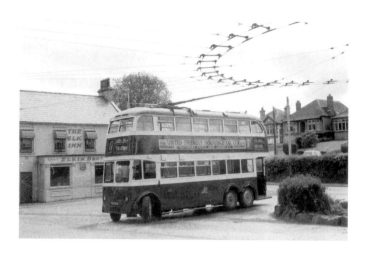

The turning circle at the Dundonald terminus was an exceedingly tight one. The trolleybuses forked off Upper Newtownards Road and turned into Comber Road. They then immediately turned onto the forecourt of the nineteenth-century Elk Inn and continued this loop back into Upper Newtownards Road pulling up to the stop just beyond the junction. Here, a freshly repainted trolleybus, 113, (FZ 7898), is undertaking this manoeuvre before returning to Belfast via Albert Bridge as a 17. (J.Shearman)

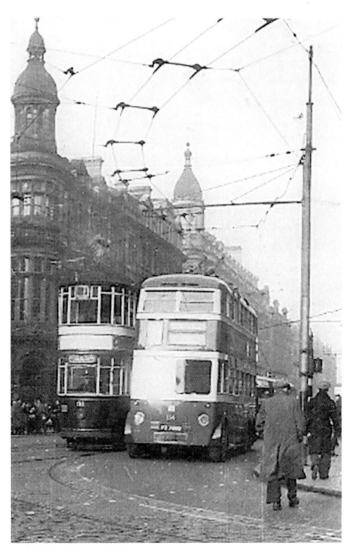

Waiting to turn left from Royal Avenue into Castle Place in about 1948 is Guy BTX 114, (FZ 7899), whose dent-free Harkness-body contrasts with the tram alongside it. It has come into the city from Glengormley along Antrim Road. This trolleybus is in pristine condition, as it is virtually brand new. Travelling out of the city in Royal Avenue, it is totally enclosed tram 31, which was one of the rebuilt Brush-bodied former open-top tramcars dating from 1905. (A. Ratcliffe)

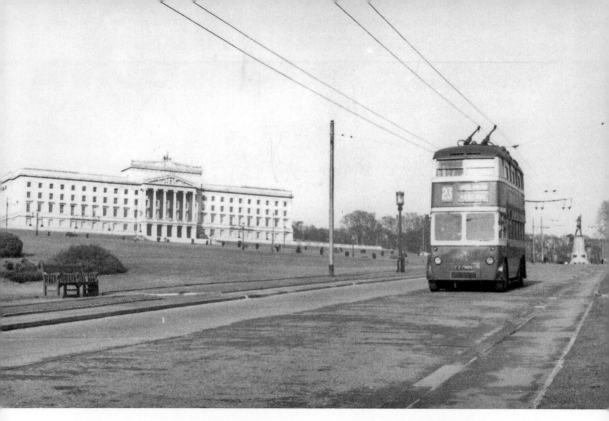

The impressive location of the Parliament Buildings at the top of the hill at Stormont, dominated a huge area of landscaped gardens. The building, opened by Edward, Prince of Wales on 16 November 1932, was designed by Sir Arnold Thornley in the Greek Classical style and fronted in Portland stone. Although it looks white, since the Second World War, it has always seemed slightly dull. This was because it was camouflaged with supposedly removable 'paint' made of bitumen and manure! Unfortunately, after the war, removing the paint proved to be very difficult, with the paint having scarred the stonework. It took seven years to remove the worst of the paintwork, and as recently as 2007, another attempt was made to restore the building's original white colouring. During the Second World War, the building was used by the RAF to co-ordinate the allied activity in the Atlantic Ocean, and it was from here that the attack and eventual sinking of the Bismarck was planned and co-ordinated. Guy BTX 115, (FZ 7900), travels down the hill from the distant statue of Lord Castle towards the Massey Avenue Gates while working back to the city in April 1962 on the 23 route by way of Albert Bridge. (C. W. Routh)

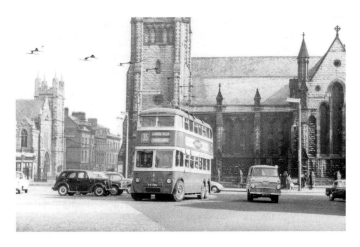

Turning through Carlisle Circus in April 1962 is 8-foot-wide, Harkness-bodied Guy BTX trolleybus 116, (FZ 7991), which is working on the 35 route to Carr's Glen. It is turning right into the lower part of Antrim Road and is being passed by a Thames 15-cwt van. The trolleybus has climbed up Clifton Street from York Street along a thoroughfare lined with high-quality, Victorian professional chambers and St Enoch's Presbyterian church of 1871. Towering over the 8-foot-wide trolleybus is the Carlisle Memorial Methodist church, which was designed by W. H. Lynn in a High Gothic style and was completed in 1875. (D. F. Parker)

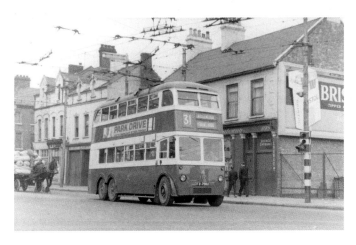

Guy BTX 117, (FZ 7902), one of the Harkness H36/32R bodied trolleybuses dating from April 1948 is about to cross the traffic lights in Bridge End and turn right into Mountpottinger Road on its way towards Castlereagh Road. Behind the trolleybus is a heavily laden horse-drawn cart that looks as if it has plodded its way up from the docks. Even at this late date, 25 April 1962, horse-pulled wagons were frequently seen on the streets of Belfast. The trolleybus is passing the Gateway lounge bar at 108 Bridge End, long-since demolished as part of the Queen Elizabeth II Bridge scheme. (C. W. Routh)

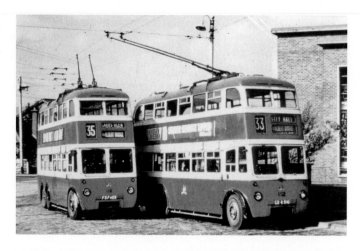

The two Guy BTXs stand on the cobbles at the Cregagh terminus outside Castlereagh Borough Council's office building. On the left is 118, (FZ 7903), which is already prepared to return across the city to Carr's Glen. On the right is 152, (GZ 8516), whose only distinguishing feature when compared to the trolleybus on its right is that it has managed to retain its Guy Motors badge mounted just above the front fleet number. (D. R. Harvey Collection)

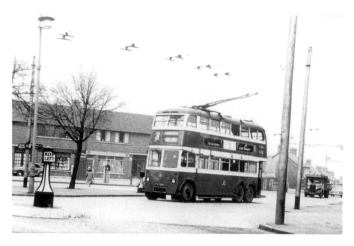

The Bloomfield terminus of the 30 route was at a traffic island where Bloomfield Road met North Road and Grand Parade. The trolleybus turning in front of the row of 1950s shops is Harkness-bodied Guy BTX 119, (FZ 7904), during April 1962. As usual at trolleybus termini in Belfast, 119 is going all the way round the traffic island without passengers and will return to the pick-up point in Bloomfield Road roughly opposite the approaching Bedford O-type lorry. (D. R. Harvey Collection)

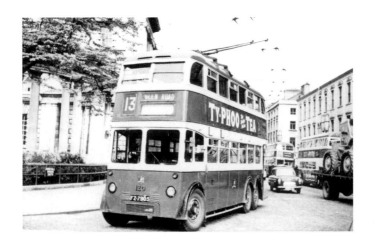

Turning from Donegall Square South into Donegall Square West around the rear of City Hall is trolleybus 120, (FZ 7905). Carrying an advertisement for Typhoo Tea, this sixty-eight-seat Harkness-bodied Guy BTX is going to take up duties on the 13 route to Glen Road. Just visible is one of the Daimler 'Fleetline' CRG6LXs with seventy-seven-seat MH Cars bodywork, which were purchased in order to replace trolleybus services on the east side of Belfast. This 1948-built trolleybus, unlike a large number of these Guys, would survive the wiping out of the County Down-side trolleybus routes and remain in service until 7 February 1966. (G. Stainforth)

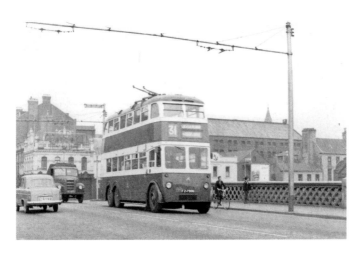

Travelling out of the city centre is Guy BTX 121, (FZ 7906). The trolleybus is just beginning to cross Queen's Bridge in an easterly direction, easily recognised by its lattice metal work on the balustrades on both sides of the bridge. Behind the Harkness-bodied six-wheeler is Donegall Quay, which led along the west side of the Lagan and on towards the berths for the cross-Irish sea ferries. Following behind the trolleybus, which is working on the 31 service to Castlereagh, is a Fordson Thames ET6 4D lorry. (G. Stainforth)

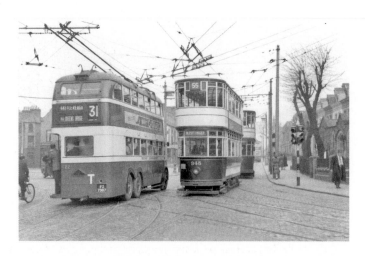

Travelling out of the city and crossing from Mountpottinger Road into Castlereagh Street is Guy BTX 122, (FZ 7907), when still fairly new and working on the 31 service. The Harkness body still has its fleet name on the waistrail while displaying a large destination display at the rear. The broken-white cream band below the emergency window has yet to be painted out while the rear dome is in red rather than the later matt green used to disguise the unsightly grease drips coming from the trolleyheads and the overhead wires. Beneath the large T at the bottom of the bus is the end of the tube that carried the trolleypole. This was a much better place to store it than the exposed position on hooks over the nearside waistrail as on the earlier AEC 664T six-wheelers. Returning to Mountpottinger depot is tram 345, one of the fifty Brush, totally enclosed 'Chamberlain' trams mounted on Maley & Taunton 8-foot trucks dating from 1930 and is passing Mountpottinger Presbyterian Church. (R. W. A. Jones)

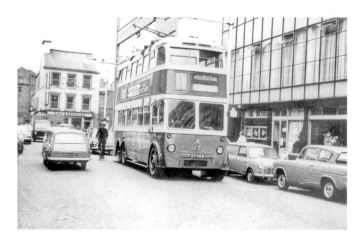

Travelling along Queen Street, where nearly thirty years earlier the opening procession of fourteen trolleybuses had queued, is Guy BTX six-wheeler 123, (FZ 7908), which ran for its last years with a rather battle-scarred nearside front wing. This trolleybus is working on the 11 route to Whiterock Road in April 1965. The Whiterock route was the final trolleybus route to open in the city in 1959, when it was numbered 45. Trolleybus 123 has just passed the 1960s Westgate House, which is still in use at the time of writing, though the newer building behind the Ford Anglia 105E was demolished some years ago. Behind the trolleybus is The Hercules public house opened originally in 1875 and renamed in 1901, taking its name from Hercules Street, now known as Royal Avenue. It is still today one of the best traditional public houses in Belfast's city centre. (D. R. Harvey Collection)

118

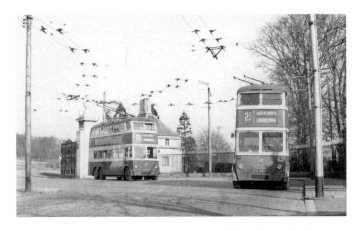

On 25 April 1962, the trolleybus parked in the turning circle at the end of Massey Avenue is 124, (FZ 7909), while coming through the Massey Gates from Stormont is 161, (GZ 8525), a similar Guy BTX with a Harkness H36/32R body. Both vehicles are working on the 23 route. The only difference between them was that 124 inherited one of the 1940 registrations reserved for the twenty-six AEC 664Ts that were cancelled by the MoWT. Massey Avenue was named after William Ferguson Massey, who was born in Limavady in 1856, and after his family emigrated to New Zealand in 1870, he became Prime Minister in 1912 until he died in office in 1925. This road looked as if it was a thoroughfare of some importance, yet it petered out at the side gate to the Parliament Buildings, which were locked at night, thus making Massey Avenue a cul-de-sac. (C. W. Routh)

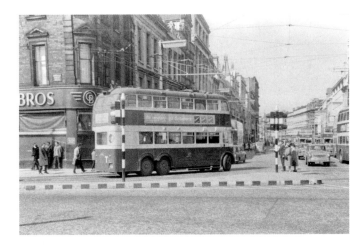

Turning into Donegall Place from Donegall Square North in front of Gilpin Brothers gentlemen's outfitters is Harkness-bodied Guy BTX 125, (FZ 7910). The trolleybus is almost certainly working on one of the Falls Road routes. The sad fact, if one is an enthusiast of trolleybuses, is that this is the only trolleybus in view and all the other buses are Daimler 'Fleetlines' with MH Cars bodies, which would eventually replace the big six-wheelers. (R. Symons)

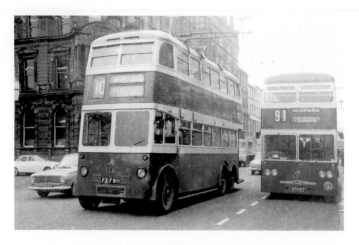

Overtaking bus 570, (570 EZ), is Harkness-bodied Guy BTX six-wheeler 126, (FZ 7911). The MH Cars-bodied Daimler 'Fleetline', 570, (570 EZ), serves as an interesting contrast to the trolleybus. Although both are 30 feet long, the compact rear-engined bus could seat seventy-seven passengers while the much bigger trolleybus could only manage sixty-eight people. The trolleybus is working on the cross-city 10 route along Shore Road to Whitewell having come into the city centre from the Falls. The rather square-bodied 'Fleetline' whose body frames, like the trolleybus, were supplied by Metal Sections of Oldbury, is going to Oldpark on the 91 route. This terminus was actually in Cliftonville Road, which it reached by way of Crumlin Road and was a shortworking of the service to Carr's Glen. (A. J. Douglas)

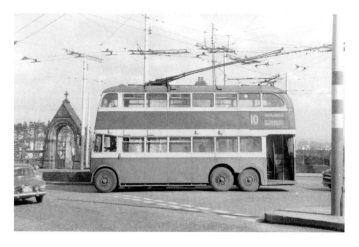

A very dusty-looking Guy BTX trolleybus 127, (FZ 7912), is working on the 10 route to Whitewell. It is negotiating the traffic island in Falls Road. Behind the trolleybus is the impressive gateway into the Milltown Cemetery, which is opposite the Falls Park depot. The Renault Dauphine on the left has entered Falls Road from Glen Road. The trolleybus has come in from the Casement Park Gaelic football ground turning circle in Andersonstown. (M. Corcoran)

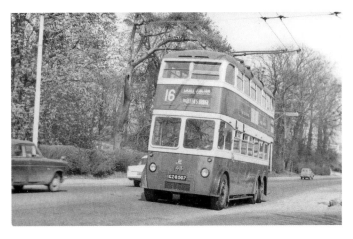

Just pulling away from the Elk Inn at the terminus of the 16 route at Dundonald is the first of the GZ-registered Guy BTXs. On the right is Comber Road into which the trolleybuses turned in order to gain the anticlockwise turning circle. 143, (GZ 8507), looking a little battered around the front mudguards, entered service on 3 January 1949. It is working on the 16 service back to the city centre by travelling the length of Newtownards Road and crossing the River Lagan over Queen's Bridge. (C. W. Routh)

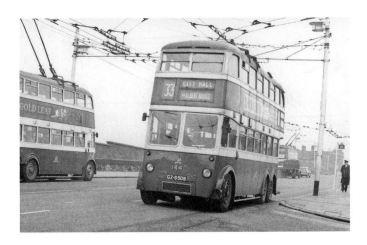

With the Belfast Electricity Department's huge power station, dating originally from 1898 in the background, trolleybus 144, (GZ 8508), has just crossed the railway bridge in East Bridge Street, where today's Belfast Central railway station is located and is passing the entrance to Turley Street. Both these trolleybuses had Harkness H36/32R bodies that were virtually identical, though the ones fitted to the BUTs sat slightly lower on the chassis. The trolleybus is travelling into the city from Cregagh, but as it is only going as far as City Hall, it is displaying the 33 destination rather than the 35 service number if it were to be continuing across the city to Carr's Glen. (R. F. Mack)

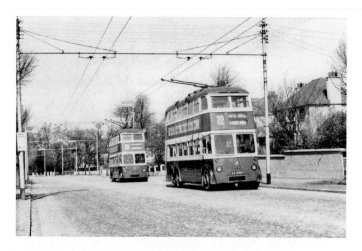

A pair of Harkness-bodied Guy BTXs, 145, (GZ 8509), and 149, (GZ 8513), travel away from Stormont along Massey Avenue when both are being employed on the 22 route working back to the city centre. Although belonging to the same batch of vehicles, 145 entered service on 14 April 1948, while 149 began its operating life almost nine months later on 11 January 1949. This latter date was in time for the conversion of the Antrim Road routes from tram to trolleybus on 24 January, for which thirty-one of these Guys were placed in service. What it also showed was just how slowly Harkness were able to build and deliver buses, as they took twenty months to deliver the seventy Guy BTXs. (C. W. Routh)

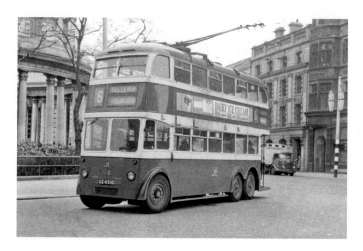

Guy BTX trolleybus 146, (GZ 8510), swings around into Donegall Square West with the Cenotaph and War Memorial at the rear of City Hall. It appears to be arriving into the city centre from Haymarket depot to take up duties on the Antrim Road shortworking to Bellevue. Other than the driver, the only occupants of this Harkness-bodied sixty-eight-seater are two crew members, which in normal service conditions, would have to be regarded as something of a luxury. (R. Symons)

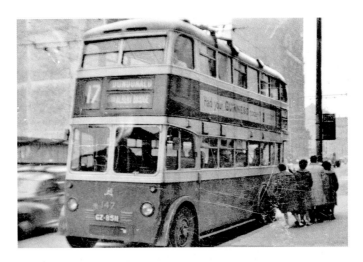

On a dull-looking day, 147, (GZ 8511), loads up with passengers in Chichester Street. It is working on the 17 service to Dundonald in about 1960. The Guy BTX trolleybus would leave the bus-stop and proceed to turn right in front of the Royal Courts of Justice into Victoria Street before turning left into East Bridge Street and then across Albert Bridge over the River Lagan. (D. R. Harvey Collection)

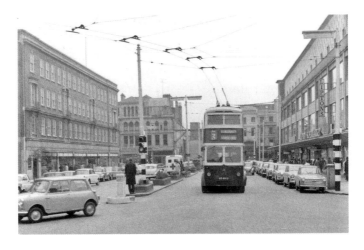

On 15 June 1964, trolleybus 148, (GZ 8512), is travelling on the 3 route along the short length of Bridge Street and is about to do a right-left dog-leg turn across Waring Street and into Donegall Street. Bridge Street was only wired for outbound trolleybuses working on the Antrim Road services towards Glengormley. It has come out of High Street at the end of the block of shops on the right. They were built in 1957 replacing buildings destroyed by the Luftwaffe on the night of 15 April 1941. (J. C. Gillham)

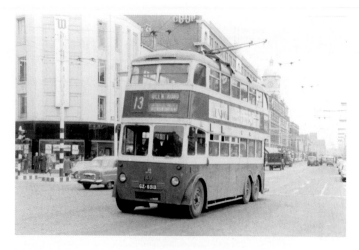

At one time, the shopping habits of many of the good folk of Belfast were dominated by the all-embracing Belfast Co-operative Society. Their headquarters was in York Street on the out-of-town side of Donegall Street and comprised a series of imposing buildings built between 1911 and 1932. The premises contained the head offices and drapery, outfitting, footwear, furniture, hardware, radio and television, jewellery, sports, pharmacy, optical, grocery, butchery, coal departments as well as the Orpheus restaurant and ballroom. Guy BTX 149, (GZ 8513), comes out of York Street and crosses the junction with Donegall Street with Woodhouse's furniture shop occupying a very Art Deco-style building. The trolleybus is working on the 13 route from Whitewell and will cross the city before going along the Falls and on to Glen Road. (D. R. Harvey Collection)

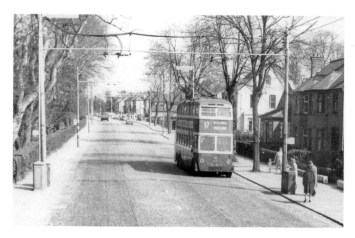

Having just passed Cabin Hill Gardens, Guy BTX trolleybus 150, (GZ 8514), pulls up to pick up passengers outside the little Knock Evangelical Presbyterian Church in Upper Newtownards Road on 27 April 1962. It is working on the 17 route to the City Hall by way of Albert Bridge. This route had been introduced on 8 March 1943 some four months after the first trolleybus conversion to Dundonald. The stop sign is a survivor from the days of the tram service. (C. W. Routh)

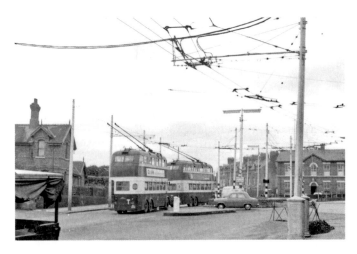

Located at the junction of Falls Road, to the left of Glen Road is Falls Park depot. Opposite the depot on the left is Milltown Cemetery. Although not a running depot for trolleybuses since 1938, it was still wired up for them, as it was the main overhaul works on the system. About to turn right into Glen Road on 15 June 1964 is an unidentified Guy BTX while behind it is similar Harkness-bodied 151, (GZ 8515), which is following the main route to Andersonstown. Trolleybuses could turn back to the city at this point as well as turning right into Divis Drive in order to gain the depot. (J. C. Gillham)

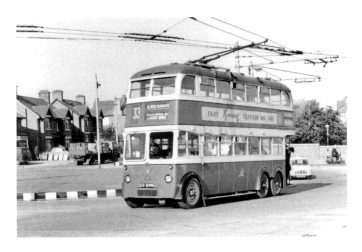

Turning around the Bell's Bridge Island in September 1963 is Guy TX 152, (GZ 8516). The Harkness-H36/32R-bodied trolleybus is being followed by a Morris Minivan. 152 is going to the terminus of the 33 route at Cregagh and is not going to use this, the only turnback point on the route, to return into the northern half of Cregagh Road, which the lorry is entering. This shortworking was given the number 34. On the extreme left near to the corner of Mount Merrion Avenue is the Bell's Bridge Stores, which survives today as an off-licence. (R. F. Mack)

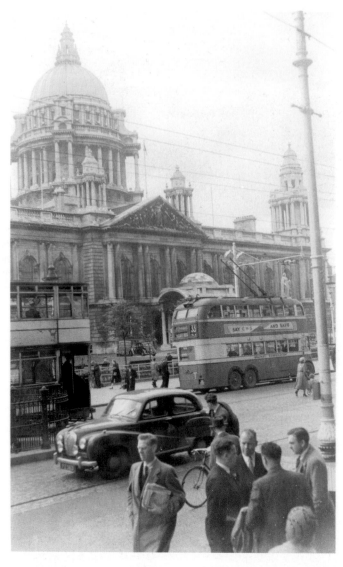

An almost new Austin A40 Somerset travels out of Donegall Square North towards Chichester Street in 1952. The imposing Belfast City Hall was completed in 1906 to the design of architect Sir Alfred Brumwell Thomas. This magnificent piece of Edwardian architecture is built in Portland stone in the Baroque Revival style. The building dominates Donegall Square with its 173-foot, lantern-topped copper dome and towers at each of the four corners. In the days before the clockwise one-way system was introduced, Harkness-bodied Guy BTX trolleybus 153, (GZ 8517), is picking up passengers outside City Hall while working on the newly introduced cross-city route to Carr's Glen. The trolleybus, carrying the national advertisement 'SAY CWS AND SAVE' is sharing the north side of Donegall Square with a soon-to-be-withdrawn four-wheeled 'Chamberlain' tramcar. (A. Ingram)

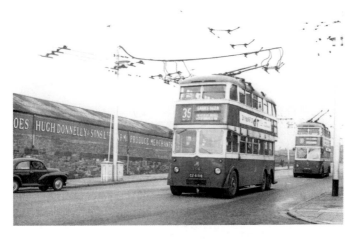

Having crossed over the distant Albert Bridge, two trolleybuses bound for the city centre travel down the slope of East Bridge Street towards Cromac Square. As the driver coasts beneath the overhead feeder cables in his Guy BTX six-wheeled 154, (GZ 8518), he is passing part of the May's Market complex. 154 is going to Carr's Glen on the northern side of the city and is being followed by 178, (GZ 8542), another Harkness-bodied Guy BTX, which is working on the 30 service from Bloomfield. (R. F. Mack)

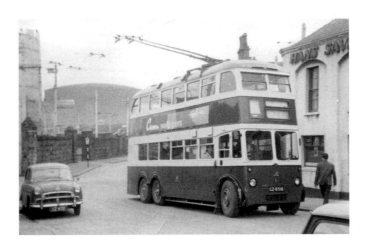

154, (GZ 8518), was chosen to be the tour vehicle for the National Trolleybus Association's visit to the Belfast system. Leaving Haymarket depot and turning into Turnley Street at the start of this NTA tour on Wednesday 13 April 1966, 154 had been given a good clean for the event, though a touch of black paint on the offside front mudguard wouldn't have gone amiss. 154 would survive until the closure of the trolleybus system on 12 May 1968 and was one of the trolleybuses offered to the NTA for preservation. In the event, 168 was chosen and 154 would be scrapped. (R. Symons)

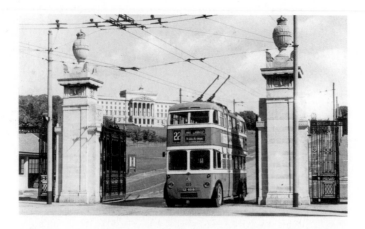

In the early 1950s, passing through the Massey Gates of Stormont, with the Parliament Buildings on top of the hill behind it, is trolleybus 155, (GZ 8519). It is leaving Stormont on the 22 route, having driven down one of the most impressive sections of trolleybus route probably in the world. The smartly presented Harkness-bodied Guy BTX is in its as-delivered livery with the full fleet name on the lower-saloon waistrail. (A. Ingram)

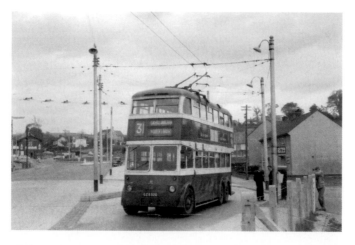

The terminus of the 31 route was just beyond Prince Regent Road on the opposite side of Castlereagh Road and just short of the distant junction with Knock Road. Trolleybuses did a normal right-hand turn into this tight turning circle, which still exists in front of the semi-detached house on the right. With its destination blinds set for the return journey back to Castle Junction in the city centre, Guy BTX 156, (GZ 8520), stands empty as its driver and conductor stand by the Bundy Clock waiting for their departure time to come round. (J. Shearman)

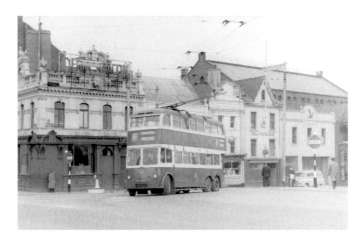

Turning out of Donegall Quay onto Queen's Bridge is Guy BTX 157, (GZ 8521), on 27 April 1963. Donegall Quay was an area of seamen's public houses, shipping lines and agents, temperance hotels and ship chandlers. A microcosm of this stands behind the trolleybus with the Red Dragon public house on the corner of Ann Street on the left, while behind the six-wheeler is The Red Star Bar. The gabled three-storey building belongs to J. Tedford & Co., who was a ship chandler and sail maker who moved into Donegall Quay in 1855. The trolleybus is working on the 16 route to Dundonald. (C. W. Routh)

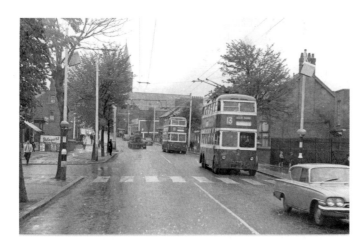

Dropping down the valley of Clowney Water as it is about to pass Iveagh Drive on the right is 158, (GZ 8522), a Harkness-bodied Guy BTX. It is behind a speeding Ford Consul Classic 315 saloon that is heading towards Belfast cemetery. The trolleybus coming out of the city centre is working on the 13 route to Glen Road. At the top of the hill is the former Broadway Presbyterian Church, which in the early 1960s still had its spire on top of the square tower. Today, the church building and its associated George Thomson Memorial Church Hall are used as a local advice centre. (D. R. Harvey Collection)

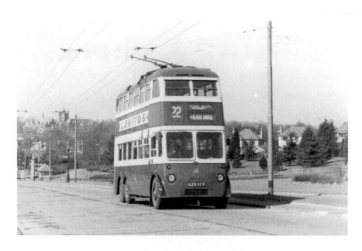

Powering up the steep hill from the Massey Gates and passing the first area of formalised ceremonial gardens is another of the Harkness-bodied Guy BTX trolleybuses. 159, (GZ 8523), is working towards the terminus behind the Stormont Buildings on the 22 route. In the distance, on the hillside above Massey Avenue is Campbell College founded in 1894 by a linen-trade magnate, one Henry James Campbell. Until the 1970s, it was a boarding school for boys. One of its claims to fame is that Samuel Beckett, the playwright, briefly taught at the school during 1928. (D. R. Harvey Collection)

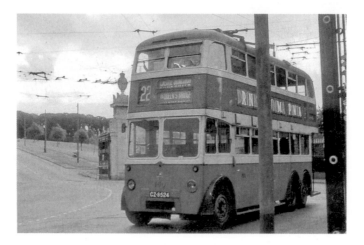

With some children sitting in the front upstairs seats of the trolleybus, 160, (GZ 8524), waits at the turning circle in Massey Avenue with the drive beyond the ornamental gates climbing up the hill through the well-manicured gardens of Stormont. The crew appears to be taking a break, so it is likely that the trolleybus has turned round here rather than gone all the way to the Parliament Buildings. (G. Lumb)

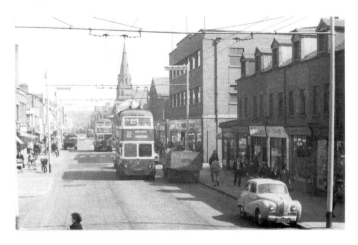

Travelling through the then busy shopping centre in Newtownards Road when working on the 22 route from Stormont is trolleybus 161, (GZ 8525). This Guy BTX with a Harkness H36/32R body is travelling into the city and has just passed Montrose Street and the Victorian Megain Presbyterian Church with its Gothic spire. Alas, today, this part of Newtownards Road is no longer a thriving shopping centre. Behind the trolleybus is bus 504, (GXV 787), a Daimler CWA6, which, as its registration cannot disguise, was formerly London Transport's D56. It arrived in Belfast in October 1953 but was placed in store until 1955 when it was rebodied by Harkness in the same body style as the 211-234 class of BUT 8641T trolleybuses. 504 remained in service until October 1970. (R. F. Mack)

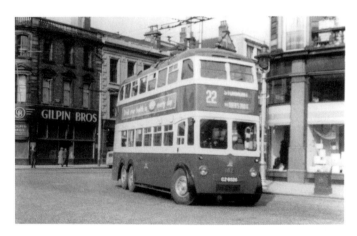

An immaculately painted trolleybus turns out of Donegall Place into Donegall Square North with the impressive Robinson & Cleaver's department store of 1888 on the right. 162, (GZ 8526), a Harkness-bodied Guy BTX is working on the 22 route to Stormont in about 1956 and will continue into Chichester Street before crossing the Lagan by way of Queen's Bridge. These six-wheeled trolleybuses always looked so much better when they had their wheels painted silver. (F. W. Ivey)

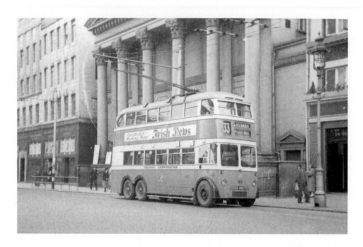

The cross-city 33 route to Cregagh had its main pick-up point in the centre of Belfast in Donegall Square East. Parked in front of the 1850 Wesleyan Methodist Church is Guy BTX trolleybus 163, (FZ 8527). This Harkness-bodied sixty-eight-seater trolleybus is in its original condition, even to the extent of still having its original trafficator arms, and is carrying an advertisement for the Irish News. This newspaper was launched on 15 August 1891 as the only independently owned daily with a moderate Irish Nationalist standpoint and is still being published in the twenty-first century. (C. Carter)

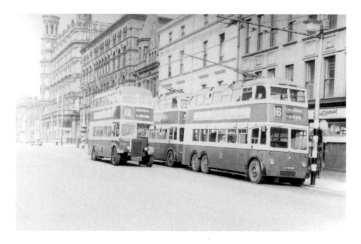

Two trolleybuses stand in Chichester Street just beyond Callender Street on Sunday 8 September 1957. The tall building above the motor bus is the former Richardson Sons & Owden's linen warehouse, built in 1889, which is now owned by Marks & Spencer. The leading trolleybus is Guy BTX 164, (GZ 8528). This is about to go to Dundonald on the 16 route. The former London Transport Daimler CWA6 going to Cherryvalley on the 76 route is 506, (GYE 65), which had formerly been LTE D75, but having survived V weapons in the capital, ironically fell victim to riot damage on 28 June 1970 at Ardoyne garage. (D. Battams)

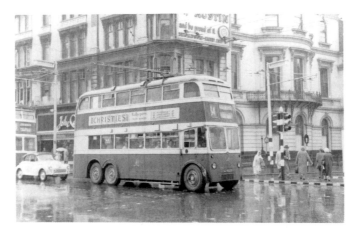

On Tuesday 23 July 1963, during a heavy shower, coming out of Royal Avenue and crossing Castle Place is trolleybus 165, (GZ 8529), which has come from Carr's Glen and is going only as far as Bell's Bridge as a 34. Following behind is one of the earlier FZ-registered Guy BTXs, 128, (FZ 7913), which is going beyond Bell's Bridge island to the 33 terminus at Cregagh. Sandwiched between the two trolleybuses is a Morris Minor 1000 convertible whose hood, one hopes, was suitably leak-proof. (A. D. Packer)

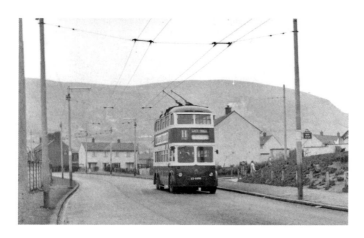

Having just left the Divismore Crescent terminus of the 11 route in Springfield Road, the trolleybus speeds down Whiterock Road and has just passed Glenalina Road on the right where the post-war council houses are situated. The route was renumbered 45 during 1962, so Guy trolleybus 166, (FZ 8530), must have been seen during the first two years of the operation of the Whiterock service. The opening of this route to the Ballymurphy housing estate must have swung in the face of convention, as when it opened on 18 May 1959, the decision had virtually been made not to order any further new trolleybuses. This was despite the abandonment of the Ormeau and Holywood trolleybus routes in 1958 and the introduction of the Sunbeam F4A 246, (2206 OI). (D. R. Harvey Collection)

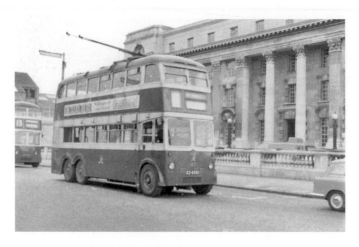

An empty trolleybus 167, (GZ 8531), speeds along May Street on its way back to Haymarket depot. It is passing the multi-columned Royal Courts of Justice building and is hard on the heels of an Austin A40 Farina saloon. The incandescent glow from the offside trafficator shows that the driver of 167 is about to turn right into Victoria Street. (M. Rooum)

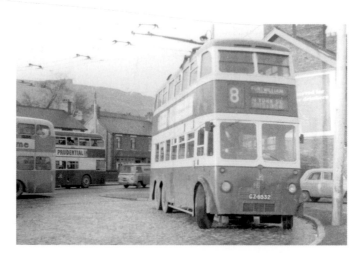

As a Corporation MH Cars-bodied Daimler 'Fleetline' travels out of the city along Shore Road and an Ulsterbus Leyland 'Titan' PD3/4 with an MCCW/Ulsterbus full-front body goes in the opposite direction from Carrickfergus, a trolleybus stands in the Fort William turning circle. Every second trolleybus on the Whitehouse route turned back at Fort William, which was given the route number 8. Guy BTX trolleybus 168, (GZ 8532), with a Harkness H36/32R body, looks as if it has a somewhat bald offside front tyre. This vehicle was subsequently beautifully repainted and was the final Belfast trolleybus to operate on the night of 12 May 1968. It was subsequently presented to the National Trolleybus Association for preservation. (D. R. Harvey Collection)

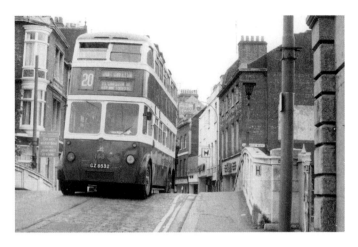

On Sunday 27 October 1968, one week before the closure of the Reading trolleybus system, 168 and Huddersfield 631, (PVH 931), a Sunbeam S7A with a sevety-two-seat East Lancs body, both successfully operated a morning and an afternoon tour of the system. Travelling across Bridge Street Bridge over the River Kennett in Reading, with a minimum of clearance, is the preserved Belfast Harkness-bodied, six-wheeled Guy BTX trolleybus 168, (GZ 8532). (R. F. Mack)

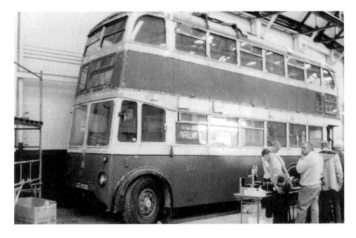

For a time, 168 was kept under cover at the Aston Manor Museum at Witton, though by this time, in July 1989, its pristine condition had deteriorated badly. At least its sojourn in Birmingham allowed the Harkness body to dry out, and it is seen standing behind a sales stall where once stood Birmingham Corporation 301-class four-wheeled, open-balcony tramcars. The visitors at the time must have wondered what the connection was between a Belfast trolleybus and the Birmingham area, though there was one. The chassis was made in Wolverhampton, the body frames were made in Oldbury and the electrical equipment was manufactured about half a mile away by GEC in Witton! (D. R. Harvey)

On 6 June 1953, 'Moffett' tramcar 340, a Brush-bodied, totally enclosed, sixty-seven seat four-wheeler was being used on a tour of the remnants of the tram system. The trolleybus is working on the 23 service to Stormont and is turning out of Albertbridge Road into Upper Newtownards Road. The immaculate-looking 169, (GZ 8533), is a Guy BTX with a Harkness body, which from the rear, could well have been built by Park Royal. (R. J. S. Wiseman)

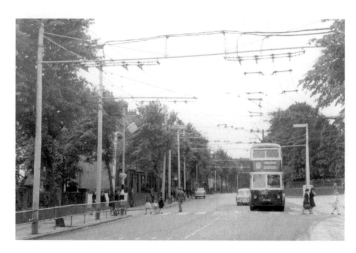

The intricacies of the overhead required to put in place a turn to the right as well as a turning circle off a mainline route are well shown at the junction of Falls Road and Whiterock Road. On 15 June 1964, Guy BTX 170, (GZ 8534), is about to cross the zebra crossing when working on the 10 route from Casement Park, across the city to Whitewell by way of Shore Road. Behind the trees on the right is the entrance to Belfast Cemetery. (J. C. Gillham)

136

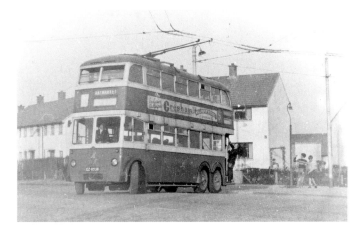

The conductor on the back platform of the trolleybus winds his destination blinds so that, instead of showing the route number 45, the blind was altered to either Haymarket or with a white blank display. The driver of Guy BTX 172, (GZ 8536), has pulled on a hard-left lock in order to leave the turning circle at the Whiterock Road trolleybus terminus at Divismore Crescent on the Ballymurphy housing estate built in the 1950s by the Belfast local authority and after being owned by the Northern Ireland Housing Executive were sold to the householders. This was the original format of the terminus, which was anticlockwise until 1965, and as the route was renumbered to 11 after 1962, this dates this scene before this earlier date. (D. R. Harvey Collection)

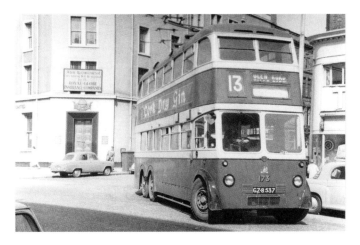

The Falls Road services entered the city centre by way of Queen Street. Here, Guy BTX six-wheeler 173, (GZ 8537), turns into Wellington Place while working on the 13 route from Glen Road. It will then continue into Donegall Square North before returning to Castle Street by way of Donegall Place. The Harkness-bodied trolleybus is carrying an advertisement for Cork Dry Gin. This brand of gin was first produced in 1793 and is the most popular variety in Ireland. (D. Battams)

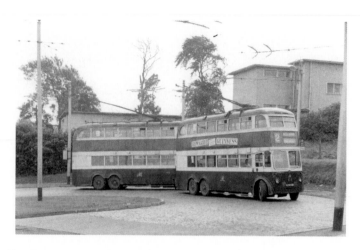

The Whitewell terminus was adjacent to the Throne Hospital in Whitewell Road. The route was opened on 26 April 1953 as the 10 service but was soon included in the cross-city 12 route to Falls Road. Waiting to return to the Falls on 15 June 1964 is a pair of GEC 100-hp-motored Guy BTX trolleybuses fitted with Harkness H36/32R bodies, 174, (GZ 8538), and 146, (GZ 8510). 174 was destined to be the only Belfast trolleybus to be destroyed in 'The Troubles' when, still carrying the same Guinness advertisement, it got caught in a riot in Divis Street on 1 October 1964 during the General Election campaign and was burnt out. (J. C. Gillham)

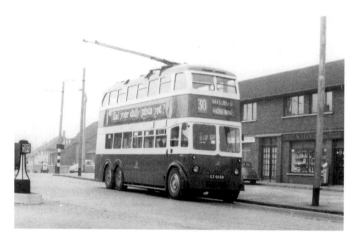

The picking up point at the terminus of the Bloomfield 30 route was outside a row of 1950s suburban shops. Already beginning to fill up with passengers, trolleybus 175, (GZ 8539), one of the later Guy BTXs with powerful GEC 100-hp motors and a Harkness H36/32R body, waits outside Goud's chemist shop with the obligatory weighing machine by the shop doorway and Hilda Robert's hair stylists. Judging by its appearance, 175 looks as if it has been recently repainted. (A. S. Bronn)

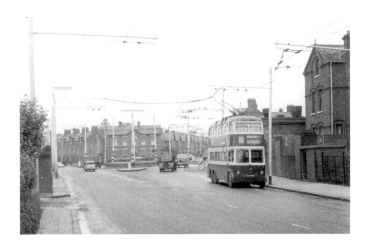

Parked outside the front of Falls Park depot on 15 June 1964, facing the city centre is Guy BTX 175, (GZ 8539). Coming from Glen Road is a Bedford O-type lorry and a Land Rover, while to the left is the continuation of Falls Road, which took the trolleybuses to the terminus just outside the city boundary at Casement Park in Andersonstown. Behind the trolleybus is the wiring into Divis Drive, which enabled the trolleybus to gain access to the depot. (J. C. Gillham)

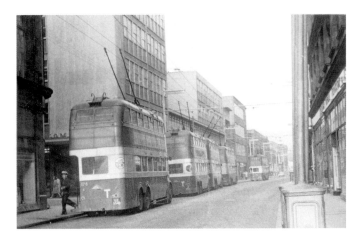

With the prospect of a long lay-over, the conductor of Harkness-bodied Guy BTX 176, (GZ 8540), gets off his charge. It is standing at the rear of a row of four trolleybuses, with BUT 9641T 195, (GZ 8559), parked in front of it in Castle Street. All these trolleybuses are working on routes bound for the Falls Road. One of the few differences between the Harkness-bodied Guy BTXs and the BUT 9641Ts was that the rear platform windows on the former were slightly more square. (R. Symons)

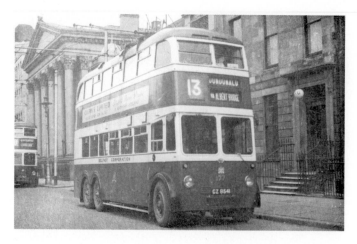

Until just into the early post-war years, the centre of Belfast still had quite a few Georgian and Regency buildings, which, when built, had been the town houses for the wealthy. One such building became the Church of Ireland Young Men's Society, outside which is parked Guy BTX 177, (GZ 8541). It is painted in its original livery a few years after it entered service on 2 May 1949. This trolleybus is working on the 13 route to Dundonald via Albert Bridge, which later would become the 17. The service to Dundonald, which was numbered 16 and used the Queen's Bridge had its city terminus in Donegall Square East. Until 1951, the trolleybus route to Cregagh was numbered 8 and AEC 664T, standing behind the Guy is showing that route number. (W. J. Haynes)

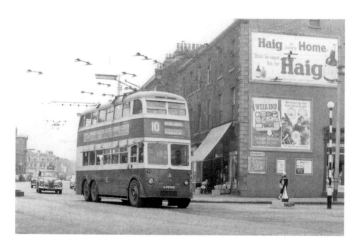

Being followed along York Road by a Humber Hawk VI, trolleybus 178, (GZ 8542), passes the junction with Brougham Street. This is where the trolleybuses bound for Duncairn Gardens when working on the 2, 4 and 6 Antrim Road services turned left away from York Road, just short of the railway station. 178 will continue along York Road and its continuation into Shore Road before turning left to reach the Whitewell terminus of the 10 route. On this shoreline arterial route out of Belfast, it is interesting to see how much of the early-nineteenth-century town remained with three-storied buildings with quoined corners. (R. F. Mack)

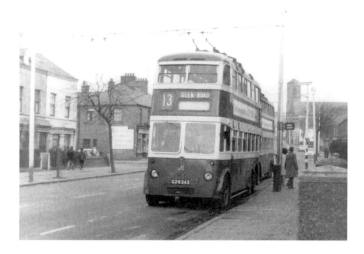

Setting down passengers at the stop near to the small bridge over the Clowney Water stream in Falls Road is Guy BTX 179, (GZ 8543). This Harkness-bodied trolleybus is going to Glen Road on a 13 working. Behind it at the top of the hill is the Broadway Presbyterian church on the corner of Fallswater Street. On the opposite side of the road between Clondara Street and Shiels Street, there were several rows of late-Victorian premises having a wide variety of retail functions such as several grocer's, a butcher's, a greengrocer's, a hairdresser's, a draper's and a newsagent's shop, making this section of the Falls an almost self-contained suburb. (D. R. Harvey Collection)

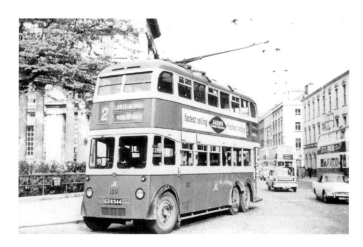

About to turn from Donegall Square South is a trolleybus working on the 2 route. This was the shortest of the Antrim Road turnbacks and after a short period when it used a reverser, after February 1950, a turning circle was put in place at Strathmore Park. With a Sunbeam Alpine and an early Vauxhall Victor F series II behind it, Guy BTX trolleybus is actually coming from Haymarket depot before taking up duties on this Antrim Road service. Seen in April 1963, the Harkness H36/32R body looks in good condition, which is a testament to the Metal Sections framework employed on these trolleybuses. (G. Stainthorpe)

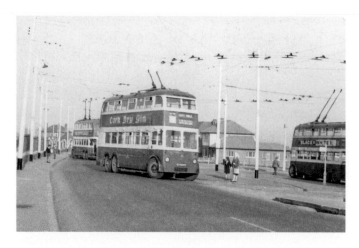

There were a lot of comings and goings of trolleybuses at the Glen Road terminus in Bingham Drive on this afternoon in April 1962 as a mother and her daughter wait for the turning six-wheeler to pass. Guy BTX trolleybus 181, (GZ 8545), turns into the terminus having unloaded its passengers opposite St Teresa's Primary School and will draw up behind another one of the same Harkness-bodied class in the turning circle. (C. W. Routh)

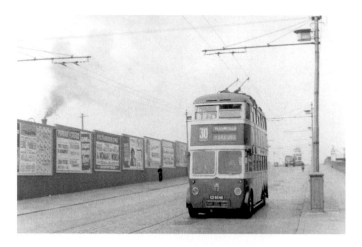

Coming off the Albert Bridge is an immaculate Harkness-bodied Guy BTX, which is going to Bloomfield on the 30 route. For most of the day, this service, which started from Donegall Square North, had a fifteen-minute headway. 182, (GX 8546), is passing the long row of advertising hoardings that help to date this photograph. The film *A Woman's World* is being advertised on the left. This sophisticated comedy starred Clifton Webb, June Allyson, Van Heflin, Lauren Bacall and Fred MacMurray and was released in 1954. (D. A. Jones)

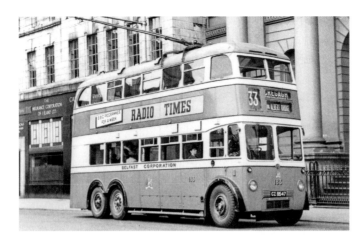

Seen when still quite new and looking very smart in virtually its original condition is Guy BTX 183, (GZ 8547). It is parked in Donegall Square East while working on the 33 service to Cregagh soon after the service had been renumbered from its original 8 route number when the cross-city extended to Carr's Glen. The trolleybus is carrying an advertisement for *Radio Times*, which at this time, would have been before it included television listings for Northern Ireland. Although a temporary transmitter at Glencairn was opened on 1 May 1953 for the Coronation of Queen Elizabeth II, regular television programmes could only be received when the Divis 405-line Band transmitter was opened by the BBC on 21 July 1955. (R. Marshall)

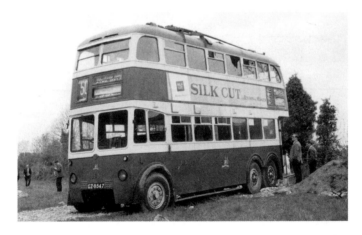

183, (GZ 8547), was repainted and restored to ex-works condition and was the reserve vehicle for the final ceremonial closing procession using trolleybuses 112, 168 and 246. After the closure of the Belfast system on 12 May 1968, 183 was presented to the Transport Museum Society of Ireland, who at that time, were based at Castleruddery. It is seen on 17 May 1970 still looking quite presentable, but after two years in the open, exposed to the elements, it was beginning to show some deterioration and vandal damage. It is now undercover at the splendid Howth Museum, but is in a somewhat sad state of repair. (R. F. Mack Collection)

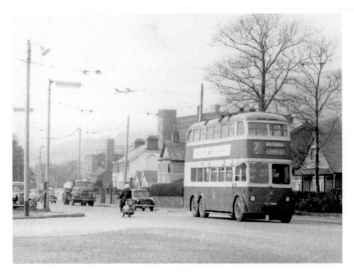

Approaching the Whitehouse terminus of the 7 route in Shore Road is Guy BTX 184, (GZ 8548), which will shortly turn right into the terminal loop in the foreground. This route was introduced on 2 October 1950 to a point just outside the Belfast Corporation boundary. Operating disputes with the Ulster Transport Authority were never satisfactorily resolved and were partially responsible for the premature closure of the route on 20 May 1962. The distinctive bungalows and the early-twentieth-century semi-detached houses still line the main road, but the turning circle on the left is now occupied by a petrol station. The industrial Greaves' Mill buildings behind the trolleybus have since been demolished. (C. W. Routh)

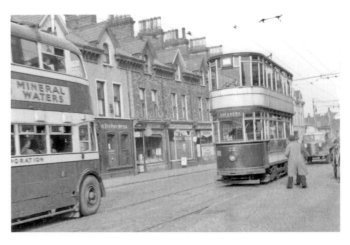

There were not many of the original four-wheeled Brush open-top tramcars that were built with equal-depth upper-saloon windows. Car 78 was one such tram as was car 22, seen here in Bridge End. It was one of fifty of Belfast's original 1905-built trams to become a totally enclosed rebuild under the modernisation programme of William Chamberlain's period as general manager. In August 1953, car 22 is on its way from Mountpottinger depot to Queen's Road to take up duties on a shipyard special for the Harland & Wolff workers. Passing the Bridge End post office as it travels out of Belfast towards Newtownards Road is Harkness-bodied Guy BTX trolleybus 185, (GZ 8549), still in its original livery layout. (R. W. A. Jones)

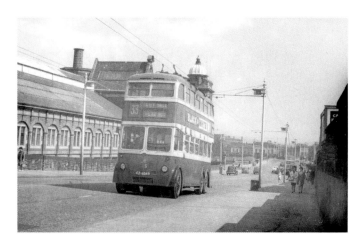

Passing Belfast Corporation Electricity Department's generating station in East Bridge Street is the penultimate Guy BTX trolleybus. This building was completed in this form in 1905 and was to last for the next seventy-five years before being replaced by modern housing. 185, (GZ 8549), which entered service on 19 January 1949, is travelling towards the City Hall while working on a 33 route shortworking. (R. F. Mack)

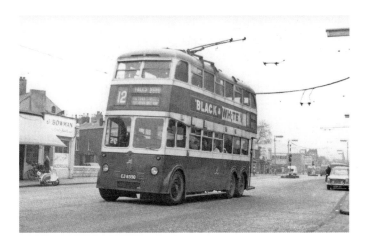

The last of the six-wheeled Guy BTXs delivered to Belfast was 186, (GZ 8550). This trolleybus was very late entering service, not going onto the streets until 1 June 1949. It was also the last Guy six-wheeler to be built, ending an era of twenty-six years production from when the first of the model, Wolverhampton Corporation's 33, (UK 633), entered service in December 1926. 186 is working on the 12 route and travelling into the city centre along York Road in the early 1960s. Later, most of this area was swept away under the redevelopment schemes that consumed most of the small properties in the area. (R. F. Mack)

CHAPTER FIVE

THE FIRST BUT 9641Ts

Once the Guy BTX model became unavailable as Belfast's post-war trolleybus of choice, it became necessary to look elsewhere for a replacement supplier of six-wheeled trolleybuses. Sunbeam was producing the S7, Crossley Motors were not taking any orders after their take-over by AC, and Daimler was running down their trolleybus production anyway. The two most successful six-wheeled chassis from the original fourteen trolleybuses for the initial Falls Road route were the AEC 664Ts, which were ordered and the Leyland TTB4s with GEC motors. In 1945, the production of AEC and Leyland trolleybuses was combined and a new production company, British United Traction, was set up. For the home market there were two models, the four-wheeled 9611T based on an AEC 'Regent' motor bus and the 9641T which was the 'Rolls Royce' of the post-war six-wheeled chassis. It was to the BUT 9641T chassis that Belfast turned and immediately ordered twenty-four chassis. This time they were fitted with GEC 100-hp traction motors, but received very similar Harkness H36/32R bodies to those on the previous seventy Guy BTXs, though there were some very detailed differences. The delivery of the completed trolleybuses began with trolleybus 190 in August 1948, but all the other twenty-three were placed in service on 2 October 1950, some twenty-six months later! The twenty-four BUT 9641T Harkness-bodied trolleybuses were identifiable from the previous batch of Guy BTXs by their larger half-shaft covers, the slightly less square rear platform windows and their somewhat lower position on the road, especially over the rear bogies.

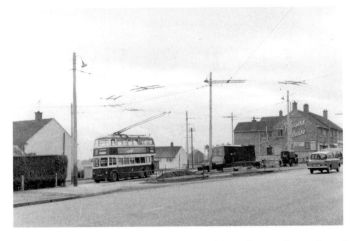

The Springfield Road terminus of the 11 route to Whiterock was located at the edge of the Ballymurphy Estate. On 15 June 1964, the first of the Harkness-bodied BUT 9641Ts, 187, (GZ 8551), stands in the turning circle before the trolleybuses were redirected in a clockwise direction around Divismore Crescent. The trolleybus will shortly leave to go down the steep hill in Whiterock Road before turning left into Falls Road. (J. C. Gillham)

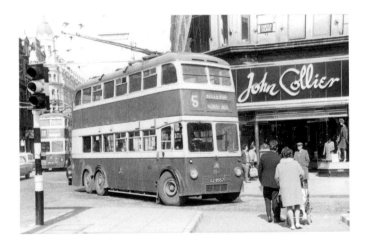

One can almost hear the second set of rear bogie wheels scrubbing on the asphalt as the trolleybus turns left from Royal Avenue into Castle Place. 188, (GZ 8552), a BUT 9641T with a Harkness H36/32R body is arriving at the city terminus of the 5 route from Bellevue via Carlisle Circus. It is passing the premises of John Collier's tailors shop before pulling up outside the Belfast Bank and Robb's department store. Behind 188 is another member of the same batch: 193, (GZ 8557), on its way across the city to Glen Road from Whitewell. (R. Symons)

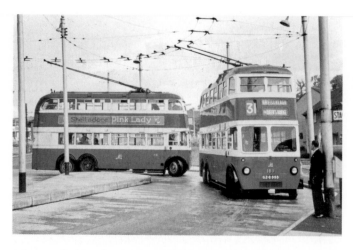

189, (GZ 8553), has made the tight turn into the Castlereagh trolleybus terminus of the 31 route not long after being freshly repainted at Falls Park Works. It is still moving up to the loading stop so that the second trolleybus can gain complete access to the safety of this turning circle. 189, a BUT 9641T, stands in front of the ten-months-older Guy BTX 146, (GZ 8510), which unusually turned round at a terminus when still carrying passengers. (D. R. Harvey Collection)

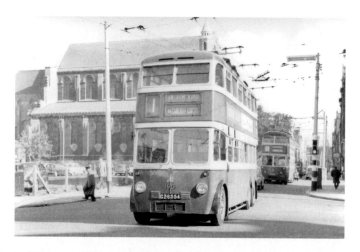

The first of the Harkness-bodied BUT 9641Ts to enter service was 190, (GZ 8554). This trolleybus first operated on 3 August 1948, over two years before all the other vehicles in the 187-210 batch of vehicles. Trolleybus 190 is travelling out of the city along Donegall Street and is almost at the junction where Royal Avenue gives way to York Street. 190 is working on the 1 route along Antrim Road to Strathmore Park on 11 August 1962. Behind it is 214, (OZ 7316), one of the second type of Harkness-bodied BUT 9641Ts of 1954, which is going all the way to Glengormley. Behind the trolleybuses is St Anne's Church of Ireland Cathedral. This was built in an unusual Romanesque style and was consecrated in 1904. Throughout the twentieth century, the Cathedral has been successively added to with the south transept being completed in 1974 and the north transept, incorporating a huge Celtic Cross on the exterior, being consecrated in 1981. As recently as April 2007, a 120-foot-high stainless-steel spire was completed and is illuminated at night and named the 'Spire of Hope'. The cathedral's organ, built by Harrison & Harrison in 1907 is the largest pipe organ in Northern Ireland. (D. Battams)

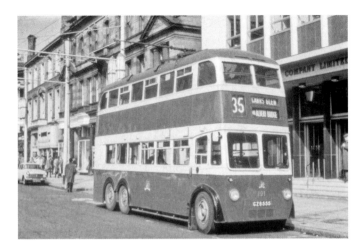

A Belfast Corporation vehicle always looked superb and it must have been the size of the six-wheelers that made them look even more majestic. Here, BUT 9641T, with a freshly repainted Harkness body, 191, (GZ 8555), stands in Donegall Square North while working on the 35 route to Carr's Glen. This was the author's favourite Belfast trolleybus route, as he had an aunt who lived just one stop away from the terminus. It was always a great pleasure to ride on these big, beautifully maintained, sixty-eight-seaters that had incredible acceleration away from bus-stops and a characteristic smell of electricity and rexine. (Trolleyslides)

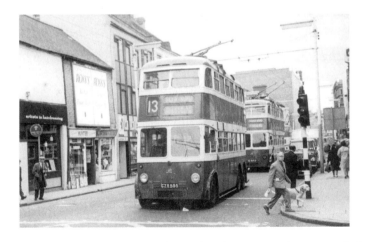

Travelling along Divis Street lined with small retail outlets on 20 July 1967 and about to cross the King Street junction is BUT 9641T 191, (GZ 8555). This trolleybus is on its way onto the Falls Road and then on to Glen Toad. It is being followed by Guy BTX 148, (GZ 8512). The easiest method of recognition between the two chassis types was their respective manufacturer's badges. (Photofives)

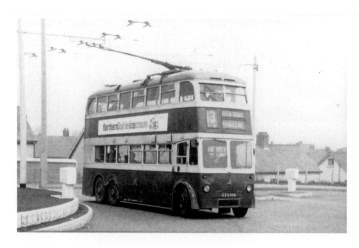

Swinging around the traffic island at Kennedy Way is trolleybus 192, (GZ 8556). It has just passed the Glenowen public house and will continue to climb past St Teresa's Roman Catholic Church and onto the terminus. This Harkness-bodied sixty-eight-seater BUT 9641T, like all the other new post-war trolleybuses purchased by Belfast Corporation, had body frames manufactured in the West Midlands by the Oldbury-based Metal Sections. Although by this time, in about 1966, 192 was typically a little damaged around the front mudguards and in need of a repaint, it would continue to work reliably until the final day of trolleybus operation on 12 May 1968 with only one of the twenty-four failing to survive until this closure date. (R. Symons)

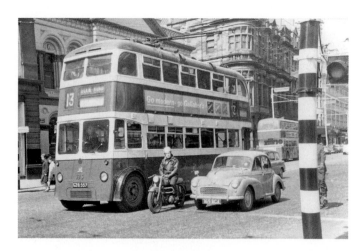

Waiting at the traffic lights in Royal Avenue with the junction at Castle Place is an early post-war BSA Goldstar motorcycle registered in Kilkenny in the Irish Republic. Unusually for this date, 20 April 1965, the motorcyclist is wearing a protective leather motorcyclist's jacket and a crash helmet fitted with a visor. He is sandwiched between a Glasgow-registered Morris Minor 1000 and one of Belfast Corporation's big, six-wheeled BUT 9641T trolleybuses. 193, (GZ 8557), waits to turn right into Castle Street having come into the city centre from Whitewell as a 13 service going to Glen Road. It is standing in front of the old Provincial Bank building completed in 1869 to the designs of W. J. Barre who died before his structure was completed. Today, this old bank is a Tesco supermarket. Going in the opposite direction is a 1963 EZ-registered Daimler 'Fleetline' CRG6LX with an MH Cars body. (R. Symons)

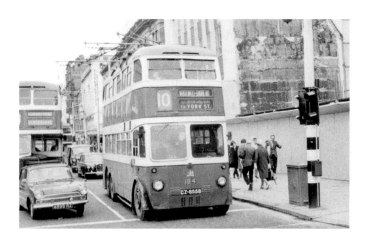

By 20 July 1967, the buildings on the corner of Donegall Square North and Donegall Place, where the three-storied Gilpin Brothers gentlemen's outfitters, dating from about 1870, had been located for years, had been demolished. This was replaced by Donegall House in about 1968. Waiting in Donegall Square North for the traffic lights to change so that it can turn left into Donegall Place is BUT 9641T 194, (GZ 8558). This trolleybus is going on the long jaunt along York Street and Shore Road to Whitewell on the 10 route. (Photofives)

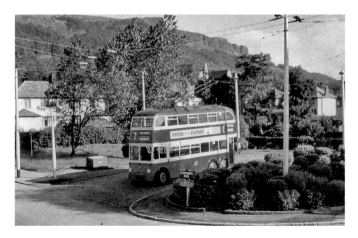

The Strathmore Park turning circle replaced the original reverser at this, the first of the Antrim Road trolleybus turnbacks. Used by the 1 route, which left the city by way of Carlisle Circus and, as in this case, the 2 route by way of Duncairn Gardens, this was another of the turning circles that was taken in an anticlockwise direction by the trolleybuses. To the left was the old gatehouse to Belfast Castle, which today is a rather superior dentist's surgery. On the skyline is the 1,200-foot-high Cave Hill, which consists of Jurassic Lias clay at its base with Cretaceous Ulster white limestone above that and the deep capping of 65 million years old Tertiary basalt lava flows. Cave Hill dwarfs the nearby Belfast Castle, the Antrim Road suburbs and trolleybus BUT 9641T 195, (GZ 8559), which is waiting in the Strathmore Park turning circle prior to heading back to Belfast. (G. Lumb)

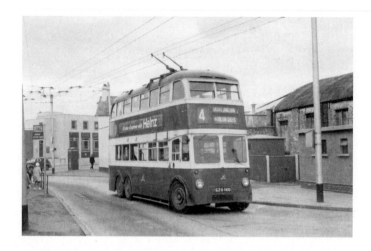

The only one of the twenty-four BUT 9641Ts with Harkness H36/32R bodies not to survive until the end of the Belfast system was 196, (GZ 8560). It was in Falls Park depot on 1 March 1966, when an accidental fire started in the fuel pump shop, that destroyed the centre section of the repair and overhaul workshops and claimed as a total loss this trolleybus and Daimler CWA6 buses 220, (GZ 2411), and 239, (GZ 2687). 196 has just entered the first cul-de-sac from the distant Antrim Road behind the trolleybus, where the 1960s Northern Bank on the corner of Farmley Road is located. 196 is about to turn right before reversing, prior to moving forward to pick up passengers at the bus-stop on the left. (J. Shearman)

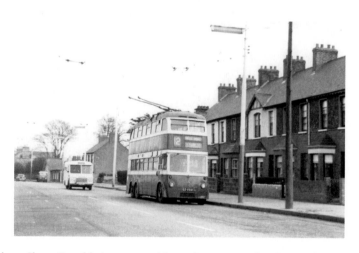

Travelling along Shore Road being pursued by a Commer Walk-Thru ambulance is trolleybus 197, (GZ 8561). This Harkness-bodied BUT 9641T vehicle is working on the cross-city 123 service to the Falls Road via York Street on 14 April 1968, which was barely one month before the final closure of the Belfast trolleybus system. Even at this late stage of the system, while the individual vehicles were beginning to look a little tired, the condition of the overhead, taut and tightly strung, was a testament to the hard work that was put in, right to the very end, by the maintenance staff. (E. M. H. Humphries)

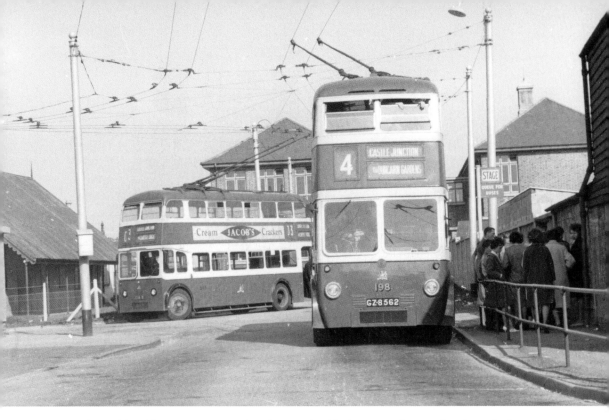

Just short of the old tram terminus at the Glen Hotel public house in Glengormley, the trolleybuses right-turned off the main A6 Antrim Road and into one of the many side roads and cul-de-sacs that were confusingly also called Antrim Road. In about 1960, BUT trolleybus 198, (GZ 8562), has turned round in the cul-de-sac and is at the loading-up stop where a group of passengers wait for the conductor to give the 'OK' to get on board. Reversing from the triangle on the left is the unique 246, (2206 OI), the 30-foot-long two-axle Sunbeam F4A, which will go back to the city centre as a 3 service via Carlisle Circus. The 3 and the 4 routes alternated so trolleybus 198 is going back to Castle Junction in the centre of Belfast by way of Duncairn Gardens. The Castle Junction destination was a figment of the imagination of the transport department. Strictly speaking, although 'Castle Junction' was considered to be the hub of all of the Corporation's services, there was no such place. It was the junction where Royal Avenue and Donegall Place were crossed by Castle Street and Castle Place, the latter being where both the 3 and the 4 route terminated. (D. F. Parker)

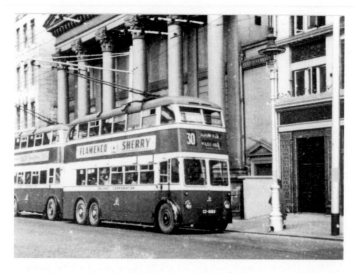

Waiting outside the Wesleyan Methodist church in Donegall Place East is trolleybus 199, (GZ 8563). The church was completed in the Roman revival style to the designs of Isaac Farrell in 1850. Today, the façade survives as the frontage to the premises of the Ulster Bank. The Harkness-bodied six-wheeler is about to leave the terminus opposite the side of City Hall when working on the 30 route to Bloomfield, which when first opened in 1946, had been the preserve of the Harkness-bodied Sunbeam W4 four-wheelers. By about 1951, when 199 was loading up, increased passenger numbers required the bigger sixty-eight-seater trolleybuses. (M. Corcoran)

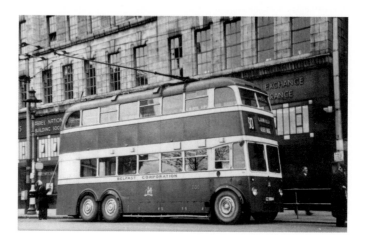

The conductor of BUT trolleybus 200, (GZ 8564), appears to be pulling down the trolleypoles of his charge as the vehicle seems to be parked without passengers. The trolleybus is standing in Donegall Square East having arrived from Bloomfield on the 30 service when still quite new, in about 1951. The trolleybus still has trafficator arms, which were located somewhat awkwardly behind the bottom of the driver's door. On the side of the bus is the City of Belfast Coat of Arms beneath which is the Latin motto 'Pro tanto quid retribuamus', which translates as 'In return for so much, what shall we give back?' (W. J. Wyse)

154

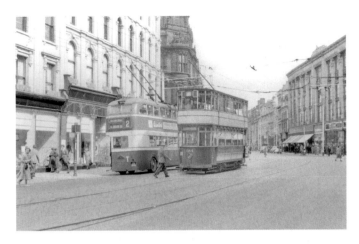

Castle Place shared trams and trolleybus termini from when the Antrim Road trolleybus conversion took place on 24 January 1949. Standing outside J. Robb's outfitters shop is BUT 9641T trolleybus 200, (GZ 8564), which is loading up with passengers before leaving to the Antrim Road turning circle at Strathmore Park. The rear of these vehicles looked a lot better when they were fitted with destination boxes. Standing next to the trolleybus is tram 384, which was one of fifty totally enclosed trams designed by William Chamberlain and delivered during 1930. This tram was one of the last ten of the class to be locally bodied by the Service Motor Works Company. (A. D. Packer)

The Grove shortworking of the 9 route went to the junction of North Queen Street where there was sufficient room to put in a large turning circle. Travelling out of the city centre along York Road in about 1965 is BUT 9641T trolleybus 201, (GZ 8565). This Harkness-bodied sixty-eight-seater is working on the 8 route to Fort William and has just passed McCann's wine and spirit warehouse. Just off the picture to the right was the Grove Swimming Baths, which when opened in the 1960s, were the only 25-metre-long pool in Ireland capable of holding international swimming competitions. (R. Symons)

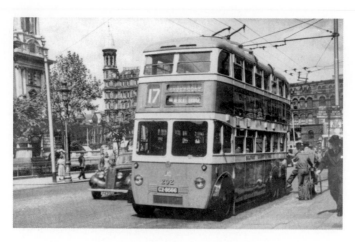

In the years just after the Second World War, those buildings in the centre of Belfast that had survived the Blitz managed to retain their somewhat decayed grandeur, which had lain hidden under years of industrial grime. But it was Donegall Place of the time when it was completed by the late Victorians and not the piecemeal redevelopment in the square of today with architecturally uninspired 1960s and 1970s office blocks. Above the speeding Humber Super Snipe car is the Robinson & Cleaver's department store of 1888 while in the distant right is Richardson Sons & Owden's magnificent linen warehouse built during the following year. The trolleybus loading up on the east side of the square is an almost new 202, (GZ 8566), which is working via Albert Bridge on the 17 route to Dundonald. (Ribble Enthusiast's Club)

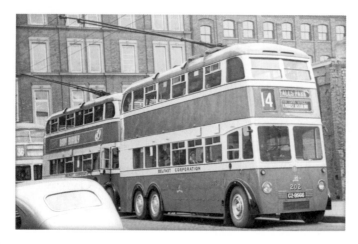

Parked in front of a wartime AEC 664T in Castle Street is BUT 9641T 202, (GZ 8566). This immaculately repainted trolleybus is being employed on the 14 route shortworking to Falls Park where it would turn around the traffic island at the junction of Falls Road and Glen Road. Like all of the class, 202 entered service on 2 October 1950, so this must have been when it was first repainted, which must have been before September 1953 when the fleet name was omitted from the waistrail. (R. Marshall)

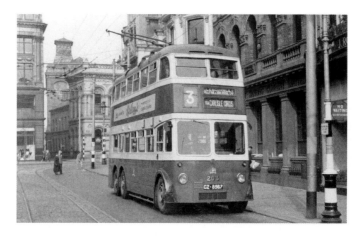

The terminus of all the Antrim Road trolleybuses was in Castle Place. Here, in the mid-1950s, when there were still tram tracks in the road, a well-maintained Harkness-bodied trolleybus, 203, (GZ 8567), stands outside the late-Victorian bank buildings. It is shortly going to begin its journey to Glengormley by the more direct route by way of Carlisle Circus, but will usually wait until the next Glengormley trolleybus arrives, which in this case, should be working on the 4 route via Duncairn Gardens. (L.T.P.S.)

Passing the Strathmore Park turning circle in Antrim Road is trolleybus 204, (GZ 8568). Hidden behind the six-wheeler is the lodge to Belfast Castle, which is through the trees behind and above the 1930s semi-detached houses behind the turning circle. With the gaunt, basalt vertical faces of Cave Hill in the distance, this BUT 9641T is travelling into Belfast on the 4 route from Glengormley. This route had been the penultimate arterial road route to be converted from trams to trolleybuses on 24 January 1949. (R. F. Mack)

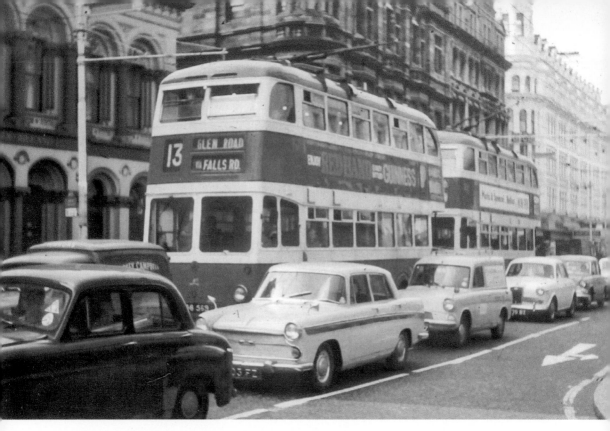

The line of traffic waiting in Royal Avenue stretches back to the distant white Grand Central Hotel building. Waiting to turn right in front of the Provincial Bank of Ireland building into Castle Street is BUT 9641T trolleybus 205, (GZ 8569), with a Harkness H36/32R body. This trolleybus is going to Glen Road on a 13 service from Whitewell. It is partly hidden by a late 1950s Standard 10, an Austin A60 Cambridge, a Ford Anglia 307E 7-cwt van and a Wolseley 1500. Behind the second trolleybus is the Ulster Reform Club, which first opened on 1 January 1885. The Grand Hotel was one of the last buildings to be constructed in Royal Avenue. Whereas most of this piece of Belfast's reconstruction and expansion had been completed by about 1885, the hotel site on the corner of Berry Street was not opened until 1 June 1893. John Robb, who owned the esteemed department store in Castle Place, had originally planned to develop a substantial central railway terminus on the site, based on the Grand Central Station in New York. The plans were turned down and Robb developed the site with a five-floor, 200-bedroom luxury hotel. It was soon to become one of the grandest hotels in the whole of Ireland and became the place to be seen and for celebrities to stay. It was closed as a hotel on 1 October 1971 when it was acquired by the British Army as a barracks. As a result, it was subjected to over 150 attacks by both gangland and the IRA and eventually was largely demolished and replaced by the Castle Court development. (D. R. Harvey Collection)

There was obviously an enthusiasts' visit to Falls Park depot going on judging by the two men with cameras as a rather battered trolleybus passes by. 206, (GZ 8570), is coming from Glen Road but is displaying the wrong destination number. The Harkness-bodied trolleybus is missing the rear-bogie mudguard while the front nearside one looks awful! Judging by the condition of the vehicle, this must have been in May 1968, when 206 became the last trolleybus to operate on the same 11 service to Whiterock. (R. Symons)

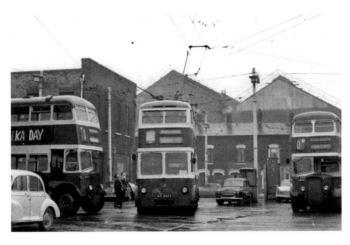

Harkness-bodied BUT 9641T trolleybus 207, (GZ 8571), was chosen for a national trolleybus tour of the remains of the system on 28 March 1967. It is seen in Short Strand depot yard in which, by this time, trolleybus arrivals were becoming unusual, as it was only being used for repairs and overhauls. It is flanked by two former London Transport Daimler CWA6s. On the left is 496, (HGF 865), which had been D188 in London, and on the right, the former D217, now 542, (HGF 894); both had entered service in 1946 with Park Royal semi-utility bodywork. These two buses were part of the 100 Daimlers purchased by Belfast during late 1953 and early 1954. Both buses were rebodied by Harkness in 1955 and survived until November 1970. 207 became the last trolleybus to operation the 12 route to the Falls Road terminus at Casement Park. (E. M. H. Humphries)

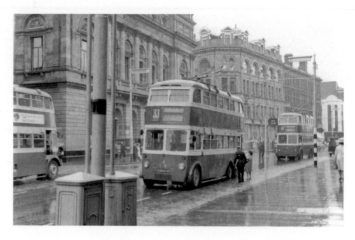

On 23 July 1963, trolleybus 208, (GZ 8572), a BUT 9641T with a Harkness H36/32R body, stands opposite the Belfast Central Library, dating from 1888, in Royal Avenue while travelling into the city centre from Carr's Glen on the 33 service. The following trolleybus is a similarly bodied Guy BTX 126, (FZ 7911), which is also working on a cross-city route, in this case, the 13 from Whitewell to Glen Road. Opposite this second six-wheeler are the premises of *The Belfast Telegraph* newspaper with its impressive clock bearing the date 1870. In the distance is the Woodhouses furniture store near to the junction with Donegall Street. (A. D. Packer)

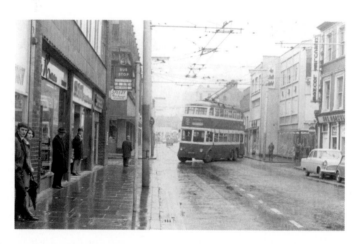

Turning right out of Castle Street into Queen's Street is an inbound 12 trolleybus service. On the right is the Hercules Lounge Bar with a Ford Consul II 204E saloon. The trolleybus is 208, (GZ 8572), a BUT 9641T with a Harkness body. The stop in the foreground, next to the 1960s Norwich Union building, is where the outbound trolleybuses along Falls Road stood waiting for their departure time to come round. (R. Symons)

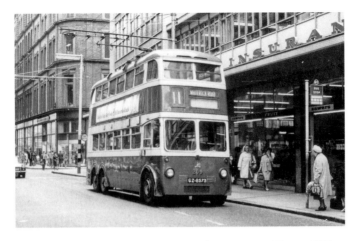

Waiting outside the Norwich Union building in Castle Street is BUT 209, (GZ 8573). This busy shopping street led directly from Castle Place and onto the inner city Divis Street. So, within the space of a few hundred yards, one could walk from the grandiose city centre shops to small mid-Victorian single-unit shops. This 10-ton six-wheeled trolleybus is going to Whiterock Road on the 11 route in the mid-1960s. (R. F. Mack)

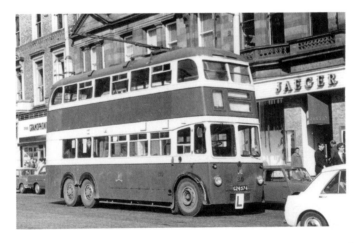

Travelling along Donegall Square North in about 1963, when being used on driver training duties, is the last of the 1950 batch of trolleybuses. 210, (GZ 8574), could hardly be mistaken for doing anything else as it has a large 'L' plate tied on to the front ventilation grill. Its trainee driver is gingerly negotiating the complicated overhead layout in the square. The trolleybus, a BUT 9641T with a Harkness body has just passed the Linen Hall Library and the later Donegall Square buildings, which survive today as the home of numerous financial institutions. (A. B. Cross)

CHAPTER SIX

THE FINAL NEW-
PRODUCTION SIX-WHEELERS

To parody a well-known introduction to a long-running BBC radio programme, "if you were cast away on a desert island, which eight trolleybuses would you take with you"; your writer would have to have one of these magnificent vehicles.

Another twenty-four BUT 9641Ts were ordered in 1951 and were delivered to Belfast in 1952, only this time they had GEC 105-hp traction motors. They were allotted fleet numbers 211-234 and were stored in Sandy Row tram depot. They were stored because the local favoured coachbuilder, Harkness of McTier Street located off Shankhill Road, were involved in the construction of the ninety-eight Daimler CVG6s and two 'new-look' fronted Daimler CVD6s. As their premises were quite small, Harkness were unable to begin the construction of the new BUT trolleybus chassis until they had virtually completed these attractively styled motor buses. These Daimlers were numbered 350-449 and their Metal Sections-framed bodies were a slightly modernised version of what had been delivered previously. They were 27 feet long, and for the first time on a motor bus, were 8 feet wide and had sliding cab doors and square-topped sliding saloon ventilators. It was from this design that the new trolleybus bodies were developed.

Because of the delay in beginning to body these 24 BUT 9641T chassis, it was not until 3 October 1953 that the first one, 211, (OZ 7313), entered service. The next three arrived in January 1954 but by March of the same year only thirteen had been delivered, despite the final delivery of the last three Daimler motor buses.

Two more trolleybuses arrived in May, three in June, and another three in July 1954, but the last three were delivered on 1 September 1954, 1 November 1954, and finally 234, (OZ 7336), on 5 November 1954. The chassis of this trolleybus had been exhibited at the 1952 Commercial Motor Show in Earl's Court, London, and because the chassis was especially finished for this important event, it had certain non-standard fittings, noticeably retaining a cream-covered steering wheel.

Despite their protracted delivery, these vehicles did look quite splendid and were a fitting conclusion to the production trolleybuses in the Belfast fleet. Tending to work on the northern routes, especially on the Antrim Road routes, they were not usually found on the eastern service unless it was on the cross-city service from Carr's Glen to Cregagh.

All but five of them survived until the very end of trolleybus operation in the city, and it was a great pity that one of them was not preserved!

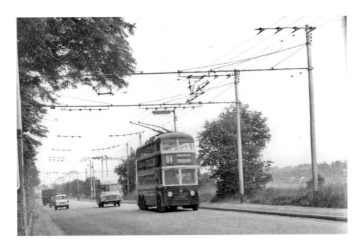

The first of the BUT 9641Ts with the new-style Harkness H36/32R bodies was 211, (OZ 7313). It is in Antrim Road on the 4 service on 15 June 1964, just south, on the city side, of the Bellevue turning circle. On the left behind the photographer is the entrance to Belfast Zoological Gardens, better known as Bellevue Zoo, which for many years was the playground for Belfast's population. It had ornamental gardens, access to the nearby Cave Hill and a funfair, which the author remembers being taken to in the pouring rain in the summer of 1951! Once the trolleybuses had replaced the trams on 24 January 1949, a turning circle for the 5 and 6 routes going only as far as Bellevue was required. Additionally, Antrim Road was equipped with four running wires so that trolleybuses going to and from Glengormley could run straight past unloading and loading trolleybuses lined up at the zoo's entrance. (J. C. Gillham)

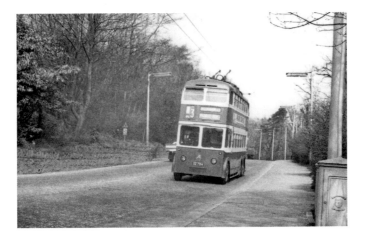

Stretching its legs in Antrim Road, BUT 9641T 212, (OZ 7314), speeds along towards the city just south of Belfast Zoo. The trolleybus blind appears to be incorrectly set as there is only pavement on the eastern side in this section of the A6 road. The Harkness bodies on these last six-wheelers were the first trolleybuses to be equipped with twin-track number blinds so ensuring that some driver or another could wind on, as in this case, blank 3 as the route number! (R. F. Mack)

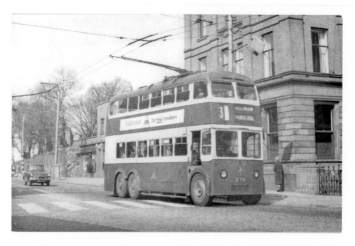

About to enter Carlisle Circus from the very southern end of Antrim Road is Harkness-bodied BUT 9641T 213, (OZ 7315). It is passing the impressive, early-Victorian premises of the Ulster Bank. This trolleybus entered service on 8 January 1954, although the chassis was delivered in 1952. 213 was one of only five of the twenty-four in the class that failed to survive to the end of the Belfast trolleybus system. It was withdrawn on 7 February 1966, just two days before the abandonment of the very Antrim Road services that it is seen working on some three years earlier. (R. F. Mack)

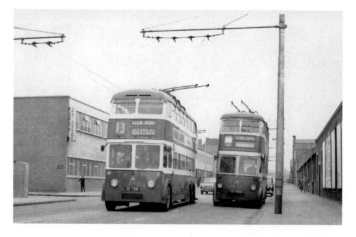

Parked in the trolleybus siding in April 1963 alongside the NCC railway station in York Road is wartime AEC 664T 47, (FZ 7832). Overtaking it is 214, (OZ 7316), an 8-foot-wide, Harkness-bodied BUT 9641T, which is working on the 13 service to Glen Road. These 1954-bodied trolleybuses were the first to have pull-out opening upper-saloon front ventilators. The difference between the 7-foot-6-inch-wide Harkness body on 47 and the newer overtaking trolleybus is most noticeable. (R. F. Mack)

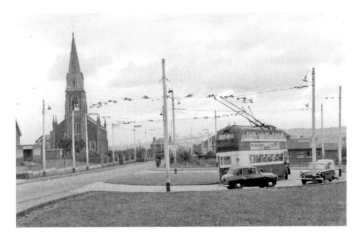

Looking east towards the city centre, trolleybus 215, (OZ 7317), stands in the Glen Road turning circle. On 15 June 1964, the big, six-wheeled BUT 9641T is parked opposite St Teresa's Church in company with a Hillman Minx Phase VI and a six-cylinder Ford Zephyr II 206E saloon. If there was one disappointing aspect to the design of these Harkness-bodied trolleybuses, it was that the corporation's specification did not include a rear set of destination boxes. This left a large blank panel beneath the emergency rear window and somehow highlighted the set of clips used to hold this window open and the ladder over the rear dome used by electrical fitters to gain access to the trolley gantry and poles. (J. C. Gillham)

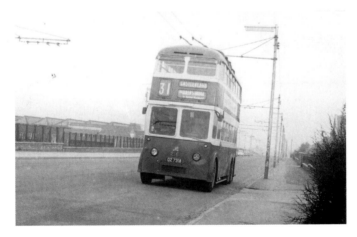

Approaching the terminus of the 31 route in Castlereagh Road during April 1962 is BUT trolleybus 216, (OZ 7318). It is opposite the early post-war factories built in this part of south-eastern Belfast. There were two sets of overhead power lines on the inbound side of Castlereagh Road with the inner set being used to park trolleybuses before the 'work whistle' sounded and there was a rush out of the gates by the factory employees to get onto the waiting vehicles. Alas, for most of the time, the number of workers never really justified the luxury of an overtaking line, and so this extra was only infrequently used. (C. W. Routh)

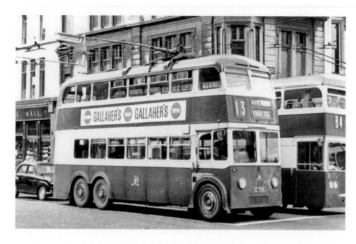

Waiting to turn right from Royal Avenue into Castle Street is trolleybus 217, (OZ 7319). Even though it was now about ten years old and the trolleybus fleet was already being phased out by the type of MH Cars Daimler 'Fleetlines' passing it on the nearside, these Harkness-bodied six-wheelers were still handsome-looking vehicles. 217 is working on the 13 route to Glen Road from Whitewell, though the bottom destination blind is incorrectly set showing 'CARLISLE CIRCUS'. Almost parked on the rear platform of 217 is a 1956 Standard Eight. (J. Bishop)

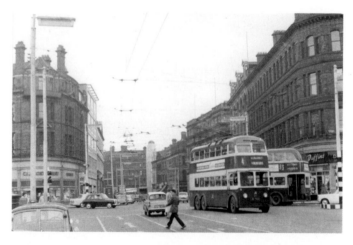

On 15 June 1964, 218, (OZ 7320), one of the 1954-bodied BUT 9641T trolleybuses turns right out of Donegall Street into York Street. It is working on the 4 route to Glengormley via Duncairn Gardens. Behind the trolleybus is Royal Avenue with *The Belfast Telegraph* buildings on the right. Turning into Royal Avenue is an ex-London Transport rebodied Daimler CWA6s working on the 93 service from Carr's Glen via Oldpark Road. (J. C. Gillham)

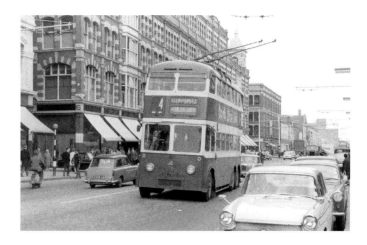

The Antrim Road routes extensively used the 1954-batch of 105-hp BUT 9641T trolleybuses. Their larger GEC motors were well suited to the long run though Bellevue to Glengormley. 219, (OZ 7321), was one of six of the class that entered service during March 1954. The trolleybus is passing the impressive Belfast Co-operative Society's department store in York Street, which always seemed to have the canvas blinds down during business hours, irrespective of whether it was rain or shine. 221 is travelling into the city on the 4 route having reached York Street by way of Duncairn Gardens. (D. R. Harvey Collection)

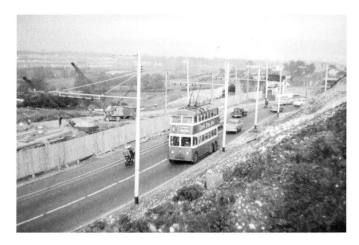

The construction of the M2 motorway below the Antrim Road caused some disturbance to the trolleybus route to Glengormley. Other systems, such as Walsall and Wolverhampton, when faced with similar problems simply abandoned the route, especially when the route was going to be closed down anyway in the near future. Here, however, temporary trolleybus overhead was put in using a series of single bracket arms located on the western side of the road. Crossing the roadworks on 27 March 1964 as it travels on its way to Glengormley on the 4 route is trolleybus 219, (OZ 7321). The bridge carries the Antrim Road over the motorway at a severe skew angle of about 62 degrees. Work began on this first section of the M2 on 2 September 1963, and this and the A8(M) were opened to traffic on 24 October 1966. Despite all the extra overhead put in place over the civil engineering work, the Antrim Road services were still abandoned on 5 February 1966. (D. R. Harvey Collection)

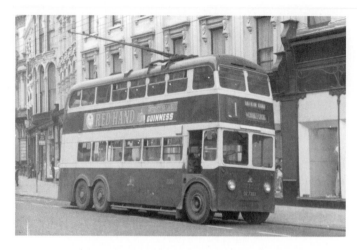

Standing in Castle Place with its interior lights on is BUT 9641T trolleybus 220, (OZ 7322). On 5 June 1964, the trolleybus is working on the 1 route to Antrim Road. The driver of this trolleybus has left his cab and is probably having a 'chinwag' with his conductor. Although the sliding cab door concept was a good one, allowing particularly closer rows of vehicles parked in yards, they did have numerous disadvantages, not least the physical contortions required by the driver to actually get into his cab! Another was that, just like on Bedford CA 15-cwt vans, the door would slide shut under acceleration and burst open on braking. (J. C. Gillham)

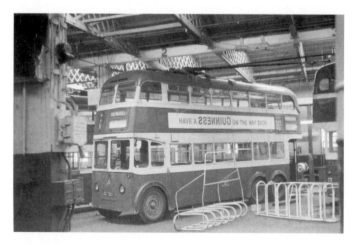

Parked over the pits in the workshops in Falls Park depot is 221, (OZ 7323). This Harkness-bodied BUT 9641T trolleybus is receiving some mechanical repairs having come to the works from its home depot at Haymarket. Parked alongside motor buses, this six-wheeler does look remarkably long and overhangs the main driveway through the depot. The trellis roof supports, known as a Belfast Roof, were cheap to construct and could enclose a large space. Unfortunately, it was made of wood and was therefore a fire hazard, and alas, there were two fires in the 1960s, one of which 'did for' trolleybus 196 on 1 March 1966. (J. Shearman)

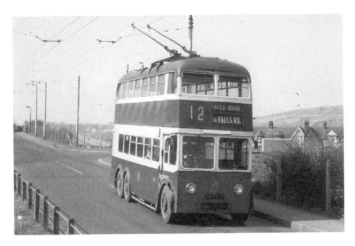

Travelling down the hill from the Whitewell terminus towards the junction with Shore Road near to Greencastle is 221, (OZ 7323). This BUT 9641T is being used on the cross-city 12 service to Glen Road. These 1954 Harkness-bodied trolleybuses had a much neater body design when compared to the earlier post-war classes of Guy BTXs and BUT 9641Ts, making them some of the best-looking trolleybuses ever built in the United Kingdom. Behind the trolleybus is the M2 motorway, which was still under construction at this time. (D. R. Harvey Collection)

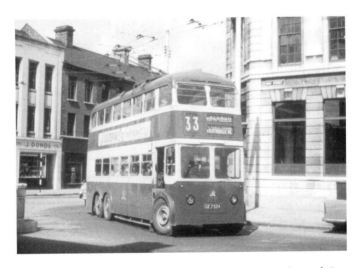

Turning into May Street from Victoria Street when on its way to Cregagh is a rather smart-looking trolleybus, 222, (OZ 7324). The trolleybus is just west of the 1933 Royal Courts of Justice building. This BUT 9641T has crossed the city centre from Carr's Glen and is about to pass the building owned by the Northern Ireland Bank which survived until about 2007. Like most of the class, 222 would only have a service life of a little over fourteen years, which for such robustly made vehicles was far too short. (Trolleyslides)

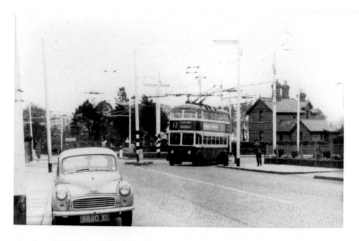

Looking towards the city with Falls Road beyond the parked Morris Minor 1000, BUT 9641T trolleybus 222, (OZ 7324), while working on the 13 service, turns around the traffic island to enter Glen Road at the junction with the Falls. To the extreme left, the trolleybus overhead goes up Divis Drive in order for trolleybuses to get to the Falls Park works. Behind the trolleybus is the early-nineteenth-century Roman Catholic Milltown Cemetery, which was built on the site of a brickyard. (R. Symons)

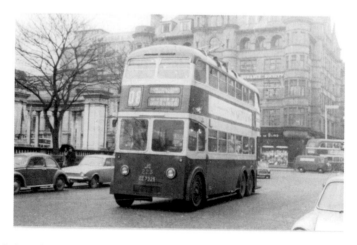

The interior lights of trolleybus 223, (OZ 7325), are switched on as this 1954-bodied trolleybus hurries around Donegall Square North. It is working on the 8 route to Fort William along the Shore Road, and despite it being about 1965, the trolleybus looks in a good state of repair. On the left is the Belfast Cenotaph at the rear of the City Hall while on the right, turning into Bedford Street, is a fairly new Daimler 'Fleetline' with an MH Cars body. (A. J. Douglas)

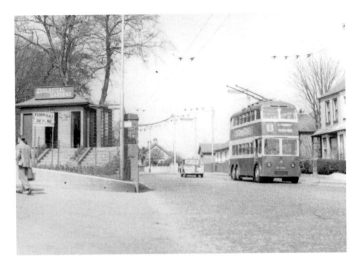

Using the outer set of overhead wires as it travels into Belfast, trolleybus 224, (OZ 7326), is working on the 3 route from Glengormley. On the left is the entrance to the Bellevue Zoological Gardens and the 1930s Art Deco Floral Hall ballroom. In the late 1950s, you paid 2s per adult and 6d for a child at the entrance kiosk to get into the grounds. On leaving the gardens, you had to pass through the one-way turnstile gates at the top of the steps. Then you walked across Antrim Road to get on one of the waiting trolleybuses parked with their booms up on the nearside set of running wires that would take you back to the city centre. The silver-painted wheels were the final touch of stylishness for all Belfast trolleybuses, and this Harkness-bodied BUT 9641T looks extremely smart as it passes the Victorian houses opposite the entrance to the zoo. The trolleybus is being followed by an Armstrong-Siddeley Lancaster saloon. (R. F. Mack)

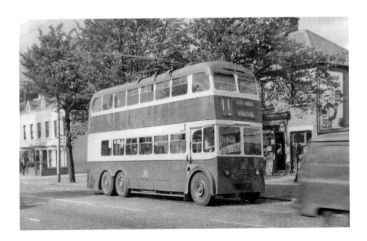

A 1954-bodied BUT 9641T trolleybus stands at the Beechmount Avenue bus-stop in Falls Road outside the confectionery and tobacconist shop. 225, (OZ 7327), is travelling into the city while working on the 11 route between 1959, when the route to Whiterock was opened, and 1962, when the service number was altered to 45. Hidden by the speeding Bedford CA van is where the small Clowney Water flows underneath Falls Road. (C. Carter)

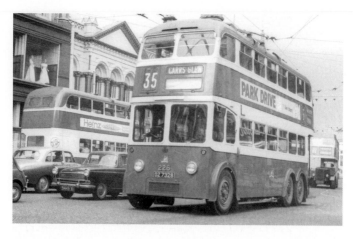

Going across the Castle Place junction from Royal Avenue is Harkness-H36/32R-bodied trolleybus 226, (OZ 7328). The trolleybus is apparently going to Carr's Glen but is in fact coming from that northern suburb. It is showing the route number 35 because it is only going as far as Donegall Square and is most likely to be turning round there before returning to the Joanmount Gardens turning circle on Ballysillan Road. Behind this BUT 9641T is a Harkness-rebodied former London Transport Daimler CWA6 511, (GYL 272). (R. F. Mack)

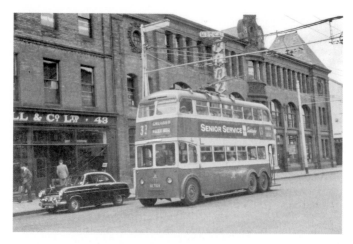

The Plaza Ballroom building dated from 1906, but it was from the late 1950s until the 1960s that it had its most exciting period. The Plaza became one of Belfast's biggest and best ballrooms throughout the early Irish showband era. It was located in Chichester Street beyond the corner of the just-visible Montgomery Street about halfway between Donegall Square East and Victoria Street. The Plaza finally closed in 1970 and went out in a blaze of glory when it was destroyed by fire in 1975. Overtaking the parked all-over-black Ford Consul EOTA, of which Henry Ford would have been proud, is trolleybus 227, (OZ 7329), which is working on the 33 service to Cregagh. (J. Shearman)

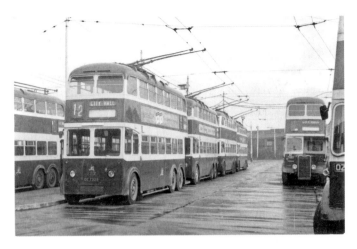

Standing at the head of a row of four trolleybuses in Haymarket depot's open yard is trolleybus 227, (OZ 7329). Looking southwards into the depot on 16 June 1964, the 8-foot-wide, Harkness-bodied trolleybus makes an interesting comparison with the same manufacturer's bodywork built to a width of 7 feet 6 inches on the motor bus on the right. This 1950 Guy 'Arab' III is 335, (MZ 7433), and was one of a batch of forty-five double-deckers built, quite unusually with a Wilson preselector gearbox. (J. C. Gillham)

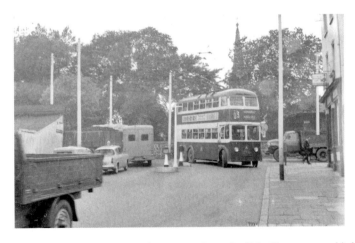

The inbound 3 trolleybus from Glengormley, on reaching Carlisle Circus, turned left into Clifton Street, but in order to gain York Street to get back to Royal Avenue, took a totally different route to the outbound Antrim Road trolleybuses. BUT 9641T trolleybus 228, (OZ 7330), makes the tight turn from North Queen Street into Frederick Street on 15 June 1964. Through the trees above the trolleybus is the spire of Clifton House. Set in its own extensive grounds, it is the oldest surviving building in Belfast. It was completed in 1774 as 'The Charitable Society's Poor House and Infirmary' and today is a luxury conference centre. The public house on the right corner of Frederick Street has a sign for William Younger's beers whose symbol was 'Wee Willie'. Enough said, and it was ghastly beer as well! (J. C. Gillham)

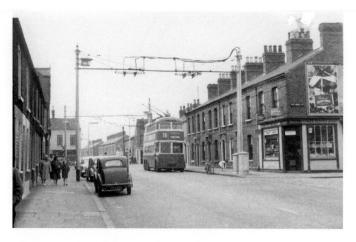

The distant curving overhead shows that the trolleybus has just turned left into Beersbridge Road from Woodstock Road. The driver of Harkness-bodied BUT 9641T 229, (OZ 7331), a GEC 105-hp motored vehicle will pull away from the bus-stop and then coast under the large gantry carrying the power input lines. Under traction pole on the right is a pair of junction boxes in front of the tobacconist shop on the corner of Pottinger Street. The trolleybus is working on the 30 route to Bloomfield. (D. R. Harvey Collection)

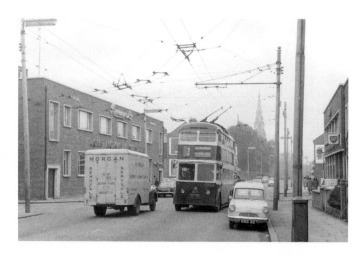

Travelling away from the distant Carlisle Circus and Clifton Street is trolleybus 229, (OZ 7331). In the distance, the tall Transylvanian-style spire of the Carlisle Memorial Methodist Church, built in 1875 to the designs of W. H. Lynn, stands against the skyline. The BUT six-wheeled trolleybus is working on the 3 route to Glengormley on 15 June 1964. It is passing the 1950s premises of John Morgan & Sons furniture removal company. On the left is the Churchill Street reverser, which was used to turn trolleybuses back to either Glengormley or Carr's Glen when the 12 July processions blocked Clifton Street. (J. C. Gillham)

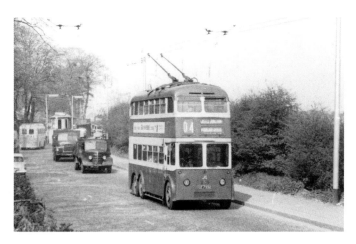

In the 1960s, the Antrim Road, in common with many other arterial routes out of Belfast, was, by today's standards, remarkably narrow. On Friday 27 April 1962, 230, (OZ 7332), is seen going towards Castle Junction in Belfast's city centre on the 4 route and is being followed by a pair of Bedford lorries. The trolleybus has just passed the entrance to the Belfast Zoological Gardens, which is being approached by an Ulster Transport Authority underfloor-engined Leyland 'Tiger Cub' PSUC1/5Ts with a UTA B43F body delivered in about 1956. (C. W. Routh)

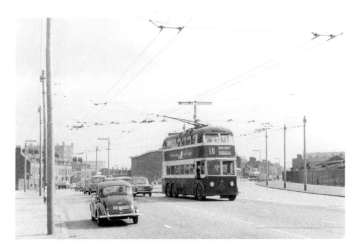

Passing the Grove turning circle for the 9 route shortworking at the junction with North Queen Street is BUT 9641T trolleybus 231, (OZ 7333). This was the first turn back on Antrim Road and was used by the trolleybuses to get back to the York Road railway station. This solid-looking Harkness-bodied six-wheeler is in York Road on Monday 15 June 1964 and is proceeding to Whitewell along the Shore Road when working on the 10 route. Behind the trolleybus are the international-size Grove Swimming Baths. Just visible in North Queen Street is a UTA Leyland 'Tiger' PS1 single-decker with an NIRTB rear entrance body and a luggage roofrack. (J. C. Gillham)

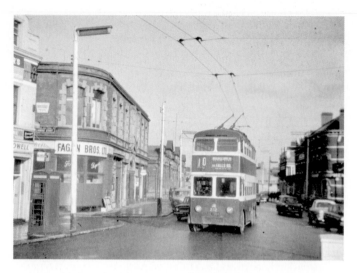

Trolleybuses taking up service from Haymarket depot used East Bridge Street in order to reach firstly Cromac Square and then Victoria Street and May Street to gain the back of the City Hall in Donegall Square South. Here, 232, (OZ 7334), the only one of the twenty-four BUT 9641Ts to be delivered in September 1954, passes Market Street as it makes its way along East Bridge Street before taking up service on the Whitewell route. It has come out of Annette Street where a silver-painted traction pole is located and is visible just to the right of the trolleybuses platform. (D. R. Harvey Collection)

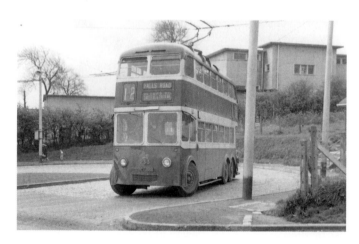

A rather dented 233, (OZ 7335), stands in the Whitewell turning circle adjacent to the Throne Hospital in early 1968. By this time, the trolleybus fleet was beginning to deteriorate, as minor damage was not going to be worthwhile repairing. Fortunately, the Metal Sections framework on these trolleybuses remained robust until the end, and despite their down-at-heel appearance, they were quite serviceable and perhaps only needed a little 'TLC', but this would never happen! This Harkness-bodied BUT 9641T is about to set off across the city to the Casement Park terminus of the 12 route on the Falls Road in Andersonstown. (M. Corcoran)

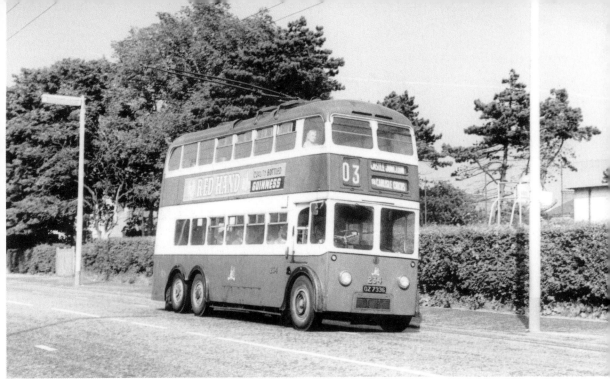

The chassis of this trolleybus, 9641T 588, was exhibited at the 1952 Commercial Motor Show, Earls Court, and as a specially prepared chassis, it was given some non-standard features. While it soon lost its chrome-plated chassis nuts and bolts, it did retain throughout its Belfast service a cream steering wheel. After being bodied by Harkness, 234, (OZ 7336), finally entered service on 5 November 1954, some thirteen months after the first of the batch, 211, went on the road. It is seen here in pristine condition, the state in which one would like to remember these magnificent-looking six-wheelers. 234 is travelling along Antrim Road on an inbound 3 service in June 1964. Four years later, 234 became the last trolleybus to leave the Glen Road terminus on 12 May 1968. (M. A. Sutcliffe)

CHAPTER SEVEN

SECOND HAND FROM WOLVERHAMPTON

Belfast approached Wolverhampton Corporation about the possible purchase of some of their 'pre-war' trolleybuses. This was because Belfast had a shortage of trolleybuses and they wanted enough vehicles to operate the Shore Road services after the abandonment of tram routes.

This was Belfast's first venture into the second-hand market and the only one for trolleybuses, for after this, the Corporation purchased 100 former London Transport wartime Daimler CWA6s or CWD6s from W. North of Leeds. The eleven Sunbeam MF2s were some of the last of the model to be constructed before Sunbeams began construction of the wartime W4 chassis. Although only ten years old, these trolleybuses were made redundant in their home town after a batch of wartime Sunbeam W4s were fitted with new bodies. They were contemporary to Belfast's indigenous AEC 664T six-wheelers.

Eleven trolleybuses were required to cover for the late delivery from Harkness of the 1952 BUT 9641T chassis, and so Wolverhampton's 182 and 286-290, with Park Royal H28/26R bodies, were selected as well as Wolverhampton's 291-295, which had Roe H29/25R bodies. They were purchased for the bargain price of £150 each. The eleven vehicles were given the fleet numbers 235-245 and all received a full overhaul, Belfast-style front destination boxes and a complete repaint into the fleet livery.

Initially, they were used on the Shore Road routes, but it was soon realised that, with their low-powered motors and small seating capacity, they were really only suitable for shortworkings, peak-time extras and football specials. As a result, they were destined to have brief lives in Belfast, as once the 211-234 had begun to arrive in 1954, these non-standard four-wheelers began to be taken out of service. Six were withdrawn in the latter half of 1954, while the remaining five soldiered on until 1956. After withdrawal, these second-hand vehicles were towed into Knock depot and stored there until they were sold for scrap.

Not all of these trolleybuses were photographed in Belfast, but those that were not are shown, for completeness, in their native Wolverhampton.

Right: The only known photograph of 235, (DDA 182), is a rather murky one taken in the early post-war years when it was still Wolverhampton Corporation's 282. This Sunbeam MF2 had a Park Royal H28/26R body built to pre-war standards and entered service with the West Midlands municipality on 20 March 1940. Wolverhampton purchased thirteen of the last fourteen of these four-wheelers before the model was replaced by the wartime Sunbeam/ Karrier W4 model. 282 was the only one of the pair of 1940 Park Royal MF2s to be purchased and had a service life of barely two years in Belfast. (D. R. Harvey Collection)

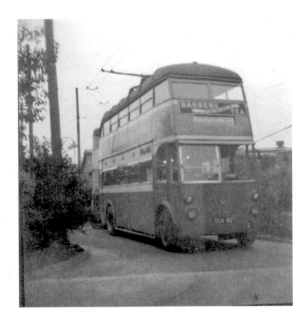

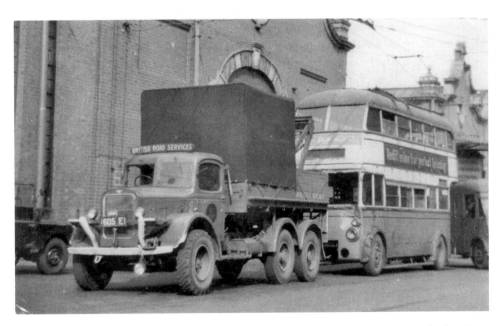

The ex-military Austin K6 3-ton 6 x 4 six-wheeler stands outside Cleveland Road trolleybus depot on 9 June 1952. The Austin, equipped with a towing crane, belongs to the recently nationalised British Road Services and was based in Walsall, but it is fitted with a set of Irish trade plates. The lorry is hitched up to Wolverhampton's 286, (DDA 986), a Park Royal-bodied Sunbeam MF2, which dated from 4 March 1942. The trolleybus is about to leave Wolverhampton for shipment across the Irish Sea from Heysham on 9 June 1952. This trolleybus, although damaged around the cab front, would receive 'the full Belfast treatment', but this did not ensure a long life in the city, as it was taken out of service on 30 August 1954. (D. R. Harvey Collection)

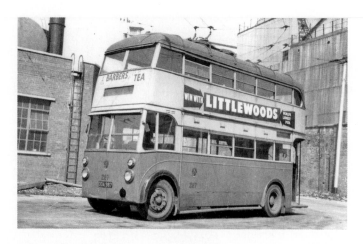

The recently acquired Wolverhampton Corporation 287, (DDA 987), is parked in Short Strand depot yard. It is seen immediately after it arrived in Belfast, having left its home town on 27 May 1952. Weighing in at 6 tons 17 cwt 1 qtr, this ten-year-old Park Royal-bodied Sunbeam MF2 trolleybus must have seemed a good bargain at just £150, but it was, to an extent, a case of 'buy in haste and repent at leisure'. After the conversion of the Shore Road services on 2 October 1950, there was a need to obtain more vehicles fairly quickly. When these vehicles became available eighteen months later as surplus to Wolverhampton's requirements, eleven vehicles were purchased. They were purchased in order to release larger six-wheelers from other duties to work on the Shore Road services. The Sunbeam MF2 four-wheeled chassis obviously only had a small seating capacity, thus restricting them to either the shorter trolleybus routes or shortworkings and so their initial sojourn on the Greencastle service was a very short one. In addition, these eleven trolleybuses only had 80-hp BTH motors and so were underpowered for the needs of Belfast. But on this day in early June 1952, these purchases must have seemed a good buy. (D. R. Harvey Collection)

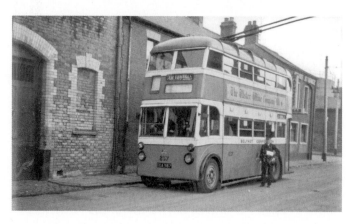

In Annette Street, alongside the typical Victorian terraces, is the recently acquired 237, (DDA 987). It had received a full set of Belfast's front destination boxes, though the side one was just the single-line aperture as used in Wolverhampton. This 1942-vintage Sunbeam MF2 had a Park Royal H28/26R body and, despite entering service in August 1952, was withdrawn on New Year's Eve 1954. It is about to work on a shortworking or a peak-hour extra to Cliftonville where there was a turning circle at the junction of Old Park Road. This had its own route number, which was 36 and was a shortworking of the 35 route to Carr's Glen. The 36 route was most frequently used on match days when Cliftonville were playing at home at their Solitude Ground. Cliftonville had been founded in 1879 and were one of the eight clubs that founded the Irish Football League in 1890. (D. R. Harvey Collection)

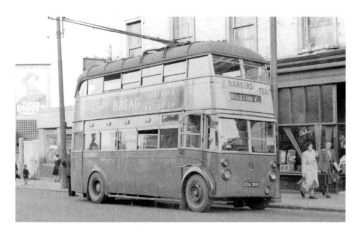

This is how 238, (DDA 988), looked in its latter days when it was working for Wolverhampton as their 288. The Park Royal-bodied trolleybus originally entered service on 18 February 1942 and served in the green and yellow livery of the Black Country town for ten years and one week. It is parked in Victoria Square, Wolverhampton, while working on the Bilston service. As Belfast 238, this Sunbeam MF2 trolleybus must have been one of the better ones of the batch, as it lasted until the last day of 1956. (S. N. J. White)

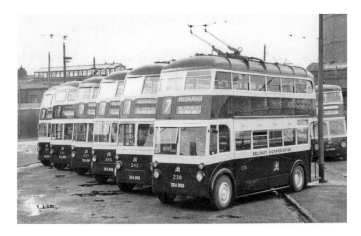

Lined up in Haymarket depot, immediately after receiving Belfast destination boxes and red and broken-white livery, are six of the eleven former Wolverhampton trolleybuses purchased in 1952. From right to left are 239, (DDA 989), 242, (DDA 992), 245, (DDA 995), 237, (DDA 987), 238, (DDA 988), and at the far end of the row is 243, (DDA 993). 239, 237 and 238 all have the slightly severe-looking Park Royal bodies, while the other three have the more curvaceous Roe H29/25R bodywork. All of these vehicles display the GREENCASTLE 7 route destination, for which task they soon proved rather unequal. 238 had been rebuilt with rather ungainly rubber-mounted front upper-saloon windows. The trolleybus on the extreme right is 210, (GZ 8574), the last of the first batch of BUT 9641Ts dating from 1950. (D. R. Harvey Collection)

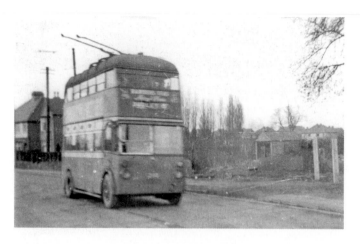

Beyond the Fighting Cocks turning circle, the Wolverhampton to Dudley trolleybus service moved into Wolverhampton Road East before the route began the long, steep climb from Ettingshall into Sedgley. The trolleybus working on the 8B route, Wolverhampton's 290, (DDA 990), in remarkably original condition, was their last 'pre-war' trolleybus to enter service on 27 October 1942. Becoming Belfast 240 in October 1952, this Park Royal-bodied trolleybus remained in service until 31 December 1956. It was also the longest-lived of all the second-hand trolleybuses as it became Caravan No. 17 at Caston's Farm site in Portrush, surviving until June 1964. (R. Hannay)

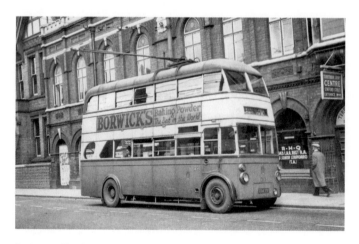

Standing outside the Staffordshire Regiment's drill hall in Stafford Street, Wolverhampton is that Corporation's 291, (DDA 991). This was the first of the final five pre-war Charles Roe bodies built to their pre-war style. They had a deep roofline, which was single-skinned making for a lot of drumming from the overhead gantry and poles in the upper saloon. The rest of the body was pleasingly curved and the seating capacity split of twenty-nine/twenty-five gave away the fact that it had a Roe two-landing patent staircase behind the curved offside rear window. (D. R. Harvey Collection)

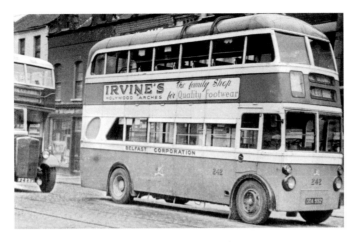

In Albertbridge Road, coming into the city on a football special service from the Oval Ground of Glentoran FC, is trolleybus 242, (DDA 992). The Oval Ground is to the north of Newtownards Road alongside the old Belfast & County Down railway's Belfast to Bangor line. The ground was usually served by the Dundonald trolleybus service using the Connswater shortworking. This Sunbeam MF2 had a Roe H29/25R body and, despite its well-presented appearance, was to operate in Belfast for just twenty-three months. Behind the trolleybus is UTA's R276, (FZ 233), a 1938 AEC 'Regent' with a L27/24R body, which was one of the last double-decker Cowieson bodies to be built. (J. C. Brown)

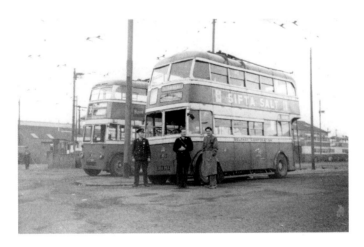

Looking a little shabby towards the end of its Belfast career, 243, (DDA 993), is parked in Haymarket depot yard. This Sunbeam MF2 had a BTH 80-hp motor and a Roe H29/25R body. A driver, conductor and an enthusiast pose in front of this trolleybus, while behind them is AEC 664T 78, (FZ 7862), which like the former Wolverhampton four-wheeler, dated from 1942. (D. R. Harvey Collection)

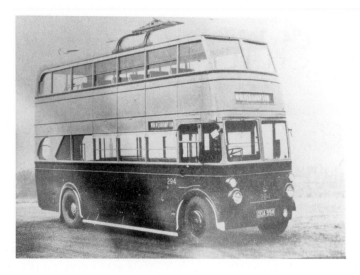

On 9 June 1952, 244, (DDA 994), became one of the two Sunbeam MF2 trolleybuses to leave Wolverhampton en route to Belfast. Ten years earlier, the trolleybus, as 294, (DDA 994), was used by Charles Roe as the subject of their official photograph in February 1942, although, despite having white-painted blackout markings, it has neither hooded headlights nor masked interior lighting. (D. R. Harvey Collection)

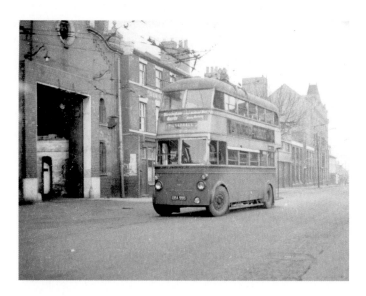

When owned by Wolverhampton Corporation 295, (DDA 995), the last pre-war-bodied trolleybus to be delivered to the Black Country municipality seemed to be cursed. This Roe-bodied Sunbeam MF2 crashed over the embankment at Newbridge, Tettenhall Road on 22 May 1946 and then overturned outside Bantock Park on 22 November 1946. It is in Cleveland Road, having reversed into the road from the depot in about 1948. Wolverhampton must have been pleased to see the back of it in June 1952 when it was sold to Belfast, becoming their 245. It must have been 'doomed' in Belfast; having entered service on 2 August 1952, it was withdrawn in July 1954. It is also seen as the third trolleybus from the right, in full Belfast livery, in the earlier view of Haymarket depot. (D. R. Harvey Collection)

184

CHAPTER EIGHT

THE LAST TROLLEYBUS

The final trolleybus to be purchased by Belfast Corporation was 246, (2206 OI), a solitary Sunbeam F4A fitted with Harkness-H36/32R-finished bodywork on Metal Sections frames. For the first time since the pair of Sunbeam MS2s of 1938, a BTH motor was specified, which was rated at 120 hp, making it easily the most powerful of any Belfast trolleybus. The bodywork on 246 looked very similar to the last twenty-four six-wheeled BUT 9641Ts, numbered 211-234, but its height was considerably lower. It was the only two-axled 30-foot trolleybus bought new by Belfast and weighed 8 tons 13 cwt, which was about 27 cwt lighter than the BUTs. 246 was notable for being the first trolleybus in the United Kingdom to have a reversed registration.

246 was the second of the four trial vehicles of this length to enter service. These vehicles were purchased in order to be appraised for a future fleet renewal programme. The first of the four was motor bus 550, (WZ 7484), an AEC 'Bridgemaster' B3RA with a Crossley H39/31R body, which arrived early in 1958. The second vehicle was the trolleybus 246, which entered service on 1 October 1958, while the third was a very early rear-engined Leyland 'Atlantean' PDR1/1 with an Alexander H43/34F body, which entered service in April 1960 as 551, (5540 XI). The final bus was 552, (8760 AZ), a Dennis 'Loline' III with a Self-Changing Gears four-speed semi-automatic gearbox and an attractively proportioned Northern Counties seventy-six-seater body. This vehicle entered service during 1961.

The F4A chassis had been introduced in 1953 when the first 20 were built for Glasgow Corporation, starting with chassis number 9001. These trolleybuses were 27 feet 6 inches long with five being bodied by Alexander and fifteen by Weymann. The next chassis was shown at the 1954 Commercial Motor Show and was subsequently dismantled, as was chassis 9044 some two shows later in 1956. Meanwhile, Walsall Corporation ordered the pioneering 30-foot-long F4As with Willowbrook bodies in two batches numbered 851-872, which were delivered between November 1954 and October 1956. Built on chassis 9022-9043, special dispensation had to be given to these two-axled trolleybuses as the current construction and use regulations only allowed the operation of 27-foot-6-inch-long double-deckers, which was only rescinded in 1956.

The only other 30-foot-long Sunbeam F4A to be constructed was chassis number 9045, which became Belfast's 246. It was the last of the chassis built in this sequence,

as all the remaining Sunbeam F4As were built by Guy Motors for Derby and Reading Corporations to a length of 28 feet 6 inches and had TFD-prefixed chassis numbers.

So 246 was something of an experimental trolleybus both from the manufacturer's and operator's viewpoint. It was a splendid looking trolleybus and, despite problems with its Lockheed braking system, seemed to make a sufficiently good impression with Belfast Corporation that by the end of the spring of 1959, an article in *The Belfast Telegraph* stated that the success of this trolleybus would mean that it was to be the precursor of up to one hundred new trolleybuses. It was a premature press announcement, as by the end of the summer, after the General Manager and the Transport Committee had met, not only were there to be no more new trolleybuses but the trolleybus system would be gradually abandoned.

Just as in 1939 when the placing of the large pre-war trolleybus order went to a combination of chassis, electrical equipment and body, which had not been trialled, the prototype three buses and solitary trolleybus became something of an interesting but protracted diversion, as in 1961 an order was placed for eighty-eight Daimler 'Fleetline' CRG6LXs. The bodywork contract for these buses went to MH Cars who were a new Belfast-based coachbuilder. This virtually spelt the end of Harkness as a bus bodybuilder as well as 246 being the swansong for the Belfast trolleybus fleet.

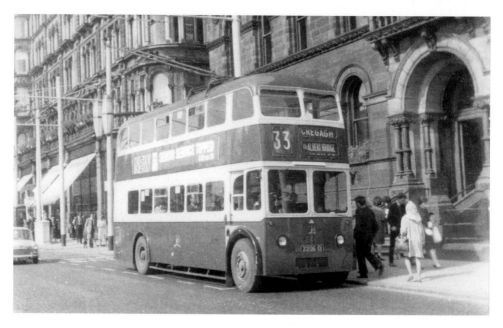

Parked outside Richardson Sons & Owden's linen warehouse in Donegall Square North, with Robinson & Cleaver's department store behind it, is Belfast's last new trolleybus. 246, (2206 OI), was a 30-foot-long and 8-foot-wide two-axled Sunbeam F4A, and other than the twenty-two Willowbrook-bodied examples built for Walsall Corporation, this was the only other F4A constructed to these 'box' dimensions. 246 had a Harkness H36/32R body design based on the style of the twenty-four OZ-registered BUT 9641Ts, but noticeably lower. 246 is picking up passengers before heading across the Albert Bridge to Cregagh on the 33 route. (D. R. Harvey Collection)

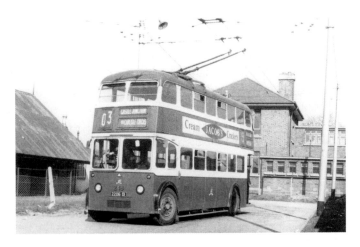

Reversing at the Glengormley terminus of the 3 route on 25 April 1962 is Belfast's last new trolleybus. 246, (2206 OI), a Harkness-bodied Sunbeam F4A, was, according to an announcement in *The Belfast Telegraph* in the early summer of 1959, the prototype for 100 new trolleybuses. By the end of August, this decision had been reversed and even worse was the announcement that all of the trolleybus routes across the River Lagan on the eastern County Down section of the system would be withdrawn as soon as was practicable. The body on 246 was constructed as usual by Harkness, but this handsome trolleybus was destined to be their last body for Belfast Corporation. (C. W. Routh)

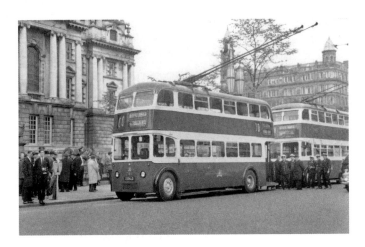

On Saturday 11 May 1968, the day before the final day of Belfast's trolleybus operation, the three overhauled and repainted trolleybuses destined for preservation were lined up in Donegall Square East for an official 'Last Trolleybus' parade. Led by 246, (2206 OI), the Sunbeam F4A four-wheeler, which was briefly the hope for a resurgence in the fortune of the Belfast trolleybus system, stood alongside City Hall and the *Titanic* Memorial. Behind it was Guy BTX 112, (FZ 7897), which is now at the Cultra Folk & Transport Museum, while at the rear was 168, (GZ 8532). The fourth restored trolleybus, Guy BTX 183, (GZ 8547), was used as the reserve vehicle. The three trolleybuses were drawn up on the wrong side of the road so that normal traffic would not be obstructed. (M. Corcoran)

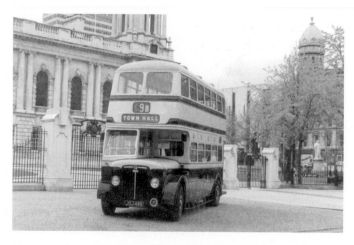

On Sunday 27 April 1997, after winning the Vehicle Travelling the Furthest prize, the Best Double-Decker and the Best Vehicle at the Rally 1st Prize, the previous day at the prestigious Belfast-Bangor rally, the author, with other members of the 2489 Group took the bus into Belfast's city centre. 2489, (JOJ 489), a former Birmingham City Transport Crossley DD42/6 with a Crossley H30/24R body dating from 1950, stands in Donegall Square North in front of the magnificent City Hall. This was just around the corner from where the ceremonial line-up took place twenty-nine years earlier. (D. R. Harvey)

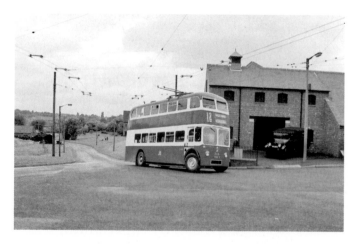

246 was stored for many years at the excellent tram and trolleybus museum at Carlton Colville near Lowestoft. Over thirty years after it had last operated in Belfast, 246 was taken to the 26-acre site of the Black Country Living Museum in Dudley where it received attention to its troublesome Lockheed braking system. The restored 246 has resided at the museum on an extended loan from Carlton Colville and has performed quite splendidly on the long figure of eight circuit around the extensive site. On 21 June 2008, the Sunbeam has just returned from the distant 'village' and has climbed the steep hill back to the turning circle outside the trolleybus depot. It looks absolutely splendid and now drives beautifully! (D. R. Harvey)

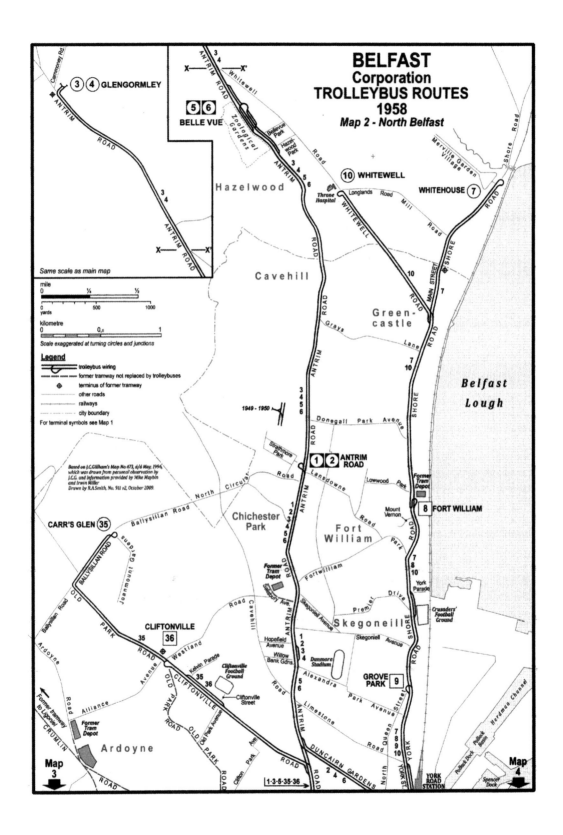

BELFAST
Corporation
TROLLEYBUS ROUTES
1958
Map 2 - North Belfast

(3)(4) GLENGORMLEY

(5)(6)
BELLE VUE

(10) WHITEWELL

WHITEHOUSE (7)

Hazelwood

Cavehill

Green-castle

Belfast Lough

Same scale as main map

mile
0 ¼ ½

0 500 1000
yards

kilometre
0 0.5 1

Scale exaggerated at turning circles and junctions

Legend
trolleybus wiring
former tramway not replaced by trolleybuses
terminus of former tramway
other roads
railways
city boundary

For terminal symbols see Map 1

Based on J.C.Gillham's Map No.473, d/d May, 1994,
which was drawn from personal observation by
J.C.G. and information provided by Mike Maybin
and Irwin Miller.
Drawn by R.A.Smith, No. 911 v2, October 2009.

CARR'S GLEN (35)

Chichester Park

Fort William

Former Tram Depot

(8) FORT WILLIAM

North Circular Road

Ballysillan Road

Crusaders' Football Ground

CLIFTONVILLE

(36)

Skegoneill

Former Tram Depot

York Parade

Hopefield Avenue

35

36

Cliftonville Football Ground

Cliftonville Street

Dunmore Stadium

GROVE PARK (9)

Alexandra Park Avenue

Former Tram Depot

Ardoyne

Map 3

1·3·5·35·36

YORK ROAD STATION

Spencer Dock

Map 4

1949 - 1950

(1)(2) ANTRIM ROAD

Lowwood Park

Mount Vernon

189

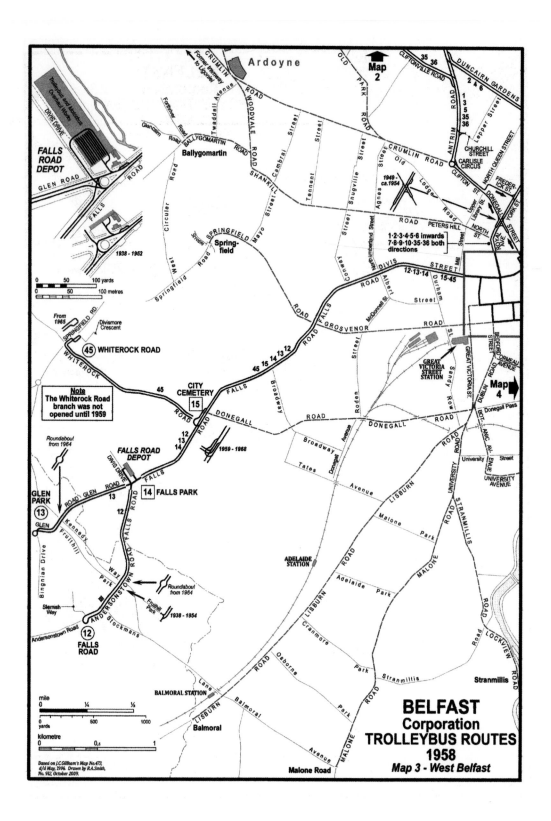

BELFAST
Corporation
TROLLEYBUS ROUTES
1958
Map 3 - West Belfast

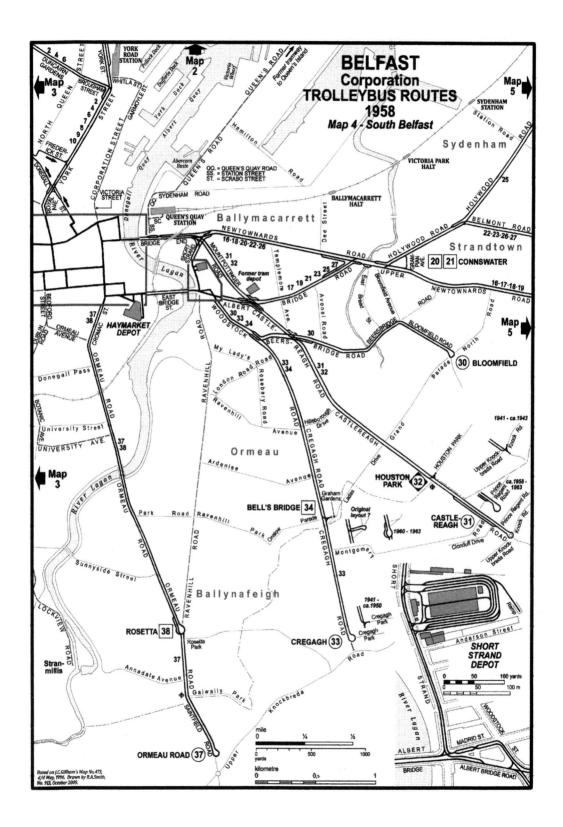

BELFAST
Corporation
TROLLEYBUS ROUTES
1958
Map 4 - South Belfast

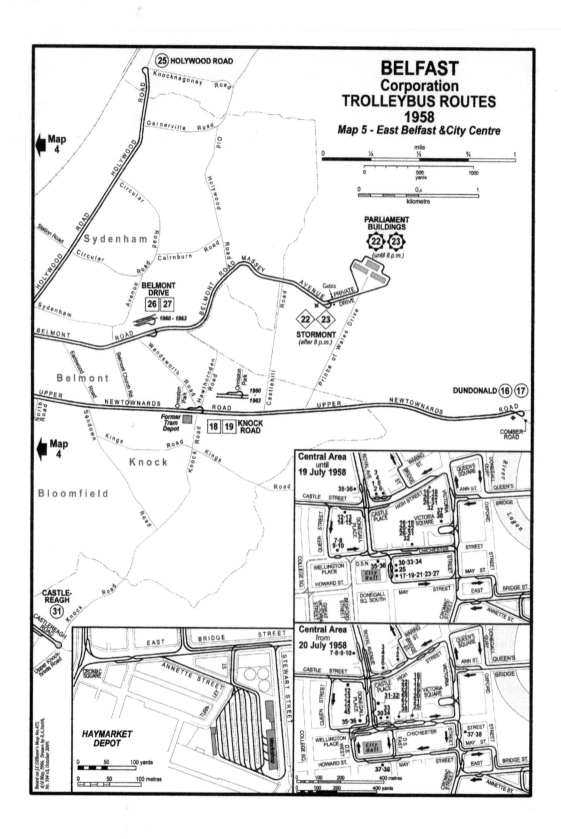

BELFAST
Corporation
TROLLEYBUS ROUTES
1958
Map 5 - East Belfast &City Centre